THE VISUAL LANGUAGE OF
DRAWING

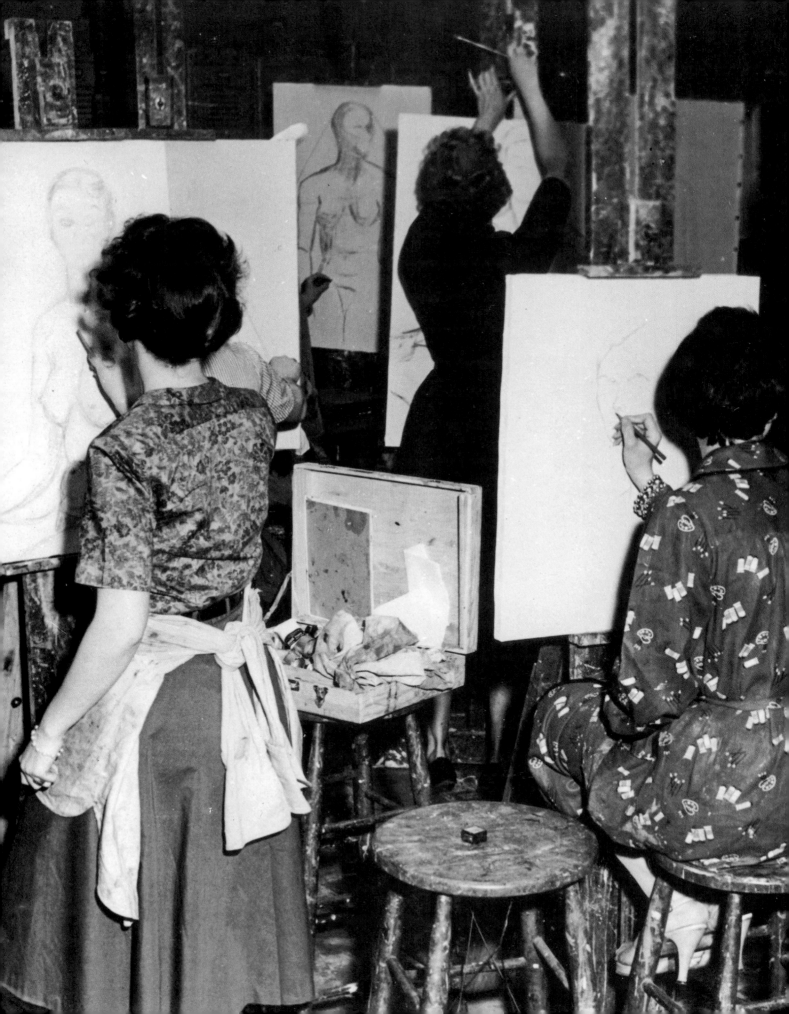

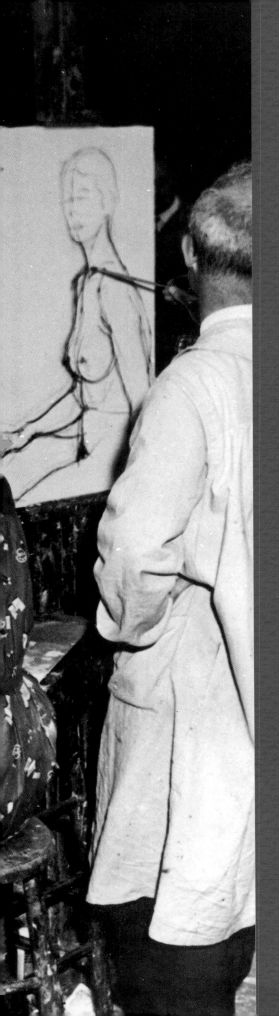

THE VISUAL LANGUAGE OF
DRAWING
Lessons on the Art of Seeing

James Lancel McElhinney and
the Instructors of the
Art Students League of New York

Foreword by Ira Goldberg

STERLING
New York

STERLING
New York

An Imprint of Sterling Publishing
387 Park Avenue South
New York, NY 10016

ISBN 978-1-4027-6848-4

Distributed in Canada by Sterling Publishing
c/o Canadian Manda Group, 165 Dufferin Street
Toronto, Ontario, Canada M6K 3H6
Distributed in the United Kingdom by GMC Distribution Services
Castle Place, 166 High Street, Lewes, East Sussex, England BN7 1XU
Distributed in Australia by Capricorn Link (Australia) Pty. Ltd.
P.O. Box 704, Windsor, NSW 2756, Australia

Author and general editor: James Lancel McElhinney
Book design, layout, and editorial services: gonzalez defino, ny/gonzalezdefino.com

For information about custom editions, special
sales, and premium and corporate purchases, please
contact Sterling Special Sales at 800-805-5489
or specialsales@sterlingpublishing.com.

Manufactured in China

2 4 6 8 10 9 7 5 3 1

www.sterlingpublishing.com

Frontispiece: Students drawing and painting in class
at the Art Students League of New York in the 1940s.

Contents

Part 1

Lessons on Drawing and Contemporary Works

from Instructors and Students of the Art Students League of New York

(continued)

Part 2

Drawing Concepts and Lesson Plans

An Illustrated Outline for Teachers and Students

Foreword

VISUAL ART BEGINS WITH DRAWING. From the first mark that is made on the page, the artist is designing, structuring the picture surface, speaking visually. Drawing determines where forms sit in space; their placement is critical to composition and how the viewer is engaged.

Drawing is the visual armature that lies beneath a painting, the study that precedes a sculpture, the image made by a needle applied to an etching plate. It is the response to what is seen, a reaction to the observance of behavior, the capturing of the power of a gesture, or the form given to perception. It is an idea made visible. In short, drawing is the foundation of the language of art.

For many, the first image evoked when they think about the Art Students League is the drawing studio, where the model poses nude on a platform circled by thirty or more students sitting in front of their 18 x 24-inch newsprint pads—each intensely focused on creating an accurate interpretation of the uniquely complex person in front of them. In fact, the instructors teaching drawing classes at the League offer not only life drawing but a gamut of approaches that focus on design, color, and abstract form. The means of drawing are not limited to graphite pencils or charcoal. Pastels, oil sticks, brushes, pens, and watercolor are all media of drawing, as are lithography and etching processes.

Early in the League's history, proficiency in drawing from plaster casts of classical sculptures had to be demonstrated before one could graduate to drawing from the model; only when that proficiency was attained could one begin to take up painting or sculpture. Of course, for most of our history, we have left it up to each individual student to determine his or her own course of study, but the emphasis League instructors place on drawing as essential to the process of making art has never waned; the League's drawing classes are often filled to capacity.

The meaning of art has been frequently redefined in recent times and the number of media employed to create art increases with every technological advance, but one thing remains constant: the need to draw. For whatever the device used, whether it's a paintbrush or an iPad, understanding the fundamentals of visual language that are learned from drawing will allow the artist to master any means of visual expression and have the freedom to discover the limitless possibilities of art.

— Ira Goldberg
Executive Director
Art Students League of New York
October 2011

Preface

DRAWING: A LIVING TRADITION

THE PURPOSE OF THIS BOOK is to reassess the art of drawing at the beginning of the twenty-first century—not as an artistic genre but as a visual language. The book itself was conceived as an illustrated volume simultaneously blending a general appreciation of drawing with a basic series of lesson plans and including an anthology of texts and commentaries by working artists who teach at the Art Students League of New York—a hybrid book designed to be more accessible and inviting than conventional classroom textbooks and less didactic and style-bound than ordinary self-instruction books. Readers can open to any page and find inspiration and knowledge.

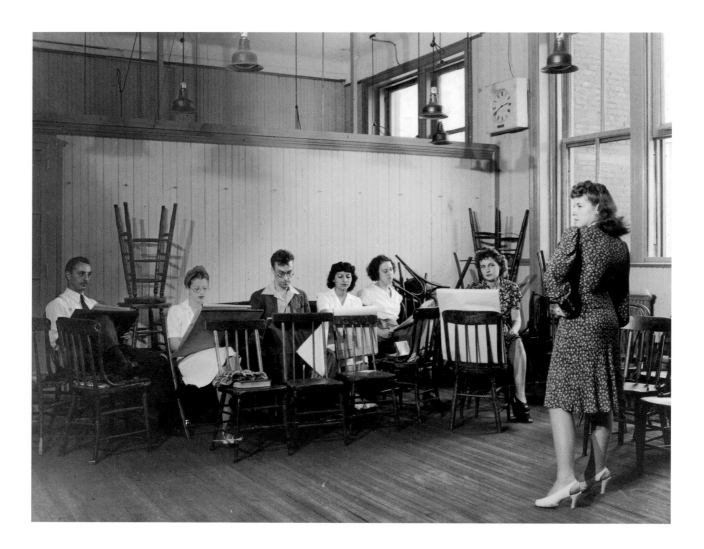

The internal logic of the book is driven by the inclusive and diverse environment of the Art Students League—one of the nation's oldest studio art schools, in continuous operation since 1875. Classes run year-round. Each instructor contributing to this book project follows her or his own teaching methods in class. There is no integrated curriculum. Students are admitted without portfolio requirements. Attendance is never taken. Grades are never given. Each student pursues an individual training program tailored to his or her own ambition and ability. Anyone with the desire and courage to walk through the doors can receive intensive, individual instruction—as students have for nearly as long as the League has existed. The current student population includes people of all ages—many of whom are artists working in publishing, design, architecture, fashion, entertainment, and of course the fine arts.

The League's approach to art instruction focuses on the individual. To some this may seem an outmoded paradigm, while to others it may look like the future. Both are correct. Differences in method and style between one instructor and another or one student and the next might be drawn in sharp contrast, but all meet in consensus that drawing is the starting point for all visual art.

Interest in traditional drawing skills—making graphic visuals by hand—was revived when digital imaging tools reached parity with freehand drawing. Proficiency in life drawing is now a required skill for animation and game designers. A burgeoning crop of new, unaccredited neo-academic ateliers attract growing numbers of students, not all of whom want to paint like *artistes pompiers* (French neoclassic academic painters). Drawn to classical training, many correctly believe that academic instruction will better prepare them for whatever they decide to do. After all, a strict regime of drawing antique casts and live models was the whetstone against which early modernists like Picasso, Kandinsky, Matisse, and Mondrian honed their creative skills before they rejected its stylistic dogmatism, equipped with the authority invested in them by such rigorous training.

Atelier schools today respond to a growing demand for skills that are neglected in many accredited art schools, colleges, and universities. After 1945, a boost in college enrollment was driven by the GI Bill of Rights. A second wave of new students consisted of baby boomers who flooded into university art programs; as a result, former service areas and enrichment programs became new schools and colleges, offering undergraduate and graduate degrees in every studio art genre. As programs grew, emphasis shifted from classical training in traditional skills to personal expression.

Students drawing a clothed model in a life-drawing class in Studios 1 and 2, the Art Students League of New York, 1940s.

However, a lack of visual intelligence and the technical proficiency to marry materials to ideas makes it impossible to distinguish between something that is merely demonstrative and that which is truly expressive. That lack has been noted by many institutions that are now restoring rigor to drawing classes and returning them to the core curriculum.

AMATEUR DRAWING practiced by self-taught enthusiasts has always been the bedrock of American art, championed largely by members of the upper and middle classes who truly loved art, who collected it and supported cultural activity within their communities. These same people took an active role in their personal enrichment by drawing, painting, and making art. Without these grassroots patrons there would be no art programs in the schools. It was they who advanced the so-called Art Crusade of the nineteenth century—in part by reading books on drawing by such American artists as Rembrandt Peale and John Gadsby Chapman and the English critic and artist John Ruskin, and then picking up a pencil. This book neither promotes one particular style nor advocates a single method of teaching. Drawing is not a technique. It is a language.

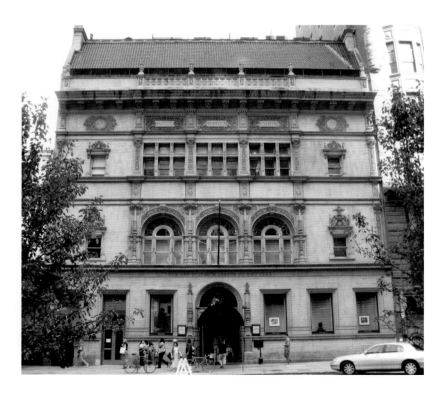

A recent photograph of the 1892 landmark building designed by Henry J. Hardenbergh on Fifty-seventh Street in Manhattan, the home of the Art Students League of New York.

The book is divided into three major sections. A general introduction discusses how drawing is appreciated, practiced, and taught, offering readers insight into ideas and methods for both making and teaching drawing.

The second section comprises contributions by fifteen artists who are or have been instructors at the Art Students League of New York and who represent a broad range of approaches in style and methodology. Their thoughts on drawing and teaching are accompanied by examples of their own work along with that of their students.

The final section presents a series of basic lesson plans—sample assignments and exercises that both teachers and self-learners will find useful for illuminating specific drawing concepts, together with information regarding materials, techniques, and other resources. Because drawing is a language and is not just defined by materials and techniques, a conscious decision was made to downplay this information by including it in the back of the book. Many instructional books on drawing open with a chapter on technique—mostly for marketing reasons. Pitching art supplies at the front of a book may make it more attractive to some retailers, but it sends the wrong message—it's like devoting the first chapter of a book on grammar to penmanship and touch typing. In his landmark 1964 book *Drawing Lessons from the Great Masters*, noted artist and League instructor Robert Beverly Hale warns his readers against being misled: "Remember that technique is but a means to an end, and should never be confused with the end itself."

John Sloan taught at the League from 1916 to 1938, and in 1931 briefly served as its president. His teaching style was less autocratic than that of some of his colleagues like Kenyon Cox or George Bridgman; it promoted art as a way of life as much as something one could learn by instruction. Comments attributed to Sloan echo Hale:

> I have very few things to teach you and fortunately few are new . . . there are no formulas, no little secrets and shortcuts to making art. There is no one right way to do it. There are no measurable standards of excellence.

This book's goal is to illuminate and demystify the practice of drawing by rendering it less intimidating and more accessible to all those who yearn to draw. A full appreciation of the information and knowledge imparted in this book might be enhanced by exploration of a few historical precedents.

—James L. McElhinney

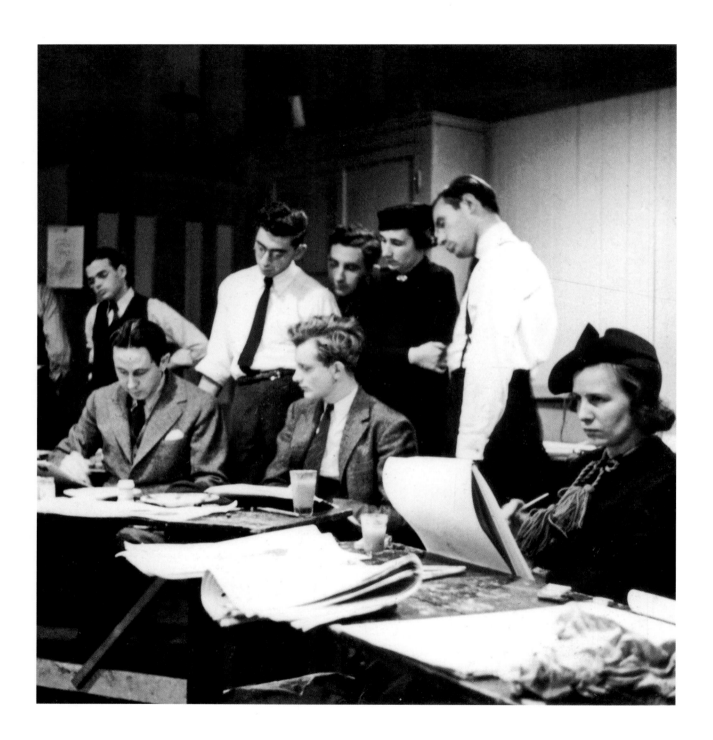

Introduction

DRAWING MANUALS: THE ORIGINAL DISTANCE LEARNING

In the past, drawing manuals celebrated the generosity of the princes and wealthy patrons to whom they were dedicated and for whom their contents were largely intended. Apelles of Cos, an ancient Greek painter, is said to have written one of the earliest treatises on painting in the fourth century BCE. Books written by Vitruvius and Pliny the Elder were read not just by painters huddled over paint pots but by Roman elites. Florentine painter Cennino d'Andrea Cennini's *Il libro dell'arte* (The craftsman's handbook; c. 1437), was a tell-all that revealed closely guarded techniques to fifteenth-century readers. Cennino's manual has survived because of a broadening interest in art, practiced as a pastime by privileged literates who took pains to preserve their libraries. In one amusing entry, Cennino warns his (male) readers to observe strict rules of personal conduct:

> Your manner of living should always be regulated as if you were studying theology, philosophy, or any other science; that is to say, eating and drinking temperately at least twice a day, using light and good food, and but little wine; sparing and reserving your hand, saving it from fatigue as throwing stones or iron bars, and many other things which are injurious to the hand, wearying it. There is still another cause, the occurrence of which may render your hand so unsteady that it will tremble and flutter more than leaves shaken by the wind, and this is frequenting too much the company of ladies.—Let us return to our subject.

In the fifteenth century only the elite possessed such books, which were laboriously copied by scribes onto vellum; today Cennino would have his own blog and television show.

The invention of the printing press and moveable type in the late fifteenth century transformed a trickle of instructional manuals into a flood that shows no signs of ebbing. Leon Battista Alberti's *Della pittura* (On painting; 1436) was a departure from the more practical approach taken by Cennino. Erudite historical references in Alberti's text hinted at a growing preference for classical learning on the part of painters, sculptors, and architects and a decline in apprentice training in guild-sanctioned workshops. Blending professional training with a liberal education improved an artist's prospects via social mobility, a trend that led to the formation of new art academies from the sixteenth century onward.

Many artists followed Alberti's example and wrote books of their own. Albrecht Dürer Giorgio Vasari, and, later, Giacomo Palma Giovane ("the Younger")

OPPOSITE PAGE
Men wore suits and ties and women wore hats during League drawing classes, such as this one in 1937.

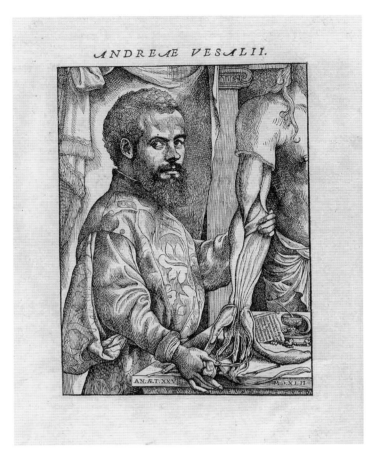

ANDREÆ VESALII.

all published books on art and treatises on perspective, drawing, and painting. In 1543, Flemish physician Andreas Vesalius published *De humani corporis fabrica (On the fabric of the human body)*, an influential tome on human anatomy that linked art with science. In an early attempt at copyright protection, Claude Lorrain (1600–1682) compiled drawings of his painted compositions into a personal catalogue raisonné, the *Liber veritatis* (Book of truth). These works by Vesalius and Claude exerted a huge influence on their contemporaries and were widely consulted by artists as visual reference material.

J. M. W. Turner (1775–1851) assembled his *Liber studiorum* (Book of studies) from 1806 to 1816 in order to upstage Claude as much as to emulate him. In one bold stroke, the enterprising Turner set new benchmarks for topographical drawing and personal marketing. In the early nineteenth century in the United States, Archibald Robertson, Fielding Lucas, Rembrandt Peale, and John Gadsby Chapman all published drawing manuals geared toward more popular audiences. During the 1800s, drawing entered the educational curriculum as a core subject. Ruskin's enduring *The Elements of Drawing: In Three Letters to Beginners* (1857), which he wrote for ordinary readers while he was drawing master at the Working Men's College in London (since absorbed into the University of London), was perfectly in synch with the zeitgeist. The South Kensington (later the Victoria and Albert) Museum in London was founded in the 1850s on the belief that art would provide an example to inspire working men and women to take more pride in their labors—a concept that found its way into the philosophical underpinnings of nearly every museum in America. In the midst of the age of industrial revolution, Ruskin wrote:

> We are all too much in the habit of confusing art as applied to manufacture, with manufacture itself. For instance, the skill by which an inventive workman designs and moulds a beautiful cup is a skill of true art; but the skill by which that cup is copied and multiplied a thousandfold, is skill of manufacture. . . . Try first to manufacture a Raphael; then let Raphael direct your manufacture. He will design (for) you a plate, or cup, or house, or a palace . . . and design them in the most convenient and rational way. . . . Leave your trained artist to determine how far art can be popularised, or manufacture ennobled.

○

Throughout the mid-nineteenth and early twentieth centuries cities turned swaths of land into sprawling public parks, salubrious mid-city getaways for exercise and recreation designed to foster public health and fitness. In the introduction to his drawing manual *Graphics* (1835), Rembrandt Peale crusaded for drawing by appealing to similar values:

> The advantages of correct perception and accurate discrimination belong to the educated eye, and the power of exact definition and precise demonstration alone to the experienced hand. Whoever has acquired the art of drawing, together with the habits of observation which are induced by it, possesses an ever varying fund of enjoyment. Not only are the works of art better understood by those who can draw, but the heavens and the earth display their beauties and magnificence in and endless succession of natural pictures, with greater charm to his instructed eye; and are more productive of refined and inexhaustible pleasure.

Peale, like Ruskin, advocated the study of drawing as part of a general education. Knowing that no one would dare question the value of penmanship to writing, Peale shrewdly conflated it with drawing to first pitch and then sell his agenda to America's growing middle class. Drawing was not just for future laureates but for everyone. One word stands in quotations on the title page of Peale's *Graphics*:

<div align="center">"Try"</div>

BELOW RIGHT
Page 71 from *Graphics: A Manual of Drawing and Writing, for the Use of Schools and Families,* by Rembrandt Peale, published in New York in 1835. The textbook was created for America's first high school curriculum in drawing and penmanship, and was reprinted in many editions during the nineteenth century.

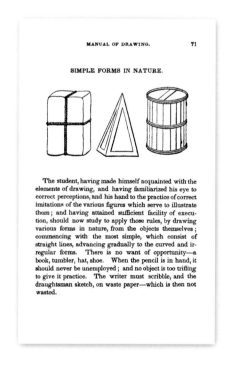

Art instruction was for everybody; it was no longer reserved for a privileged few. The back pages of *The Child's First Book in Arithmetic* (1853), by Nelson M. Holbrook, each display a dozen or more images ranging from straight lines and simple shapes to shaded three-dimensional geometric figures. Instructions appear at the top of page 108:

> The children may learn the names of these figures, study their forms, and practice drawing them on their slates.

Several subsequent pages display line drawings of familiar objects to be copied, prefaced with these instructions:

> Lessons in Drawing: The following objects may be drawn by the pupils, first on their slates, then on paper, or in a blank book.

The first drawing is of a glass tumbler, followed by a mug, jug, cup, hat, and shoe; two pages of practice images end with the head of a woman, a boy reading, and a girl sitting with a basket. The back page displays an "alphabet in script." Drawing exercises may seem out of place in a first-grade arithmetic book, but American art historian and curator Mark Mitchell expressed to me that while drawing was once part of a general education, drawing and math today are subjects about which people confess total ignorance without fear of reproach. Combining math and drawing instruction within the same volume, Holbrook assigns great value to the connection while Mitchell's remark laments its loss.

The mid-nineteenth century was an age not unlike our own. Advances in technology like photography and chromolithography flooded the world with millions of new images. People responded by learning how to draw, to inform and enhance the experience of vision. Drawing was for everybody—not just professionals. Rembrandt Peale argues the point in his introduction to *Graphics*:

> The advantages of speech are enjoyed by almost all mankind, of whom but a small number advance to the refinement and power of eloquence. In like manner, although only a few, peculiarly talented, may succeed in becoming proficients in the higher departments of drawing or painting, yet every one, without any genius but application, may learn the simple elements of this art in a degree sufficient for the most useful purposes.

Why then is drawing instruction today reserved for those who declare an artistic ambition, while language and mathematics are still required for everyone?

The twentieth century leveled distinctions between high and low art. Fine and applied arts were blended in the new field of design, taught at schools like the Bauhaus in Germany and various others in Europe and America. New manuals coming out of these schools embraced more formal, inclusive approaches to design that ignored hidebound distinctions between fine, applied, and decorative arts. Wassily Kandinsky's *Concerning the Spiritual in Art* (1911) and Paul Klee's *Pedagogical Sketchbook* (1925) blended theoretical ideas with practical methods. Colors and shapes were discussed

in terms of emotional responses based on sensory equivalents; a line was discussed as a path, or as a vibration that divided and animated adjoining spaces. These drawing manuals were not self-help guides or lesson plans geared toward a single integrated system of instruction. Josef Albers, György Kepes, Armin Hofman, and Edward Tufte all produced influential books that shaped teaching and creative practice by proposing new ways to think about design.

○

Drawing and painting manuals played a role in non-Western traditions as well. The seventeenth-century treatise *The Mustard Seed Garden Manual of Painting*, first published in English in the 1950s, is typical of Chinese instructional books. Similar to lettering workbooks in the West, Chinese painting manuals are codebooks of pictorial symbols that closely parallel written language. Specific characters representing words and sounds are composed of a series of carefully measured brushstrokes laid down in a predetermined sequence and direction. Brushwork is similarly prescribed for making the pictorial symbol for a cloud or a pine tree, the roof tile of a temple, or the scales of a fish. Students must study and master each of these forms before using them to compose pictures, like students learning to write the spoken language. Mastery is achieved when artists create new manuals of their own, from which their pupils will study.

Feudal Japanese society was addicted to printed matter. Instructional books were available on every subject from martial arts to lovemaking. One of the greatest draftsmen of the Edo period, Katsushika Hokusai (1760–1849), generated a massive output of drawings, publishing many in a series of *manga* or sketchbooks, about which author James A. Michener wrote a splendid book, *The Hokusai Sketchbooks: Selections from the Manga* (1959). Michener quoted Hokusai's introduction to volume 10 of *Hokusai Manga*, which encouraged readers to copy from these books to learn about drawing:

> I cannot feel but a thousand regrets at my own inability. I only hope that the gentlemen of our world will not take too hard their own inability when they try to emulate the master. They don't have a chance!

Sixteen years later, at the age of seventy-five, Hokusai published a statement in another book of sketches that reads like an anthem to his lifelong passion for drawing. Michener quotes him again:

> From the age of six I had a mania for drawing the form of things. By the time I was fifty, I had published an infinity of designs; but all I produced before the age of seventy is not worth taking into account. At seventy-three I learned a little about the real structure of nature, of animals, plants, trees, birds, fishes and insects. In consequence, when I am eighty I'll have made more progress; at ninety I shall penetrate the mystery of things; at a hundred I shall certainly have reached a marvelous state; and when I am a hundred and ten, everything I do, be it but a dot or a line, will be alive. I beg those who live as long as I to see if I do not keep my word.
> (Signed) The Old Man Mad about Drawing

TEACHING DRAWING AT THE ART STUDENTS LEAGUE OF NEW YORK

Numerous volumes on technical aspects of the fine arts have been published by artists associated with the Art Students League of New York. George Bridgman, Kimon Nicolaïdes, and Robert Beverly Hale are but a few whose books have been in demand for decades. Perhaps because the student population is so diverse, or perhaps because the instructors approach teaching in such different ways, the unique, vital environment of the League functions as a laboratory for teaching, learning, and publishing.

In 1875, a group of students at the National Academy of Design School in New York—tired of the school's closefisted control of its library and other resources—decided to set out on their own when they were informed that life drawing classes had been temporarily canceled due to funding shortages. With help from drawing professor Lemuel Wilmarth, they organized new classes in sweltering attic rooms above a piano loft on Fifth Avenue at Sixteenth Street. The members of the quickly growing Arts Students League voted to incorporate in 1878 and moved to a new building on Fifty-Seventh Street in 1892.

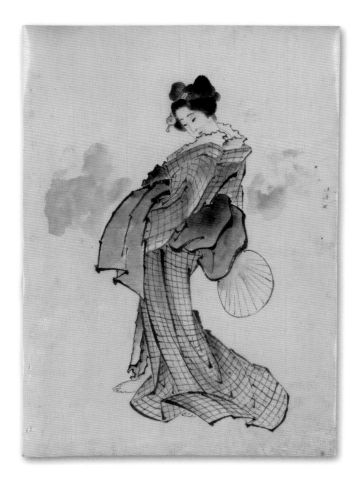

Bijin-ga (Beautiful Woman), Katsuchika Hokusai, c. 1840, ink and wash with pigments on handmade paper.

Instructional culture at the League today is rooted in a tradition of collegiality: the early instructors frequently clashed on method, style, and philosophy, while the fundamental importance of drawing was never in question. Instructors like Walter Shirlaw and Frank Waller provided a wealth of experience along with conflicting views on how art should be taught. Shirlaw had been trained in Munich; Waller in Paris. Like Shirlaw, William Merritt Chase and Frank Duveneck were exponents of the more direct, painterly Munich approach, while Kenyon Cox advocated the more dogmatic teaching style of French academic artist Jean-Léon Gérôme. Academic training was based on several principles. Art does not imitate nature but improves it. Mastering form, space, and color teaches us not how to behold nature, but how to see it. Current League instructor Knox Martin puts it more simply:

In order to make a work of art you must know what art is!

In the days preceding the rise of large public museums that were open to the public on a regular basis, students studied engravings of masterpiece paintings and plaster-cast replicas of antique and Renaissance sculpture. Students seeking formal academy training were presumed to have prepared themselves with drawing skills gleaned from self-instruction drawing manuals by Peale, Chapman, and Ruskin. Based on a portfolio evaluation by the instructor, a student might be required to follow a course of such basic exercises as drawing straight lines, geometric figures, and perspective. Drawing from observation was permitted only when a student had mastered the basic principles of drawing. In *Drawing Lessons from the Great Masters*, published eighty-nine years after the League's founding, Robert Beverly Hale gives voice to the enduring logic of this approach:

It is most important to cultivate the habit of forcing everything you see into its simplest geometric form . . . to feel a form in its entirety, disregarding details which are so loved by the beginner.

Copying masterworks in a dedicated "antique" studio or sketching in museums is quite different than drawing from life. Drawing from masterpieces challenges students to penetrate the mysteries of a work of art, to inhabit the mind of its author and thus to discover the genius of its creation. When asked recently what drawing students need today, acclaimed American artist and former League instructor Will Barnet was emphatic:

I'd tell them to look at the great masters. That's it. That is what drawing is all about. Look at a great Titian. When you look at a portrait it is like looking at a mountain.

Students will develop personal aesthetic sensibilities in part by honoring what appeals to their undeveloped taste, and in part in accordance with or resistance to the rigors of an academy drawing-room. During the 1800s, they would have had access to engraved reproductions of famous paintings and plaster casts of celebrated statuary.

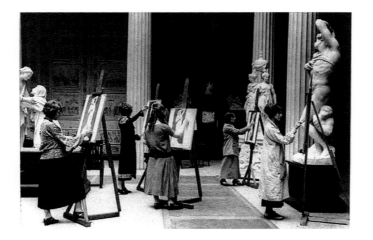

Students drawing a cast replica of Michelangelo's *Dying Slave* in the Corcoran Gallery of Art, Washington, D.C., 1924.

The message is clear: while students must learn from nature, they must also learn from their predecessors how to transform such lessons into works of genius.

In the past, once students showed proficiency in drawing inanimate replica antiques, they would be allowed to join the life class. Crowded around a posed nude model, usually on an elevated platform, the students were stationed about the room according to seniority. The teaching of human anatomy via methods including écorché (multilayered sculptural constructions of flayed figures that reveal the position of musculature in relationship to the skeleton) and dissection enhanced student comprehension; it informed and improved their drawings. Will Barnet recalls how philosophical difference drove Philip Hale, Barnet's teacher in Boston, to forbid him to study anatomy with George Bridgman, for many years a popular teacher at the League whose books on "constructive anatomy" remain in print today. Thomas Eakins used cadavers in his anatomy classes, a practice that Philip Hale dismissed as playing at science while neglecting classical aesthetics.

Classical teaching methods survived well into the twentieth century and are being revived today, not just by small classical realist ateliers but by the same mainstream art schools that dumped anatomy as a subject forty years ago—something the Art Students League never did. Once condemned as tyrannical and repressive, academic training prepared early modernists with the skills they needed to succeed as rebels and pioneers. Those skills are once again in demand.

○

Aftershocks from the 1913 Armory Show that marked the debut of European modernism in New York redirected the trajectory of American art. While longtime instructors like Frank DuMond and George Bridgman continued to teach, they were joined by younger and more progressive artists like John Sloan, Jules Pascin, and Stuart Davis—artists who were divided by style but who shared a passion for drawing. Davis once declared that for him drawing and painting are one and the same:

Drawing is the correct title for my work.

Museum-affiliated schools in large urban centers developed new curricula to serve the combined study of fine and decorative arts. As a fine arts school, the Art Students League did not add new classes in design, glassblowing, ceramics, or textiles, but teaching at the League was affected by the widespread changes that were under way elsewhere. In a letter to Kimon Nicolaïdes dated October 9, 1936, his good friend and former student Mamie Harmon described a series of drawing exercises for memory poses (creating gesture drawings of a model from memory after observing several poses), compositions, and drapery studies for a book she was helping him produce, the now-classic manual entitled *The Natural Way to Draw* (1941):

> I am making copies of the text. I am not chopping it up, as the schedule prescribes, but am keeping it together under the following main headings:

1. Introduction
2. Contour
3. Gesture
4. Other quick studies
5. The modeled drawings
6. Head
7. Drapery
8. Composition
9. Anatomy
10. Long studies
11. Light and shade
12. Principles of movement
13. Analysis through design
14. Studies in the subjective

The study of anatomy remains, but traditional disciplines such as mechanical drawing, penmanship, and drawing plaster casts are nowhere to be found on the list. The final heading, "Studies in the Subjective," underscores the departure from classical training by delving into the relatively new field of psychology—influenced perhaps by the writings of Carl Jung—and functions as the capstone for a curriculum designed to coincide with the number of weeks in a conventional college semester. *The Natural Way to Draw* remains one of the most influential textbooks on drawing.

The sudden influx of European artists and intellectuals fleeing Nazi and Soviet repression in the 1930s and 1940s radically altered the cultural demographic of New York City and of the Art Students League, dealing a deathblow to the supremacy of traditional academic training. Hans Hofmann and George Grosz, who began teaching at the League in the years between the wars, were but a few of these artists. New curricular models were implemented. College-level programs still taught in America today were inspired by the Bauhaus model. Roosevelt's New Deal created public arts projects that raised League instructors Thomas Hart Benton, Philip Guston, and John Steuart Curry to national prominence. The growing presence of Latin American artists like Diego Rivera, Jean Charlot, and Rufino Tamayo intensified the international character of the city. Cuban artist Emilio Sánchez was one of many Hispanic artists who studied at the League. African American artists Norman Lewis and Jacob Lawrence personified diversity at the League many years before that term became a buzzword for multiracialism.

The rise of Abstract Expressionism and the New York School after the Second World War expanded the stylistic complexion of the League. Unlike populations at conventional art schools, instructors and students who constantly migrated from one institution to another made the League a cultural crossroads for visual artists in Manhattan. Embracing drawing as a core value, the League is home to an increasingly diverse community of artists who are all committed to teaching. Fifteen of these artists describe their methods and philosophy of drawing instruction in the pages that follow—sculptor and printmaker Sigmund Abeles; painter and printmaker Will Barnet, whose work spans abstraction and figuration; printmaker William Benkhen; painter and animation designer George Cannata; abstract painter Bruce Dorfman; figurative artist Ellen Eagle, who is known for her work in pastel; figurative and landscape painter Henry Finkelstein; classical realist painter Michael Grimaldi; painter Charles Hinman, who is best known for dimensional abstractions; sculptor Grace Knowlton; Knox Martin, who works in a number of styles; abstract painter Frank O'Cain; figurative sculptor Jonathan Shahn; realist painter Costa Vavagiakis; and painter/printmaker Alex Zwarenstein. Together these artists represent a wide range of personal styles and approaches to teaching that will be presented in the next section of this book.

DRAWING CONCLUSIONS

During the Industrial Revolution, popular interest in drawing was sparked by new imaging technology like photography and color printing and was buoyed by a desire to effect civic improvements that cleared slums, built boulevards, raised aqueducts, and created pastoral parklands for public recreation. Populations began to enjoy the leisure that derived from these physical amenities and hungered for new forms of entertainment and improved access to the arts in general. Public theater and musical performances became popular, while spectator sports like tennis, crew racing, and baseball promoted culture and fitness that could elevate the citizenry in an age of social mobility. The first public art museums were organized and art schools were opened. Miniaturist Archibald Robertson, trained as a draftsman in an Edinburgh trade school, ran New York's first fine art academy, the Columbian Academy of Art, which opened in 1791. Charles Willson Peale (the father of Rembrandt Peale) grew up on Maryland's Eastern Shore, where he learned saddle making before leaving the trade to become a painter, scientist, and entrepreneur who opened a museum that included everything from new gizmos to plant and animal specimens to works of art.

The nineteenth century was greatly affected by the rise of public education. The philosophy was that better schools would create a more literate populace, who, with the benefit of access to great works of art, would be inspired by their example to do better work, and perhaps to become better neighbors. An education that included the cultivation of literacy in general—and drawing and penmanship in particular—would inspire masons to lay truer courses of bricks, carpenters to frame every wall to plumb, members of every trade to take greater pride in their efforts, and the gentler

classes who were their patrons to better appreciate their workmanship. This very sentiment was espoused by the founders of what would become the Victoria and Albert Museum in London and motivated Ruskin to publish *Elements of Drawing*, which, along with an assortment of instructional books on related subjects, not only enhanced the professionalization of Euro-American society, but also denied high art a monopoly on drawing.

Everybody draws in one way or another. Football coaches sketch out plays on locker-room blackboards. Engineers draw. So also do architects, archaeologists, cartographers, geographers, geologists, mathematicians, and urban graffiti "wall writers." By downplaying, even dismissing the importance of drawing, many K–12 institutions are gambling with the future. Drawing teaches us how to reason visually in the same way that other artistic pursuits like music reinforce mathematics and poetry improves language skills. Drawing is seeing made active by graphic means. By allowing us to measure, move, and animate space, it lets us look beyond horizons and within what we behold. Imaging technology can record the visible, but only drawing allows us to write pictures of things that encode our unique, personal memories of how we experienced them, how we came to understand them. Drawing lets us eat the whole world through our eyes and to indelibly burn the vision onto our mind as a durable memory. Drawing lets us own what we see, all by using nothing more than the tip of a pencil.

Nineteenth-century Vermont proto-environmentalist George Perkins Marsh, who suffered from poor eyesight for most of his life, wrote eloquently on the universality of learning to see in his 1864 book *Man and Nature*:

> To the natural philosopher, the descriptive poet, the painter, and the sculptor, as well as to the common observer, the power most important to cultivate, and at the same time, hardest to acquire, is that of seeing what is before [you]. Sight is a faculty; seeing, an art.

The quantity of visual information that most of our recent ancestors encountered in a lifetime is comparable to what we process and consume in a week. If one considers the volume of visual tasks that faced educated people in the mid-nineteenth century relative to the visual skills they possessed (basic drawing and penmanship) and compares it to the task and skill ratio of educated people today (whose visual tasks have increased exponentially against a sharp decline in skills), the result is a recognition that as far as visual literacy is concerned, we have a long way to go to catch up with our nineteenth-century ancestors. Because design begins with drawing and because all that has been manufactured for human use existed at some point in time as a drawing, it is impossible to understand the clothes we wear, the cars we drive, or the places we inhabit without some competency in drawing.

Attitudes toward drawing are changing. In fall 2009, the Columbia University Department of Art History and Archaeology announced that it would provide funds to allow its doctoral students to study life drawing; that semester, the departmental

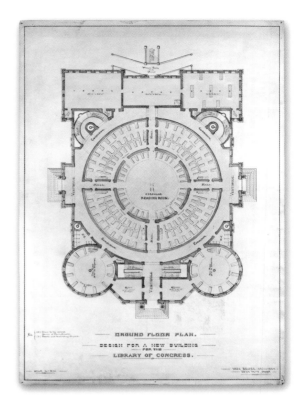

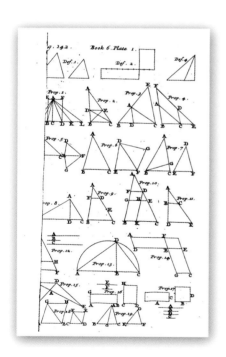

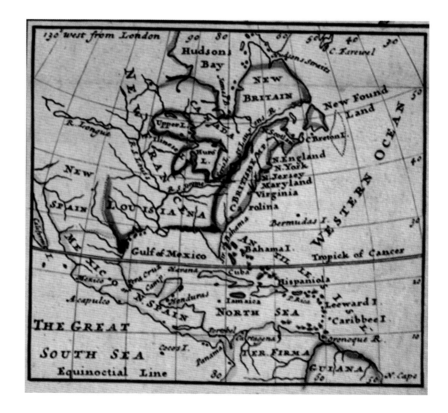

newsletter included comments by art history professors William Hood, who argued that "drawing from the figure . . . is an extremely effective method of helping students focus on what is purely visual information, that which cannot be translated into words," and Robert E. Harrist, who remarked that "drawing is a process through which the hand teaches the eye to see. . . . We were able to fund life-drawing classes for a number of students and hope to expand this initiative in the coming academic year." This laudable initiative must not be confused with innovative thinking, but instead should be taken as a hopeful sign that things may finally be getting back to normal.

Drawing is for anyone who wants to comprehend nature as well as the visible aspects of the man-made world. Like our more visually literate nineteenth-century forebears, many of us today return to drawing as a way to interact with changes in our environment brought about by new technologies. The Internet, rapid transit, and the rise of new global markets draw distant peoples together to face challenges like HIV/AIDS, global warming, and arms control. Good designers are more necessary than ever.

Early-twentieth-century American poet Nicholas Vachel Lindsay, known as the "Prairie Troubadour," is said to have once remarked that a bad designer is a bad citizen. Recovering lost skills by learning how to draw again will reconnect us to our world in ways that money and technology cannot—and will benefit everyone, including artists and the people who value their work. ∎

— James L. McElhinney

OPPOSITE PAGE,
CLOCKWISE FROM LEFT
Diagram of an American football play drawn on a green chalkboard; ground floor plan for the Jefferson Building of the Library of Congress, Leon Beaver, 1873, graphite and wash on paper; detail of a 1715 map of North America by cartographer Herman Moll; page of geometric models from a 1723 translation of Euclid's *Elements of Geometry*, by John Keil and Samuel Cunn, published in London.

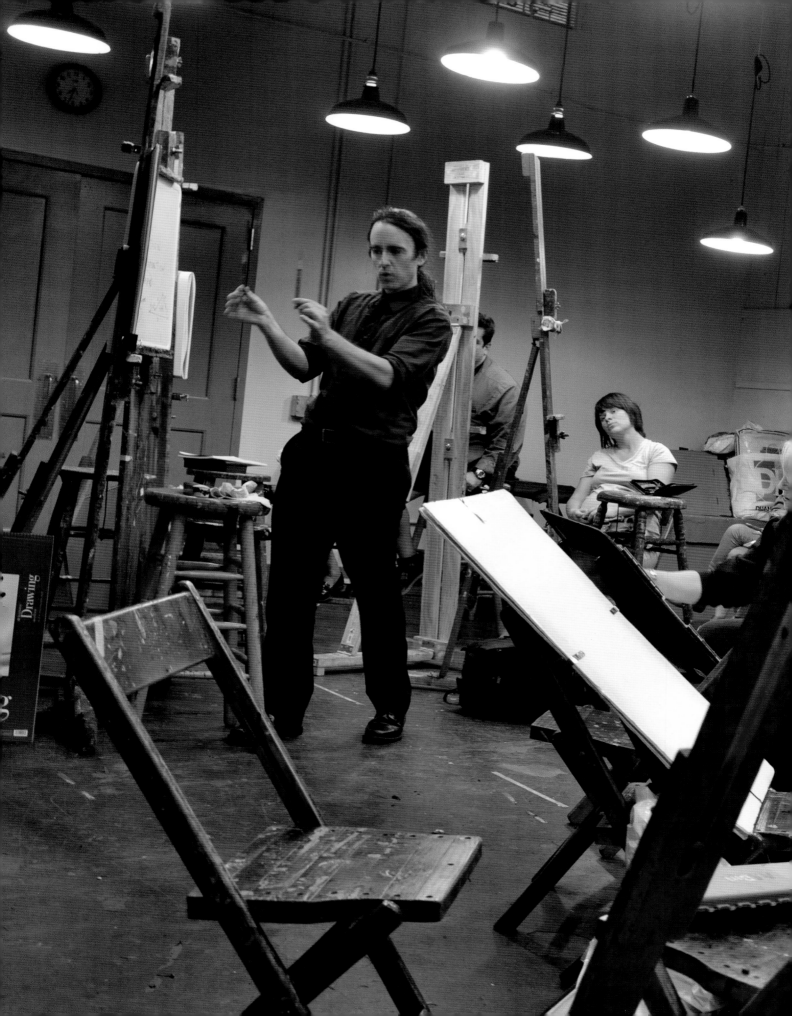

Part 1

Lessons on Drawing and Contemporary Works

from Instructors and Students of the Art Students League of New York

Art Students League instructor Dan Thompson teaching a drawing class.

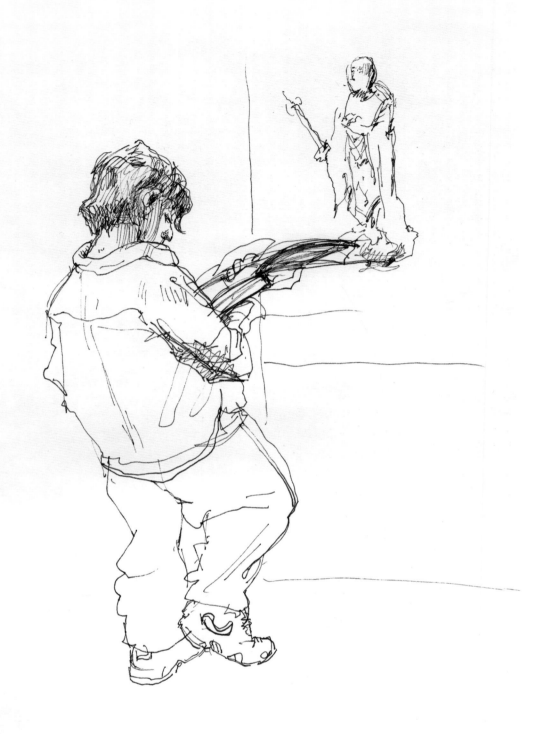

MAX DRAWING
Asia Sol 1·14·95

SIGMUND ABELES

SIGMUND ABELES IS A PAINTER, printmaker, and sculptor. A New York native raised in South Carolina, Abeles now divides his time between New York City and Columbia County, New York. He is professor emeritus at the University of New Hampshire in Durham. Abeles teaches at the League from time to time and has lectured and presented workshops at many colleges, universities, and art schools. The recipient of many prizes and awards, Abeles is a member of the National Academy of Design. His work has been widely exhibited in galleries and museums in the United States and abroad, most recently at the Old Print Shop in New York City, and his work is in numerous museums and private collections.

SIGMUND ABELES ON DRAWING

Drawing is a powerful tool—central to life's core experiences. Ever since I got seriously interested in art at age fourteen, drawing was my lifeline to life and to art. It's the bridge. It's the most important thing. It's the vertebra and the spinal cord of my work and all the art that I really care about—even worship. When I think about drawing I don't think about just delineating one or more solid forms in space; I think about it as a whole. The first thing is to think out the composition, placement, and proportion. People might draw in the sand with a stick to describe a piece of land or the shape of a woman—anything. It seems hard to think about art without drawing. Sculptors are often the most phenomenal drawers because they have that sense of the whole—the vitality and volume of a subject that is so highly critical. For an artist, being without drawing would be like a person who is born without a brain. Drawing is an artist's thinking tool.

TEACHING STRATEGIES AND METHODS

I do better demos in clay than in drawing, which is interesting, since people know my drawings better than my other works. I might do demos to talk about how to begin, what to observe, how to think about page placement. Compose first. That's a big part of it. I might tell students to start over again if the composition doesn't make sense, if all that is happening on the page is just a figure standing in the middle of it.

I also get students to look at masterworks. Drawing is the best of all the arts to study from reproductions, because a reproduction of a drawing can be closer to the original than a reproduction of a painting or a sculpture. When I was teaching at the University of New Hampshire, because of its distance from major museum collections I schlepped huge shopping bags filled with art books. My book budget sometimes exceeded my model budget because I felt that students needed to know all of the Rembrandt drawings; they needed to learn drawing lessons from Leonardo, Egon Schiele, and Edwin Dickinson.

OPPOSITE PAGE
Sigmund Abeles,
Max Drawing, 1995,
graphite on paper.

I try to see what students' tendencies are; some are more tonal and some are more linear. At times I ask students to copy masterworks. If they copy my work I get upset. I'm not even secretly flattered by it. I say to them, "Let's go look at Goya. Let's focus on the tried and proven masters, for God's sake!"

I make students face problems that most people are afraid of—how to draw hands, for instance. I would have them copy hands from master drawings in books, assigning them a given number of drawings. Draw ten hands from masterworks and then immediately draw ten hands from your own hands in a mirror. Try to incorporate that language in the same way you would if you were learning any new language. When you hear a really good accent you try to use it when speaking that language. Cezanne chopped out a hand, while Fragonard might whip one out. Sargent was more like Fragonard in making fingers with brushwork, as opposed to someone who is much more structural, like Cezanne. I am reading John Richardson's book on the early Picasso as a child prodigy. In his early drawings, Picasso used a lot of straight-line segments, even when drawing curvy things, partly out of respect for Cezanne. That is a good way to learn how to structure a drawing. We can follow such an idea like a thread that goes all the way back to the sixteenth century, connecting Genoese painter Luca Cambiaso with Picasso. Cambiaso might really be the first Cubist.

LAYING OUT A PAGE

I like the point-to-point method, where you construct the figure on the page by thinking of the model's pose as a series of points similar to a constellation—especially when there is more than one figure or a figure in a landscape. I try to have the students set points, telling them that drawing is initially mapmaking: locating where things are.★ Some of those points aren't going to be dead-on accurate because they're not using computers or an optical device such as a camera lucida. I expect some distortion. Personally, I never measure before I draw. I only measure when I see that something is wrong. I will use measuring tools, but since I know how to measure, it's much more interesting to have things flow. If arms are too long or feet are too big I might change them—or I might not. If it's a sustained work, requiring many hours, perhaps even multiple sittings, I am probably going to make many adjustments, but I am also interested in and even attracted to distortion as an expressive tool.

Doing quick drawings can amplify students' problems. If they draw really fast and have a chronic problem with making the legs too short (perhaps because they are short-legged, like me), they may realize that they tend to do it all the time. Because the gesture-drawing process is somewhat repetitive, it can reveal habits that students tend to repeat. A good teacher can guide students and help them see where to improve their drawing when it might be difficult for them to troubleshoot problems on their own.

★ The practice of establishing plumb lines—vertical base lines—and then calculating distances and angles of contrasting lines connecting the extremities of a figure or an object is similar to traditional "metes and bounds" land surveying.

LAYING OUT THE FIGURE

Let's say the first measurement I make is a diagonal. Often there is one long rhythmic line that courses through a pose. If I am drawing someone standing in a *contrapposto* pose, I set the angle of the hip first and then hold out a pencil at arm's length and line it up with some part of the body to get a feeling for the direction of things I am drawing. To find the axis of the hip, think about a clock face; imagine that the hips are at twenty minutes to two, and that the shoulders are at ten twenty. Do it without letting the drawing become mechanical. Try to feel it as an internalized structure. . . . True verticals contrast against rhythmic lines that go through the figure. I often work with a maulstick [instead of a pencil] to find a long interior line that might go up one leg, through the crotch, and up through the jugular notch over the neck. Plumb lines can also be useful. I taught with a wonderful guy named John Hatch who had studied at Yale. He often said that some of the most important lines are not along the edge of the figure but well within the contour. Some say that is the Yale way of working, from the inside out. That's not everything—not the whole of it, but it certainly has merit as an approach to seeing volume. Working from the outside in reinforces the potency of silhouette. Maybe sculptors understand this better than other people. Think about how you can recognize a friend or a particular dog coming toward you from way down the beach just by the silhouette.

I tell students to look at and deeply consider the whole page. A number of artists—Alberto Giacometti, for one—always drew a border inside the edges of the page around the composition. Giacometti redefined the space as if he had bought a piece of property on which he knew he was going to build a house, a studio, and a pond; he would walk that property several times to try to get a feel of where to build that house, that studio, and that pond, and where to run the fence. Apply that thinking to your page and all that will be placed on it.

The late Susan Smyly, a very talented sculptor, had a teacher who showed her how to make every mark in a drawing against a transparent ruler, down to the smallest detail. Basically, this is mapping. Susan once made a self-portrait this way; her visage was reflected in the glass eye of a dead bird. It is a moderate-size drawing, yet she swears that every mark was made against a ruler—tiny little straight lines that somehow found their way in there. After her teacher—this person who transformed her life—passed away, she carried on teaching this method as a personal mission.

IDEAS FOR EXERCISES

Degas is said to have told himself, upon waking up, to start drawing his figures—his horses and ballerinas—from the ground up. I have been forcing myself and my students to do this. It's an idea—if it doesn't work for you, so be it. But try to do it because it's logical that architecture is built and trees grow from the ground up. Compositions also need to be built on solid foundations. You may know exactly what kind of wallpaper you want in a new house, but you can't hang it until the house is ready.

Another great exercise comes from the Greek American sculptor George Demetrios. He studied with Auguste Rodin and then worked as a studio assistant for sculptor Antoine Bourdelle for fourteen years. Bourdelle was himself a star pupil of Rodin and was later one of his many assistants. When Demetrios moved to America he worked for an artist named Charles Grafly, who left him his big studio in Lanesville, a neighborhood in Gloucester, Massachusetts. In the late 1950s, when I lived and taught in Boston, I would drive up on summer mornings to George's barn studio in Lanesville with my friend, the late art historian Robert Rosenblum. Each morning, everybody in the Demetrios family came into the barn to draw—including the gardener and the cook. Drawing was a household must. George's wife had made a bundle on a children's book entitled *The Little Engine That Could*, so they lived very comfortably. His drawing group did what he called "ensemble drawing," based on what he had been taught in France. We all formed a big circle around the model. George gave everybody 120 sheets of 5 x 7-inch paper. Everyone had to do thirty-second drawings. George expected them to be anatomically correct, composed, and well placed on the page. You had to find a visual equivalent to the model's pose, whose overall shape might suggest, say, a flower. Then—boom—bam! You had to capture it as quickly as possible. He would come to you, grab your hand, direct your pencil, and say, "We are now on the wrist. . . . Come across here to the clavicle and then the knee." Bam, you've got it! It would be done. If he liked your drawing, he would tell you, "That's a peach!" If he didn't like it, he would complain, "What the hell! You are not even looking," and give you a punch on the arm. At the end of the session, everyone's drawings went on the floor. He swept them into the fireplace, struck a match, lit the pile of everyone's drawings, and said, "See you tomorrow." That was it, over and over again every day.

If you couldn't fit the figure on that five-by-seven paper he would give you a stack that was half that size and proclaim: "You can do the Grand Canyon and the Empire State building on a postage stamp. You have seen them on postage stamps, so you are in control of scale. You see this thing or that; you can make it any size you want." Best of all, he would repeat, "I am teaching you the very basis of ensemble seeing and drawing; it has absolutely nothing to do with style. On top of what we do, one could be Andrew Wyeth or de Kooning or whoever."

Scale is something you control in theory. Placement is something you can control in practice. Hokusai is said to have cut a piece of rice in half and done a very complicated drawing of a crowd scene on it; another time he took a mop and did a huge drawing of a flea across the emperor's courtyard.

In my workshops I tell the Demetrios story, but I also tell them another one. I once had a figure-drawing class at the University of New Hampshire with about forty students. It was way too big. One day I went to the store and bought a box of forty-eight Crayola-brand crayons. As the students walked into the class I had each of them choose a crayon. Jim got a blue one and Serena got an orange one, and we played "musical easels." There were two ninety-minute poses for the entire class. I blew a

whistle every five minutes, and everybody shifted right to the next person's drawing. Each student worked on each drawing a couple of times. At the end of the session, I posed this question: If everyone worked on each drawing, were all the drawings the same? Absolutely not! Why were they different? Because the students who made strong starts in the first five minutes made drawings that the weak students couldn't pull down, while weaker students started drawings that the strong students couldn't improve. To students who say, "I don't know how to finish my drawing," I say, "You don't know how to start a drawing yet, but you will."

On longer drawings I had my students make at least two starts and then ask which one is worth spending the rest of their time on. If they chose neither, then they put up another sheet of paper. Based on what they had learned from the previous two, they made a new start. Longer drawings may take two or three starts at least and benefit from preliminary thumbnail sketches. You can solve a lot of problems with a thumbnail sketch. Edward Hopper's marvelous, rich Conté crayon layouts for his paintings are musts for the study of clear thinking in drawing.

Sometimes I make students divide an 18 x 24-inch page into four quadrants and tell them, "Your only obligation is, of course, that if the model lies down, you have to rotate the page to a horizontal. You've got to evaluate the job ahead of you in a couple of seconds; you only have one or two minutes to complete your drawing." I usually have them do two-minute drawings, because while they are working on bigger pieces of paper they still have time to capture the entire figure as a totality. They have to look at the page and imagine the drawing there, on it. Picasso said that he just went over lines he saw on the paper, like he had projected them there. I wish I could do that. I can't really see the image until my initial lines begin to converge.

Another assignment calls for my students to divide the paper into quarters subdivided into quadrants and make sixteen drawings (one in each subquadrant). I tell them to try the Degas method to see if they can work from the base up, or do drawings where the model poses and they have one or two minutes to half close their eyes and block in the darks. They have to find the light source; that's the starting point. I never use the term "sketch." A sketch can be too close to a doodle. The word trivializes the idea of rapid drawing. In the briefest of drawings, each line, each mark, is highly observed and intentional. Twentieth-century painter and sculptor Rico Lebrun once said, "Those who have nothing to say, gossip, and those who cannot draw, sketch."

The story goes that John Singer Sargent was once approached by a woman who insisted on seeing him. She wanted to study with him. He explained to her that he did not teach, but she insisted. "Why me?" he asked. "There are so many teachers."

"Because I want to do what you do," she explained.

"Tell me," he asked, "what do I do?"

"You paint and draw what you see," she said.

At that, Sargent laughed. "If you want to draw what you see, wait until you see what you draw." ∎

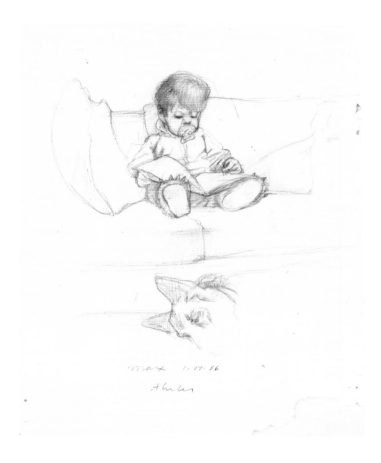

RIGHT
Sigmund Abeles,
Max Reading, 1986,
graphite on paper.

BELOW
Sigmund Abeles,
August 5, 1983, 1983,
colored pencils on paper.

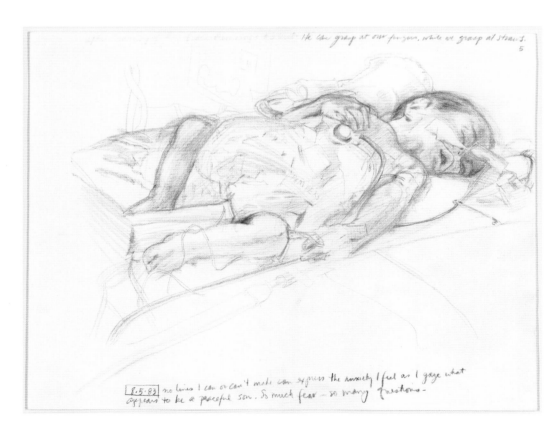

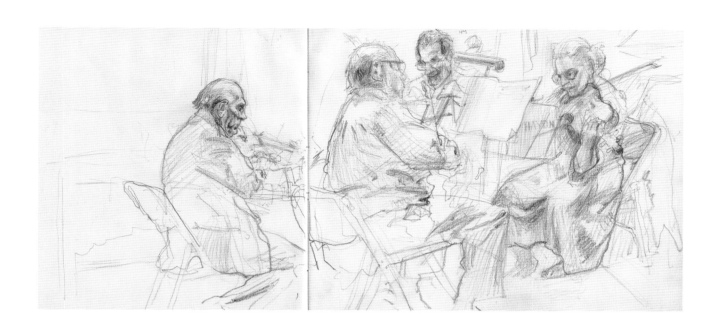

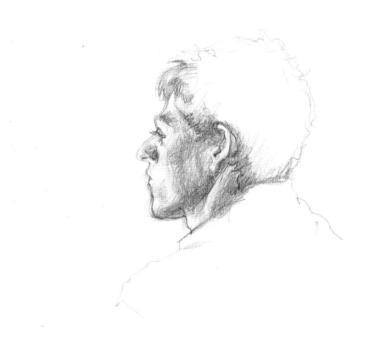

max Abeles, home from sch./Boston
2002

ABOVE
Sigmund Abeles,
Quartet,
Conté on paper.

LEFT
Sigmund Abeles,
*Max Abeles, Home
from School in Boston,*
2002, Conté on paper.

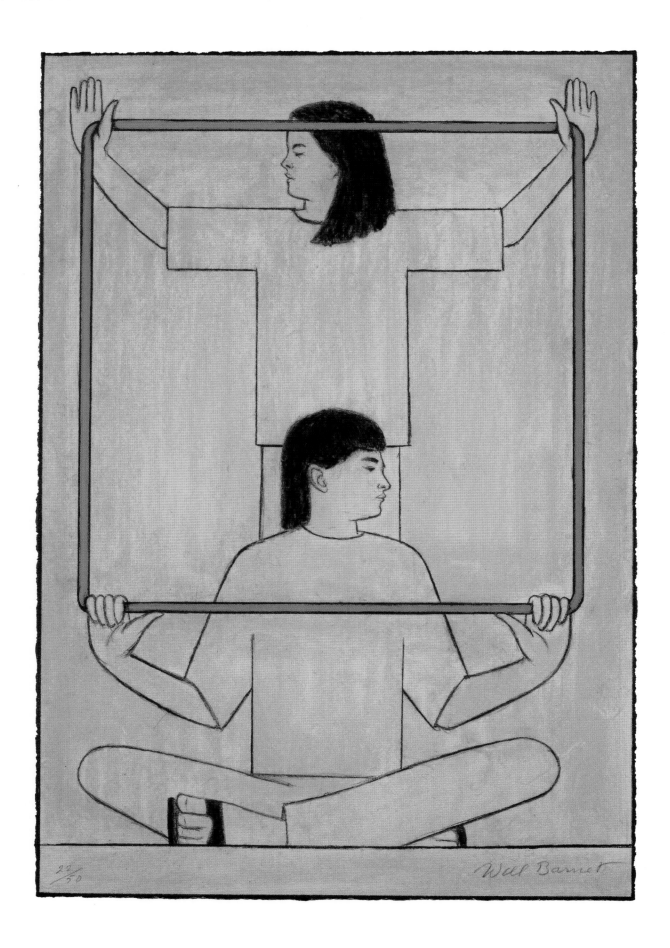

WILL BARNET

Interview with Will Barnet by James L. McElhinney

A NATIVE OF BEVERLY, MASSACHUSETTS, Will Barnet left high school to enroll in classes taught by Philip Hale in Boston before moving to New York in 1931, where the first artist he met was Arshile Gorky. Barnet enrolled in classes at the Art Students League and worked closely with Stuart Davis. In the 1930s, Barnet began teaching at the League, where he was an instructor for sixty years. He also taught at universities and art schools across the country, including the Pennsylvania Academy of the Fine Arts and the Yale University School of Art. Barnet recently celebrated his one-hundredth birthday. Despite his advancing years he is alert and full of energy. His mind is lively, clear, and agile. He paints every day. When I began conducting oral history interviews for the Smithsonian Institution's Archives of American Art, James Cooper at the Newington-Cropsey Cultural Studies Center invited me to conduct podcast interviews for the center's new website. The second of these interviews was with Will Barnet on March 2, 2008, at his apartment and studio at the National Arts Club on Gramercy Square in New York City. On June 18, 2009, I conducted a second interview with Barnet with help from my assistant Laura Schneider. A few weeks later, I returned to Barnet's apartment to merge his transcript edits with my own. Barnet suggested that we work outdoors. For two hours, in a shady corner on the northeast edge of Gramercy Park, we worked together to deliver this conversation to our readers.

JAMES LANCEL MCELHINNEY (JM): Please define for us how you gauge the importance of drawing.

WILL BARNET (WB): Drawing is the dominant factor in my work. Observations that you have through drawing lead to great ideas and things to say about the world you live in. I have been drawing since I was a kid. Most kids draw, but I drew in such a way that at the early age of eight or nine I wanted to be an artist—a serious artist, not just any artist, but somebody related to history. By the time I was twelve, I began to read all the great books on the history of art. I became imbued with Rembrandt and Daumier, the French artist. You can't look at a Rembrandt or at a Daumier without realizing how great drawing is. That's what it's all about.

In my own case, drawing from observation came very early. I could draw well before I went to art school. I only went there to refine my background by studying the French academic method that was given until 1930 at the Boston Museum School. Philip Hale was one of the great teachers there. I learned how to do the most refined kind of drawing possible. But I had already been drawing in a very real way, and in my own style, which had been influenced by Daumier.

What can drawing do for you? Well, in the first place, it can make you aware of visual things that exist, that you are interested in, and that you want to memorize on paper. My drawings have always been very much in the way of a feeling about something I am looking at. It isn't just making a drawing; it's a drawing of feeling a person. Like you are sitting there, and when I am doing a portrait I am interested in what's happening. Put your arm again like that. I am interested in what's happening and the way you sit there, the weight of your body as one hand comes on the chair and another on the table. And then I begin to see the whole thing. To me, when I am drawing, I see the whole picture. I don't draw detail. I try to see the whole picture that I am looking at. I am looking at you, your body, your hand coming up, your head there, and I am trying to conceive on the paper the feeling of your weight and the way you feel as you lean on that table. I am trying to feel you too, at that same time.

JM: It's not just about the physical information; it's about the feeling you are getting from the sitter.

WB: It's the physical information and the structure—that is one of the most important parts of my work. You can identify a Barnet because of the structure. You look at that child, sitting there with a top, painted flat, but there is real structure there. He is like a weight on that horizontal bar below there. Everything behind him is structure. It is sort of an architectural arrangement. The way the ball comes down on his knee. His other hand . . . you can feel the space. In other words, when you are drawing you are drawing space too, and you have to learn how to draw space. Drawing is more than just copying something. It is observing carefully what is taking place, and if you can do that, you can learn to really draw.

JM: And you are talking about how to organize a picture as well. Is abstraction another word for composition?

WB: The composition should always be foremost in your mind. Otherwise your drawings are just a detail or something that is fragmented. I don't believe in fragments. Fragments are something else. You can see, you know, exactly what I am talking about. It is the observation, the structure, and the feeling of the physical presence from which you are drawing. . . . What I teach my class is I try to get them to see the whole figure at one time rather than the detail of the figure.

JM: Are there any specific exercises you found effective in your teaching?

WB: It depends on the pose itself. That is what it is all about.

JM: Let's say you have a model in standing pose and you have a room full of students working at the League who are all at different levels of experience, and you haven't seen any of them yet before—it is a new class. What would you tell them to do? How would you start?

WB: Something I used to ask my fellow students at the Boston Museum School is, "Why are you concentrating on that arm over there when the figure is not standing up?" The first thing, if the figure is standing, your problem is to get it standing on the page. If you don't do that, you are missing the whole point. That's what I did when my fellow students were so careful in their drawing—how particular they were and all that—but when you look at the figure [on the page] it's not standing, not doing anything; just floating. You have to have the vertical movement of the standing form . . . then you have dimensions that take place in the body. The most important thing is to get the feeling of the presence of that person and the weight of the body as it comes down and what happens to the feet as they land on the platform. You have to get that feeling to have the drawing overall work. If you can get that feeling, then you've got the whole idea of the standing form. It could be anything standing, but it must stand. In doing that you create a monumental form that comes up and has certain strength to it as it goes up and down. I tell them to look at every part of the body as it moves up, and every part of the body as it moves down. The tension is another thing that is very important in my drawing. If the foot is over on one side with a certain amount of weight on it, I try to get that tension but relate it to the body. Don't get caught up in that alone. And whatever happens, if the other foot is just coming down vertically, that's okay. What is happening to the arms, what are they doing? Are they lying at the sides? The main thing, I find, that hampers most people—in particular, in academic training—is that they get caught up in other aspects like shadows, light, perspective. I tell them to forget it because that distracts from the real physical presence.

JM: Would you say the essence of drawing is line?

WB: Well, you can say it is line, basically. You are not smudging it, you are using a line. I have a whole book of drawings that I gave to the Arkansas Arts Center. You may have seen that. It would be interesting to see a drawing I did before I went to art school. The other thing too about training and drawing and academic training . . . which I believe in, is that one of the greatest artists who ever lived is Picasso, and his drawing education was severe ever since he was six or eight years old. He could draw like a master from his very early years. The idea that training will inhibit your ability to be free and able to express yourself personally is nonsense. You can draw like a whiz and you can express yourself like a whiz. There is nothing wrong with learning how to draw, which I think is the most important thing of all. I gave a course that became very well known called *How to Put the World Together*. I used to travel all over the United States and go to universities and give these lectures on drawing. . . . When I used to teach early on in my career at the League, with the model standing there, I'd say to students, think of the things around the model; what is the space doing around the model? What's in front, back, and so forth? I try to get them to see the whole picture as much as I can. The empty space around the figure becomes physically important. The other thing, the ability to use space as a form, is almost a miracle of perception if you get it right.

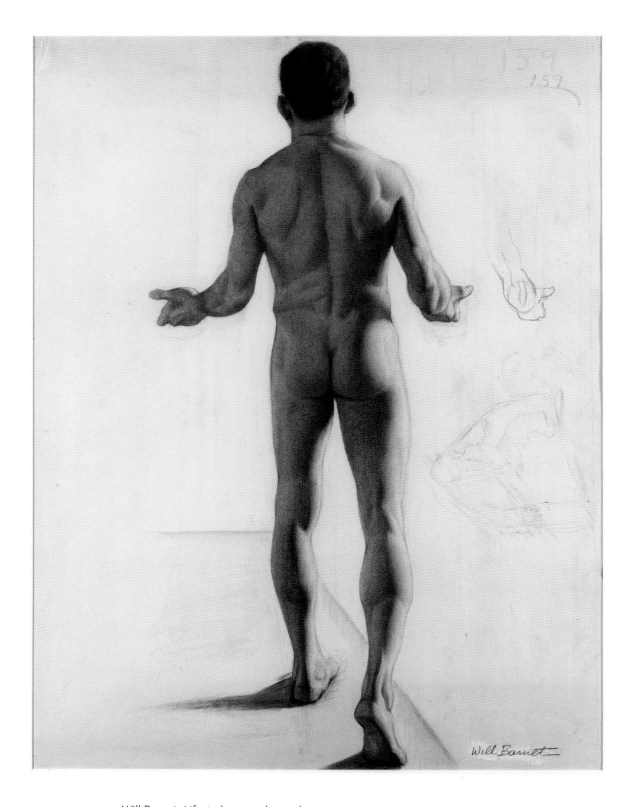

Will Barnet, *Lifestudy*, 1929, charcoal on
paper, 25 x 19 inches. Collection of the
Arkansas Art Center.

JM: Not to just see the body in the pose.

WB: Not just the body but the space around the body.

JM: You've got to make the space on the page.

B: That's right. You can divide [the process of learning to draw] into two parts. If you are learning to draw the figure you can just concentrate on the figure alone. That's one aspect. But then if you want to go farther than that you have to begin to think of what happens all around the figure. That is when you want to become a painter. You are not going to be drawing all the time on the canvas; [if] you are going to paint and try to see what is happening in front of the figure and on the side, then you have to think of the rectangle. This is one big thing I stress a great deal: you are working on a rectangle. You have a flat space, a flat pattern. I don't want to go too far into that because that is something that I lecture on a lot. It may be a little bit too far.

JM: That would be appropriate if you want to talk about it.

WB: I was talking a great deal about it recently because I'm having a film made and I was showing a big portrait I did of my wife and showed how I would extend part of the body—extend the arms out—to give it a sense of movement and a sense of composition. That interested me a great deal, organizing her body and her position on the chair. There is a whole film being made on that.

JM: What are some of the ways you got students to pay attention to the rectangle, to get them to look at the rectangle?

WB: In the first place, I introduce students to the two forces in the rectangle—the horizontal and the vertical; you have to be aware of that. I did my wife sitting in the chair. I wanted to create a strong horizontal feeling of her body as she sits, expanded across. And then the upper part has a vertical that rises up, so you have a nice stretch this way and a nice movement that way. Then you have all the intervening movements of the arms as they come down. And how to relate the two arms together, what they are doing to each other. Even the way they play on each other. It's embodying the entire spectrum of a rectangle and the horizontal/vertical expansions. It's very important to understand that. If you look at a great Ingres it's not just the wonderful clothes they wore at that time; it's a question of how he made the woman or the man go beyond the dress that's on them—how he would stretch them out. Amazing; most of the arms are not at all what they are realistically, but they become the level of what they need to be in the painting. They have to be stretched out. So this sort of thing is very important in my work. How I expand things. The woman on the couch and her arms coming out, I get that stretch as much as I can. Then the body comes down. She's sitting. Something happens.

JM: A great composition works at any scale.

WB: That's one of the most abstract figurative paintings of mine. Look at that arm. And the child is down below her. Also you have to think of the levels of spaces. The child is on the ground and she's on the couch. You have to get the feeling of these two forces.

JM: There is a very strong feeling of structure.

WB: Look at how her arm comes down, the feeling of that arm and the feeling of this arm stretching out here. And of course I organized it. . . . Don't forget the child is quite separate from the mother, but I unite them with her arm coming up—the compositional movement.

JM: Also the left arm of the woman connects the top right corner to the child's toe. That becomes another alignment. In a way, I look at this painting and I think a little bit about Piero. There is that wonderful one up at the Clark. You know the Clark Institute [the Sterling and Francine Clark Art Institute, in Williamstown, Massachusetts]. They've got a wonderful little Piero della Francesca [*Madonna and Child with Four Angels*].

WB: One of the greatest composers who ever lived. He is a miracle.

JM: Indeed.

WB: That's the history that inspired me a great deal. Look at this one: you can see the abstract qualities. It wasn't this way at all. . . . Originally I did dozens of drawings that were all representational and then I began to throw away all these things that were taking place and simplify to the point where you just have the spatial feeling of her lying back there but you don't have any perspective. There is no real perspective, but you have space. The space in front, a certain amount, then you have a cat, the woman in between and the book above. That kind of conclusion took me a long time to come to. A lot of drawing has to be done before you can come to the point of abstraction too, that's another thing, a lot more representational feeling; you try to feel the cat or you try to feel the woman. Usually the beginning is more representational. Then you begin to see this is limited, and you keep moving on and get more and more involved in being more abstract—I don't like to use the word "abstract"—but more sensitive to the physical movement that you take liberties with.

JM: More invented?

WB: Yes, much more. All these things were originally representational.

JM: They still allude to figures and cats, but they don't reproduce the appearance.

WB: I still want reality to always be there. I don't want to lose the reality. So the word abstract doesn't really mean eliminating the reality; it means integrating the two together.

JM: Do you think that without looking at nature it must be harder and harder for an artist to be surprised? If you observe the world you constantly are surprised. But if it's only in your mind, then it is replaying an idea over and over again.

WB: Well, surprised, if you want to use that word.

JM: Discovery then.

WB: Working as long as I have, . . . I've gone through many phases of feeling, trying to search out what I am feeling in that moment and what I want. Like, for instance, the shocking moment to my friends was when I went from abstraction to figuration. I didn't see much change myself, but they did. What's wrong with that? Why shouldn't it be there? So I have gone through phases where people were wondering what happened. Some of them liked this phase better than that phase because it was representational. But it is more than that. There is a lot of prejudice too in the art world that takes place because the twentieth century made a real effort to obliterate the academy.

JM: Imagery. So you are saying there were a lot of style tribes out there, and they each wanted you to believe their way, like minimal abstractionists versus painterly abstractionists versus people with figure versus realism.

WB: There was all that. I have seen it all; I have been a good friend to the Vogels [Herbert and Dorothy Vogel, collectors of conceptual art], who collected all that stuff right from the beginning, and it is something that I accept. If you enjoy doing minimalist work that is fine to me. With other kinds of work, like the conceptual, it is sometimes hard to identify what is taking place. The idea is stronger than the final result of the piece. In the art world you are dealing with all kinds of hard things. There were periods when art was considered just simply living and eating. Remember that period? It existed in the 1960s. You live with all these things, but myself I love the physical feeling of a reality that has been reconsidered in terms of being a painted form.

If I do a portrait—and I have done many—the most important thing is the painting in the end. Not the portrait. I will observe the person. I never paint from the person, by the way. If I were doing a portrait of you I would just make a drawing. Then you become part of the pattern or relationship to who you are in your life and time, what you are interested in. For instance, I always try to know the background of the person. What have they done in their lifetime? What are they interested in? If they are a professor I create a professor lecturing. I try to create the feeling of that kind of man, the presence.

One of my most important portrait paintings was Katherine Kuh, who was a great critic and a great museum person; she posed for me. She also wrote many books on art. She was very dynamic. How do you catch a person who is very dynamic? You can't just have her in a chair with a book. I first began that way, and then I was dissatisfied. I had her sitting with a book against the window where she was living. Over a year I thought about her a lot. Then one night at about three in the morning

it came to me. She had been writing a lot of books on Leger. She loved Leger. I said, why not Katherine and Leger? So what I did was I organized an image of Leger and Katherine Kuh and put them together in the painting structure. That became to me one of the most important paintings that I've done. That's kind of putting the world together—organizing it and feeling for the person who is posing. To just make a portrait, millions of photographs are made. People copy when they do portraits. But I never do. I make drawings from reality because I want to feel the person. If I make a drawing of you, I will be drawing you for hours, just studying your structure. Even from the side, from the back, and so forth, so I get the feeling of you. That is going to be part of the painting. That structure. In the end it ends up as a painting, rather than just a drawing, or just a rendition of what I am looking at. It becomes something—a whole new world.

JM: Do you find that is something that happens more often when you are working from a sketchbook?

WB: A sketchbook can be scattered. It's [a collection of] notes. That's fine, nothing wrong with that as long as you know how to put those notes together.

JM: What you are talking about, if I understand this correctly, is that drawing is putting the experience into your mind, remembering it. You make a drawing not to make a picture. Not to make a drawing for its own sake. But the process familiarizes you with what you are observing.

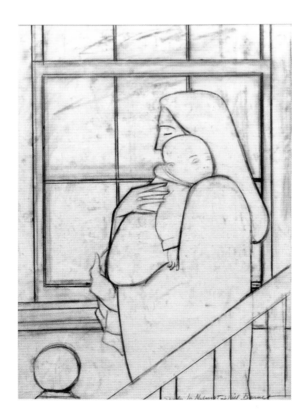

Will Barnet, *Study for Midnight*, 1984, carbon on vellum, 41 x 29 inches.

WB: Exactly. Absolutely right! That is well said.

JM: It is something that is very hard to explain. I was sitting in the Boston Museum of Fine Arts over the weekend doing a compositional drawing of Tintoretto's *Tarquin and Lucretia*. I could have bought a postcard, but it was more exciting to sit there and draw it instead.

WB: Sounds very exciting.

JM: It is. That is why it is wonderful to be talking to you because you are a master of this.

○

WB: Most of my work is eye level. Not looking down, not looking up, but looking straight at it. I used to almost break my back to get on the floor to see something if it was not on eye level.

JM: When you give yourself a critique, do you turn the painting upside down or have a look at it from another angle?

WB: I don't turn it upside down very much. I don't do that. I think there are certain advantages to doing that. You can feel the spaces and relationship of the shapes to each other if they're well formed and there is a certain unity taking place. But at the end you have to get back to where it was originally. You can't do upside down and make it be the final result. You can do upside down as an interlude to understand what you are doing, how the colors are working, and so forth, but it ends up the way it has to end up. The best example is Seurat. You can't beat Seurat. His compositions are incredible. Genius. . . .

JM: Like the big one in Chicago [*Sunday Afternoon on the Isle of La Grande Jatte*], or the one of the three models at the Barnes Foundation [*Les Poseuses*].

WB: Or his *Musicians* at the Met. I always go and look at it. What's interesting about Seurat is that when he was at art school and he was drawing in a more representational way, he was looking up at these ancient frescos. They had a tremendous influence on him, . . . contrary to the other students who never looked up.

JM: When you look at his earlier work and his copies of Holbein—that gorgeous line.

WB: Holbein, or that Hans Memling portrait at the Metropolitan Museum of Art *Maria Portinari,* ca. 1470. The woman who is praying, but she doesn't pray this way, but that . . . [Barnet presses his hands together, fingertips touching then pushes the right hand back on itself with the left.] . . . She had that long, whatever you call it in ancient times, a cap, which goes way up like this . . . [his left hand traces a diagonal up from the top of his head to the rear.] It could disappear like a perspective line, but all a sudden a piece of drapery comes right down like that and pulls it back to the front.

JM: Oh, you are talking about that conical-shaped hat.

WB: Yes, I used to lecture about it a lot in the old days. Whenever I go to the Met I always take a look at it because it's always inspiring.

JM: So you feel it is important for students to study the history of art and the masters?

WB: For me they are the fundamentals. Before I was sixteen years old, I read every book on the history of art. I got to know every civilization. The interesting thing too, even from a political point of view, if you study China, Japan, and seemingly exotic peoples from the Middle East and other places, you realize they are humans just like you and I, except they have some other ways of looking at life due to the environment or religion or so forth. . . . Reading and studying history to me is an absolute must. I hate to be a dictator about that, but I absolutely insist that students know history and they can gain a lot from it.

JM: Did you ever have your students work from the works of masters?

WB: If they wanted to. I didn't impose it on them. If they were interested in a certain painting, if they wanted to gather some information, that was fine with me.

JM: To learn about composition, though?

WB: You can learn a lot about composition from studying one of the masters. One of the greatest composers in the history of art was Vermeer. That is an interesting story because Vermeer was living in a small Dutch town. How could this guy do what he did living in this town? It was, in a sense, not isolated, but a small town in some ways. Vermeer's work has some of the most abstract concepts of interiors that anyone has been able to conceive. I used to be able to say to my class, "Look how he can take the corner of a room and make a whole world out of it—just the corner." It's how he put it together in the end. Then it becomes a world. It is interesting, isn't it? It's a really fascinating thing. I think that an artist who wants to be an artist should know history. Take Picasso; in the early years of his life his father gave him different lessons to develop, and one of them was copying. He copied a lot of great masters when he was only about eight or nine or ten. He became one of the great masters who could take the world apart because he knew it so well. He could take it apart and put it together again. I think history is a must in the education of an artist.

JM: Do you think in the last hundred years that not enough attention has been paid to history? A lot of modernism and stuff we were speaking about earlier—minimalists, conceptualists—didn't want to have anything to do with history. Everything had to be new.

WB: True. American modernists were very aware of history and very influenced by other artists of the ancient sort. The advent of the minimalist and the conceptualist is another story. Whether you can connect that up with history is an interesting problem.

JM: Or is it a rejection of history, like starting the clock every day at year zero?

WB: It could be a rejection. The best example of that . . . is the artist that did the nude and the stairway . . .

JM: Duchamp.

WB: Duchamp. The idea was more important than the final results of the idea. I've lived with all these artists who were conceptualists or [who pursued] different directions like expressionism, which is so different than being a structural painter—everyone was very free and able to let themselves lose themselves. Accident is more important than actually conceiving something. I have seen all that and I have been able to survive.

JM: Where you ever acquainted with Marcel Duchamp, who lived here?

WB: He actually came to my studio and took one of my small abstract paintings to make some money for his chess club. He wanted to raise some money to keep it going, so he got Barnet. He actually walked up four flights to see me, very nice.

JM: He was a dealer on the side and helped a lot of people with their collections.

WB: He was quite a man of the world. No question about it . . .

<p style="text-align:center;">○</p>

JM: Were there any teachers at the League whose ideas about drawing influenced you a lot? When did you come to the League?

WB: That is a great story! When I first came to the League in 1931, it was [around the same time] that Jackson Pollock came. I knew Jackson Pollock from that moment because he was studying there. The interesting thing is how we took different roads. He loved Thomas Benton. I didn't particularly care for Thomas Benton. I wasn't antagonistic, I just didn't care for the way he was working. So I went to Stuart Davis— shows you the difference of outlook. I know the League's history from the 1930s on.

JM: Were you interacting with people like [George] Bridgman or [Kimon] Nicolaïdes?

WB: I will tell you a story about Bridgman. When I was leaving the Boston Museum School, Philip Hale said to me—we liked each other, and it was very formal, of course, and in those days I called him "sir"—anyway, he said to me, "Young man, I want to tell you one thing. You are going to the League, and I want to warn you and make you aware about how I feel about you going there. One thing is important. Don't you ever study with Bridgman."

JM: Why not? Did he ever give you a reason?

WB: He didn't like the way Bridgman taught anatomy. Hale was a classical anatomist. The thing about Hale is that when you do cast drawing you are working from history.

That is a different point of view. It had to do with how they felt about a body at that time. It is interesting that the cast became a living thing. You weren't just drawing a cast. You were drawing history.

JM: Trying to penetrate the memory of time.

WB: Also, the anatomy was different than just realism.

JM: Of course, it was artwork already. It wasn't just nature.

WB: I never studied with Bridgman, but honestly I didn't like his work. It was very simple.

JM: I ask because they sell all of his books at the League store. And Robert Beverly Hale and also Kimon Nicolaïdes, whom you also knew, I would expect.

WB: I was not interested in their work or how they taught—not that I was opposed to it. I was just not interested. I had an anatomy course with Philip Hale and I did very well. I was one of the best in doing anatomy. I knew the body very well, and when they gave us exams, mine always came out pretty damn good. I knew anatomy from whatever you want to call it. The other thing that [Philip] Hale was against was studying from cadavers, something that Eakins down in Philadelphia believed in. I went along with Hale—I agreed with him on that.

JM: It seems he favored a loftier approach. He thought you would learn more from classical art than you could from a corpse.

WB: Exactly. You get that point.

JM: I get it. It is a two for one: you get art and anatomy at the same time.

WB: That's right. It is also a question of how people feel about beauty, because that comes into it—a sense of beauty. There is a certain beauty when you see the flow of a line that is not just flowing but has a structural idea behind it. There is a certain beauty and a feeling of reverence that comes to fruition.

JM: Do you suppose that that can be taught, that kind of awareness?

WB: You can only teach so much and that's it. I have taught hundreds and hundreds of students and hundreds of GIs who wanted to be artists. That was very exciting at the League at that time, in the late fifties. They all wanted to be real artists; a lot of them wanted to be abstract painters. The League, of course, doesn't have that tradition. But in my class, abstraction was really being developed all the time from my different students. Also, I have a very good relationship with my students in terms of history. Some of my students go back to fifty or sixty years ago. I still see them if they are alive.

JM: I enjoyed learning that you were a professor at Yale without a high school diploma. It would be pretty hard for anyone to do that today.

WB: The reason I left high school before finishing the courses was that I felt I didn't have the time to spend not developing my work as an artist. I didn't want to wait. I wanted to be out there in the art world. When I was very young, I read that all the great Renaissance artists began very early. I thought, "Boy, I better keep going." That was the reason I left [high school]. I left because I wanted another [kind of] development to take place in my artwork. I wanted to get out there; I wanted to be there.

JM: What advice would you offer to a young artist today?

WB: It is not easy. It is very difficult. You go to the Whitney and you see a lot of little lights moving across the floor as being art. What do you tell your students?

JM: What about your students who are interested in learning to draw? What would you tell them?

WB: That's different. I'd tell them to look at the great masters. That's it. That is what drawing is all about. Look at a great Titian. When you look at a portrait it is like looking at a mountain.

JM: A work of nature.

WB: You are teaching at the League, right? I am sure that they are getting a good course of study from you. That's wonderful. It is like carrying on tradition.

JM: People might want to make art in other ways, but for those who want to do it with a burnt stick on a piece of paper, that goes back to the beginning of time, and there is still knowledge there to be had and it needs to be passed on.

WB: What you are giving them I think is marvelous. The things you have said; it's like we met each other and coincided in brotherhood. . . . Being a student today, surrounded by all that's going on, is not so easy. So much is being said about other things than what you and I are talking about. Remember that. That's not the way a critic looks at a work of art today. Critics today can look at something that is completely empty and give it a tremendous write-up.

JM: They are writers. They've got deadlines and paychecks. It is not because they are passionate about it or not. It's because their job is to talk about it and spin it somehow.

WB: There is something that I think is so wonderful for the League to carry on. . . . The League has two parts to it. There is one part that is very academic, like Daumier and Frank Mason. Mason hated modern art. I know that because he told me. But the thing is that the League has a nice balance, which I think is so wonderful. A person like you gives the League a certain richness of tradition, but in a contemporary sense. I think the League does represent different phases in the history of art. Like when they had Kenneth Hayes Miller, who was a big shot when I was at the League, and we used to call him the Fourteenth Street Renaissance. But there was something you could

learn from Miller and Paul Cadmus and that group. Miller loved the big, expansive physical forms of the Renaissance. He wanted students to see this kind of volume as kind of like a globe, crisscrossed with surface contours. He had some very talented students. Some of them whom I knew became quite well known. Successful students are a part of why the League is important. They are part of its history. The League also had people teaching there like Vaclav Vytlacil. He was sort of a crossover between realism and abstraction. Cameron Booth also came in. The League has always been a really interesting school of differing points of view. Some of the artists that you have teaching there are quite abstract, really in the abstract world. It's all about painting: the love of painting and the physical feeling of the canvas, an image on the canvas that lights your eye. That is a point of view that is very strong and very important. Then there are other artists who think differently. They think more about what happens on the mountaintop—what they can do when they are out there in the desert. That is another point of view. I used to have Donald Judd [as a student]. He created a world of his own, but [earlier] he was at the League. Believe it or not, I had Twombly too. We got along very well. He wasn't the Twombly [we know today] at that moment. He wanted to learn what was going on. I also had Rosenquist, who was painting signs while he was in my class.

JM: He was a billboard painter, right? "The Michelangelo of Times Square."

WB: Wonderful billboards. At Cooper Union, I had Tom Wesselmann in my class. We had a very strong relationship about drawing. Wesselmann was quite a draftsman. And I had people like Eva Hess. I had a good relationship with all of them.

JM: Even though their work was not stylistically in your camp?

WB: I didn't want them to be me.

JM: That's what I meant. Some people who teach want to teach students how to be like them. Bill Bailey told me that when he was at Yale there were always a number of students who wanted to paint like Albers. Albers would say to them, "Don't paint like me. Be like me."

WB: Albers was a fascinating guy who had a big influence on my life. In the early 1950s, there was an article [published in *Art News*] that I was in called "Can Painting Be Taught?" That was the article, about me and my ideas. He read that, and the next day he called me up and said, "You've got to come to Yale." That's how I got to Yale—through Albers. My first introduction to him was on a Friday morning. At the time I was coming in to teach I didn't know who he was. I had never met him before. He came up to introduce himself, and then he put his hand up to his chest and said, "I feel nude. I forgot my necktie." That was a really interesting moment. He was wonderful. When you visited him, it was like visiting a drugstore. Everything was laid out very carefully on shelves.

JM: Looking at his work, he had to have been methodical. His wife was a weaver too.

WB: Very methodical, quite a wonderful guy. And he had a big influence too—did wonderful things. So we've had some good people around us who still believe in painting even if they are different than we are.

JM: I think another way to put it—about the culture at the League—is that people there believe in painting and drawing the way that people believe you have to eat by putting food in your mouth. There are some things that are not going to go out of fashion.

WB: You got it, boy. No one could say it better. I think that is wonderful. I am glad you are at the League!

JM: Albers was a huge influence not only on painters but on how art was taught. Some students learn by emulating their heroes and then somehow move on to find their own vision. How did that play out for you?

WB: It took me years to get over my Daumier habits—ten years. One medium that helped me a lot was woodcut.

JM: Because of the resistance of the material?

WB: Because you have to cut a shape out if you want to say something. It made me think more abstractly.

JM: Plus you have to anticipate the grain and how the grain is going to refuse the chisel.

WB: My breaking point in moving into abstraction was one particular woodcut [from 1939, called *Early Morning*]. After that I moved into more abstract things. I cut that out without a drawing.

JM: Was it just done in a direct way?

WB: On a piece of cherry block. Since then I have worked in all kinds of media: woodcut, etching, silkscreen, lithography. You name it.

JM: You have to leave the high points to receive the ink, so you have to carve around the line. That goes back to what you were saying about getting students to not look at the model but to have a look at the space around the model. Looking ahead after nearly a century of life as an artist, what are your hopes for the art of drawing over the next hundred years?

WB: [laughs] Could any of the old masters have answered that one? Every day can become a rich experience. Art *does* come out of the ordinary. Everyday events can become works of art: lovers in a park, a woman holding a baby in her arms, a couple of guys talking about art on a park bench like we are here today. Drawing connects us to these moments. And it always will. ∎

WILLIAM BEHNKEN

WILLIAM BEHNKEN FIRST TRAINED AS A PAINTER. He now teaches printmaking at the Art Students League. A graduate of the High School of Music and Art in New York City, he later earned BA and MA degrees at the City College of New York, where he has taught for more than thirty years. From 1984 to 2000 he taught at the Provincetown Art Association Museum School summer program. From 2001 to 2007 he also taught printmaking at the National Academy of Design, where he is a member. Behnken is the recipient of awards from Audubon Artists, the National Academy of Design, and the City College of New York Alumni Association. His work has appeared in numerous solo and group exhibitions and is found in the collections of the Metropolitan Museum of Art, the Brooklyn Museum, the Museum of the City of New York, the British Museum, and the Fitzwilliam Museum.

Behnken says that intaglio and lithographic printmaking techniques can be demanding in practice:

> Prints are too often regarded . . . as impressive exercises of difficult techniques, learned by a few who are less concerned with great ideas. A brief glance at the great masters of printmaking . . . will quickly dispel such mistaken notions.

Belief in the fundamental need for proficiency in drawing has always informed Behnken's approach to teaching—even during times when representational art had fallen out of favor:

> Watching students grow proficient in creating skillful and beautiful drawings, I no longer could remain quietly defensive about the value of drawing and became confidently assertive about its necessity for all students—whether or not they intended to become practitioners of art.

The value of drawing today is no longer in question, thanks to artist-educators like Behnken and others who have contributed to this book.

WILLIAM BEHNKEN ON DRAWING

Drawing has been an essential part of my life for as far back as I can remember. It has always seemed to me to be a way of holding on to meaningful experiences. As time went on, however, I not only came to realize the pleasure and satisfaction that drawing gave me, I also grew more aware of the importance it held for me as a tool for understanding the world around me: drawing was a reflection of my inner life, a process by which I could capture and embody my thoughts and feelings about those experiences.

OPPOSITE PAGE
William Behnken, *Monument to Light*, 1988, white pencil on black paper, 30 x 22 inches.

By working [drawing], I recognized how we learn to observe carefully—to attend to and focus on the characteristics of things under our view as we look at them through a process of drawing: addressing proportion, form, value, color variation, and spatial relationships. Through training either formally or informally, together with continuous practice, we can learn drawing conventions from numerous traditions that have been developed over time to represent these observed visual characteristics.

In addition to using drawing for the imitation of appearances, the act of drawing is often provoked by the need to express a sense of meaningful order, through a harmonious and coherent design, or to record a subjective, emotional intuition, reflected through a sensuous use of the drawing elements. These multiple roles of drawing—the representation of observed appearances, the organization of our sense of order and emotion—reflect our most deeply human processes of learning: analysis and synthesis.

I use drawing in my own work as a way to be certain about form, value, and spatial order before I feel free to simplify, distort, or exaggerate tonal values or rearrange space for my subjective purposes of compositional clarity or emotional expression. I want to feel confident that my stylistic synthesis reflects an authentic and credible understanding gained from initial observations and analysis.

I was not always sure of the importance of drawing for the development of an artist. During the years of my earlier study and later studio practice in the 1950s and 1960s, I felt the need for and derived pleasure from observational drawing—a practice that was

TOP
William Behnken, *Winter's Contrasts*, 2007, lithograph, 16 x 19 inches.

ABOVE
William Behnken, *Art & Illusion*, 2000, aquatint on paper, 21 x 22 inches.

loudly challenged as a hindrance to "creativity" and "freedom of expression" by vocal advocates of pure nonobjective abstraction.

From my own experience—at first as a painter and later as a printmaker—I came to understand and to realize that a lack of certitude of form, value, and spatial relationships resulted in compositional dead spots needing to be "fudged in" to allow the work to have a sense of completion. Confidently rendered details often were left floating in a surrounding sea of poorly realized forms. I soon realized that greater proficiency in drawing let me avoid or resolve these problems. I also brought this learning to bear on my prints because I wanted them to possess the same expressive import as my paintings. Once I discovered that technical demands are even more essential to printmaking than to painting, it became essential for me to work out problems of representation and composition before "attacking" an etching plate or a lithographic stone to produce works that clearly reflected my vision and feelings.

I also came to appreciate the intimate bond between prints and drawings: their focus on line, value, and texture as potent means of expression. Prints are too often regarded by uninformed audiences as impressive exercises of difficult techniques, learned by a few who are less concerned with great ideas. A brief glance at the great masters of printmaking, both past and present, will quickly dispel such mistaken notions.

I was assured of the importance of drawing when I began teaching drawing and art history courses at the City College of New York in 1970. To quote a well-worn platitude, "the more I taught others, the more I learned." I found that the process of creating a curriculum to organize my method of teaching made me more aware of the value of drawing and how it contributed to the knowledge and growth of my students. I also had to analyze processes I used intuitively to structure lessons and to present students with assignments that offered them a way to record observations and compose expressive pictures. Over the years of watching students grow proficient in creating skillful and beautiful drawings, I no longer could remain quietly defensive about the value of drawing and became confidently assertive about its necessity for all students, whether or not they intended to become practitioners of art.

For those seeking art as a profession, I cited its necessity for competency and self-assurance. For so-called amateurs or interested observers, a working knowledge of drawing methods and thinking is invaluable for producing a wiser and more well-informed audience for the visual arts.

Beyond the art school studio, I have had the pleasure and satisfaction of teaching art history and the principles of art. As I opened the eyes of numerous students about the social, political, and spiritual aspects embodied in artworks, I have also described to them how observation, imagination, and design allow artists to give form to their ideas. I explained to students how training and developing the skills needed to use materials and hardware contribute to artists' capacity to fulfill their vision.

William Behnken,
*Harlem River Nocturne /
Light & Steel*, 2008,
aquatint on paper,
18 x 24 inches.

I remind them how the intuited understanding of the world embodied in the process of creating works of art starts in the very human act of drawing.

A good drawing curriculum presents exercises in the process of analytical observation that inform both representation and expressive (pictorial) organization. Students first examine contours as represented by descriptive line, then learn to represent form and volume through the observation of value and light, and eventually learn methods for creating fictive space, including linear perspective.

They are also made aware of the organizational and expressive possibilities of visual elements. This approach for me defines a teaching practice that recognizes that drawing is both representational and symbolic.

At the Art Students League, I face a different pedagogical challenge. The curriculum in printmaking classes is based on students becoming proficient in techniques needed to create a matrix for printing their imagery. Skills and processes are taught to individuals rather than to the class all at once. Group assignments are not given, as in a typical drawing class. Students developing their own image may need or want individual critiques of their work as it progresses. I often strongly recommend that, before they begin, students clearly develop their ideas by drawing and composing, by focusing on the essence of their expressive purpose.

From time to time, when I believe it is appropriate, I gather the students in a class around an individual's work that has reached a significant technical or aesthetic goal; I use this as an opportunity for group discussion and for the students to learn about new skills and ideas from each other's achievements and growth.

When critiquing work, I generally urge students to be aware of how the inherent characteristics of printmaking materials allow their choice of process to speak as part of their expression. I encourage them to explore, for example, the delicately lyrical or pulsating, rhythmical powers of lines or the expressive possibilities of value, color, and texture. I remind them always that along with these technical skills, a consummate work of art derives its authority from a foundation of sound drawing and design.

The following three examples are prints selected from students who have worked with me over a considerable period of time and who reflect my idea of the assimilation of drawing, design, and an understanding of the expressive and sensual possibilities of the media they chose.

The first print [opposite] is by Michael Hew Wing. Entitled *Tempest*, it is done mainly in the techniques of etching, engraving, and drypoint. Each of these processes used on a copper plate produces a different character of line that Michael has exploited to serve his purpose of showing the essence of the conflicting forces of nature. The etched line appears effortlessly fluid, suggesting the movement of wind and air and the bending of the storm-blasted tree. The engraved line, sharper and harder, gives obdurate firmness and resistance to the massive tree; drypoint adds richness and drama to the image. The copper surface was also scraped and scoured to create a background that materializes the gale force direction and the power of the "tempest" of the title.

By constricting the massive trunk and cropped branches tightly within the confines of a square format, Michael has created a composition that embodies the sensation of the vital energy needed by the tree to resist the oncoming force. In this piece, line, value, texture, and an organic, rhythmical design converge in what becomes a metaphor for struggle and eventual triumph.

The second example of a print that vigorously and boldly uses etching with aquatint to create a scene of foreboding loneliness is *Forlorn*, by James Haggerty [next page]. Using lines created by slashing diagonal thrusts of his etching needle and then

Michael Hew Wing, *Tempest*, 2007, engraving, etching, and drypoint, 24 x 24 inches. Student of William Behnken.

3/50 Forlorn James Haggerty

biting them deeply in acid creates massive and textured dark areas of stark power and mystery. The aggressive character of these lines negates any sense of refined nocturnal poetry. The manipulation of perspective creates a spatial dislocation that assaults and isolates the viewer. In addition, James integrates aquatint tones into his linear fabric as splashes of light animating the solid forms of the highway and the massive superstructure. Distant lights arise menacingly from afar, adding tension to the already empty feeling of the scene.

Strength of expression is enhanced by asymmetrical order within the composition: the attraction of a few simplified blocks of tonal mass, the car, the columns, and the highway above. Visual elements and design merge to produce a mood of tension and apprehension.

The third example is a print by Julia Abraham, entitled *Beacon Theater* [below], which successfully exemplifies the process of creating a personal vision derived from an initially objective analysis of carefully observed facts. First, Julia prepares drawings that satisfy her need to render accurately the perspective of the view that interests her. Once she is confident that she has recorded the space correctly, she directs the viewer away from the plunging depth; this recalls our attention to the harmonious surface design of geometric order that reflects her fascination with the intimate clutter and monumentality of buildings in New York City.

Julia's chosen media of intaglio etching and aquatint are well suited to enhance this tightly knit design. Simplified geometric forms defined by an elegant and unassuming etched line are carefully arranged, balanced, and interlocked by unifying flat, saturated tonal values that are produced by the aquatint process. The final composition echoes the very impressive urban order to which Julia responds and demonstrates the process of creating art from first observation to expressive invention. ∎

GEORGE CANNATA

GEORGE CANNATA IS A CELEBRATED PAINTER and animation designer/ director who has worked for most of the major film studios in the United States and Canada, including Metro-Goldwyn-Mayer, Walt Disney, and Hanna-Barbera. He also headed his own production company, ECA Animation, in New York City. He is the recipient of numerous prizes and awards, including the New York Art Directors Gold Medal and the Cannes Film Festival Silver Lion, and he was nominated for an Oscar in the cartoon Short Subjects category by the Academy of Motion Picture Arts and Sciences.

Cannata's paintings and drawings have been featured in numerous solo and group exhibitions. His most recent solo exhibitions were at the River Run Gallery and the Waverly Gallery in New York City. Recent group shows include one at the Gremillion Gallery in Houston and a three-person show at Gallery Korea in New York. He is represented in many private collections in the United States and abroad. George Cannata has taught animation and storyboard design at the School of Visual Arts and now teaches at the Art Students League of New York.

> My class covers all aspects of drawing, design, and composition. Both figurative and abstract approaches are explored in a variety of media. Students work from the model and from imagination. Individual and group critiques are frequent as I wish to produce a lively exchange of ideas. My desire is to open new avenues and to guide the students past any obstacles or inhibitions that may be preventing them from reaching their full creative potential.

The following is a series of writings on drawing and teaching prepared by Cannata for this book.

ON THE NECESSITY OF DRAWING

Drawing is the foundation of my artistic practice. I begin all my paintings with a charcoal drawing. It is the foundation beneath many layers of paint.

As an animator, drawing was paramount. When I was making animated films, storyboards, character designs, layouts, and backgrounds all had to be drawn. Today many of these tasks can be done by a computer. The computer is a tool. Behind the best computer animation, I see the handiwork of well-trained artists, not to mention skilled musicians and writers.

One thing that distinguishes drawing from painting is line. In its purest form, drawing is line. I like what the late Robert Motherwell said about drawing and painting:

Painting can overcome with its sensuousness in a way that drawing cannot.
Drawing satisfies our sense of definition, even if we cannot define drawing itself.
Drawing is a racing yacht cutting through the ocean. Painting is the ocean itself.

Sometimes there is a very thin line between drawing and painting. When I think of the late pastels of Degas and the paintings of Cy Twombly, one is technically a drawing and the other a painting, but they both transcend that definition.

Drawing is the beginning of so many creations—motion pictures, architecture, interior design, industrial design, advertising, and more. It is a way of making a thought more tangible.

Drawing is essential for most graphic artists, as well as artists working in three dimensions. Learning to draw is about learning to look at things analytically. It is about translating the three-dimensional world to a two-dimensional flat surface. Doing this involves the mastering of many skills and insights. A good drawing is well designed, meaning that all the parts of the drawing work as a unified whole. Good design has to be learned. It is not based on whim. It is a fact when something is well designed. A good design has a sense of inevitability about it.

To become a good draftsman, one has to be aware of the many aspects of drawing and picture making and when and how to use them. They are, to mention some: Line, Tone, Volume, Perspective, Scale, Shape, Area, Accent, Accident, Picture Plane, Overlap, Interlock, Positive and Negative, Dark and Light, Texture, Pattern, Passage, Variation, and Tension.

Learning how to draw is about learning how to see. Many people believe the camera made drawing irrelevant. The camera is nothing more than a mechanical eye. Our eyes lie to us all the time. My students are always putting lines where they don't exist. I tell them to move their heads and the line disappears. Train tracks don't converge. A Cubist glass is closer to the truth than the one drawn in perspective. An experienced draftsman is continually editing as he draws. What he leaves out is as important as what he puts in. No matter how literal a drawing is, it is still an abstraction. A good drawing is as much about drawing as it is about the subject drawn.

ON TEACHING BEGINNERS

With beginners I try to get them to find the contour of the entire figure before they get into any detail. I don't want them drawing one part at a time. The most important thing about drawing the figure is to see the relationships between the parts. The figure has two of everything. When you draw a shoulder, make a little mark where the other shoulder is. The same with elbows, hips, knees, hands, and feet. I suggest several books on drawing. I ask students to practice contour drawing when they are at home, drawing objects in line without looking at the paper.

Maho Sakatoku, *Seated Nude*, charcoal on paper. Student of George Cannata.

ON TEACHING ADVANCED STUDENTS

When students reach a certain degree of competence in drawing the figure, I have them concentrate on composition—drawing the figure within a frame. I suggest that they cut out a rectangle or a square on a piece of cardboard to view the model through. This way they can decide on how they wish to frame the figure before they start. This enables them to get rid of a lot of extraneous background, or they can crop the figure, if they wish. Too many students add backgrounds as an afterthought. The background should be developed simultaneously with the figure. I

also teach them about scale, how they can have more than one vantage point within the same drawing. They can look down, up, and across within the same pose, thus opening up the drawing so it becomes more expansive within the frame. I also encourage them to take more liberties and push them toward the abstract.

LESSONS AND ASSIGNMENTS

I try to give a drawing assignment every other week, and give the class a week to complete the assignment. I give the same assignment to both beginners and advanced students because I want them to learn from one another. We pin their efforts on the wall and I begin my critique. This way I can show them why I think one solution is more successful than another.

One of the drawing and design assignments I might give involves bringing a package of brown paper lunch bags to class and giving each student two bags. The first part of the assignment is to open the paper bag so you can see into it. You may crunch it up a little so you create more angles or keep it more rectangular. Stand it upright or lay it down on its side and make a rendering of it. If the rendering is successful, I should feel that I could put my hand into the opening. The second part of the assignment is to use the other bag as the medium. You can draw or paint on it, cut it up, put holes in it. Whatever you do to or with this bag must have something to do with a paper bag. In other words, the bag should generate the idea.

Other assignments might include drawing a picture of a chair that concentrates on the negative spaces, or drawing something as small as a paper clip to look as big as the Empire State Building—this is scale. Draw a picture of a window in your apartment or house. The edge of the picture is the window frame. Make a very careful line drawing of the window casing and everything you see through the window. I want you to forget that you are looking out at a landscape, but imagine that everything you see is etched in lines on the windowpane. You don't have to draw every brick on a building or every leaf on a tree, but make it as detailed as your skill will allow.

I may ask the students to choose one of their better life drawings to do violence to! (Art is sacrifice.) Cut away all the surrounding space of the life drawing—leaving a rectangle with the figure touching all four sides. Cut this rectangle into nine even parts, three across and three down. Rearrange these nine parts of the drawing any way you wish as long as they come back together as a rectangle. In other words, the head might wind up on the bottom and the feet at the top. As you move these nine pieces around, you will begin to notice that the negative, or white space of the paper, begins to become more assertive. When you have a pleasing design, paste the nine pieces of the rectangle back together in their new order on another piece of paper or a board. You are allowed to add tone or line to any of the nine sections if you think the design needs it.

TOP
V. Barber, *Line Exercise*, ink on paper. Student of George Cannata.

LEFT
Adele Lonas, *Untitled*, mixed media on paper. Student of George Cannata.

George Cannata,
Two Nudes, 2000,
oil and charcoal
on paper.

ON BEING AN ARTIST

Some thoughts occur to me. They keep me focused and might help the reader through the maze of things posturing as art today. Artists should not look for an audience. Art is not show business. The Dada movement was a hiccup in art history. It was opposed to tradition. It did not mean to become one. Shock value is an empty goal. Slogans belong in advertising, not taking up valuable space in museums and art journals. Sloganeering complex subjects seems immature and reeks of advertising by talking down to the audience. If one has a gripe, write a letter to the editor. Politics are tangential to art. I find a lot of conceptual art lacking for this reason—it is a classroom exercise put on stage. Such efforts are about what every serious artist already knows. Conceptual artists who transform a site, forcing spectators to look at the familiar in new ways, are doing good things in the sense that they are instructional. But this often leaves out a key element, the objective of art being to convey something more than a message. For new media like video art to be art, production values must be at least on a par with commercial television—that is, if you insist on calling it art. Stop channel surfing with something as deep as art.

Today art is under constant attack. Mentioning the word *aesthetics* might be seen as reactionary. One dictionary definition of *art* is "skill in performance." Note how the word *skill* appears first. What is art? The question is confused. That question was answered long ago on a wall in a cave. The question should be who is an artist?

Because artists are by nature both profoundly introspective and intensely observant, true artists have very little choice. They read a book and get hooked, or they go to a dance recital or see a painting and know what to do. I tell my students they must have aspiration. They must aspire to create something great. They need goals. Artists and their media choose each other. It is like a marriage that involves fidelity. It might be more fun to play around, but the results will be less substantial.

Thinking of artists in our society as free spirits is contrary to the truth. Artists function effectively only with self-imposed limitations. The tradition of art is embodied in the pursuit of excellence. Being modern is not the goal. Change for the sake of change leads to chaos. Historical amnesia is a recipe for disaster in any field of endeavor—not just art. The great artists of any period heroically rediscovered the past and transformed it. Art does not exist outside of a continuum. Tradition is a word for cultural continuity.

Motherwell said that the modern artist must keep all of art history in his head. He was right. There are no shortcuts. ∎

BRUCE DORFMAN

ABSTRACT PAINTER BRUCE DORFMAN has had forty-six solo exhibitions in New York and throughout the United States and abroad. His most recent solo exhibitions, in 2008 and 2010, were of new works at the Kouros Gallery, in New York. For decades his work has also been included in numerous notable museum and gallery group exhibitions worldwide, and is in museum, corporate, and major private collections. He is the recipient of many awards, grants, and fellowships, including a Fulbright Fellowship and a grant from the Pollock-Krasner Foundation. Mr. Dorfman has been teaching at the Art Students League of New York since 1964. He has also taught at other institutions, including the New School in New York and Syracuse University.

Abstraction can be a puzzling realm for many novices. Just as life-drawing instructors may strive to help new students abandon literal description as a goal in favor of more imaginative approaches that engage gesture and proportion in relationship to the edges of the page, Bruce Dorfman stresses composition—encouraging his students to explore and excavate the history of art for direction and ideas. Achieving a high level of personal organization allows one to be open to ideas, wherever they may be found.

For Dorfman, drawing is the art of visual maneuver. Beauty in drawing is achieved when structure and movement animate the space across, throughout, and beyond the surface of the page. The following quotes provide an example of Dorfman's teaching method and philosophy:

> Before coming to class, prepare a box of materials to select from. Anything that will leave a trace or a mark when applied to a surface may be considered, such as pencils, pens, charcoals, inks, sumi-e ink sticks, crayons, oil sticks, brushes, twigs, sticks, or erasers. Have at least three different kinds and weights of papers. Have at least three different kinds and sizes of paper pads (rough, medium, smooth). Newsprint pads are unacceptable.

(Newsprint is an inferior pulp paper made primarily from the wood of pine trees. Highly acidic and prone to deteriorate rapidly, it may serve as a cheap, disposable surface for rapid sketching, but it is thin and absorbent; newsprint can accept only a limited number of materials without failing its user in many ways.)

> Keep water, citrus solvent, and Bounty towels on hand. You should also have a pair of scissors and paper glue. Yes! Glue, in case a cut or collaged aspect of the drawing is needed or desired.

Picasso is often credited with inventing collage (from the French word *coller*, "to glue or paste"). The technique quickly gained popularity among Cubists, Dadaists, and later abstract painters who commonly employed it as a kind of visual supplement

to shapes and images drawn or painted with line or brush. In his final years, Henri Matisse produced a series of "cutouts" that raised collage to new levels of refinement. Dorfman advocates studying not one style but every style.

> Go to museums and galleries and look at drawings in all their splendor and variety. Look at books of drawing reproductions that represent present-day works of art back to the cave paintings. Look at and compare the drawings of Rembrandt, Goya, Picasso, Matisse, Ingres, Schiele, Mu-Ch'i, da Vinci, Morandi, and Bonnard. Compare the figurative works of Utamaro with those of Michelangelo. Study the drawings of Rodin, Kollwitz, and Motherwell.

Studying masterworks in books and museums can reveal tried and true methods for problem–solving in technique and composition, but since we lack the opportunity to look over the artist's shoulder from the first mark to the last, we must become like detectives who try to unravel the process. Dorfman proposes that:

Bruce Dorfman,
Drawing Lesson, 2010,
mixed media,
12 x 17 inches.

> When you are in class, remember to follow this simple plan:
> a) choose
> b) look
> c) compose

Whether the image is representational or abstract, keep doing these three things until you decide to stop working on the drawing. Choose your drawing tools carefully and lovingly. This includes the variety of surfaces you use to draw upon in terms of material, shape, and size. Be prepared, and be willing to alter and change any aspect of your drawing, in any way at all that may be helpful to it. Pay attention. Look at the drawing as it evolves as much as anything else that you may also be observing. Remember that you are making a drawing, not a replica. For example, foreshortening and perspective are simply devices that an artist may or may not choose to use to create an illusion—as a way of rearranging and changing how something actually appears to the eye in order to make a work appear more "real." Utilize such drawing devices only to the degree that they are necessary to the ideas of the drawing at hand, or do not use them at all.

Dorfman's instructional method does not propose a specific method or style. He promotes instead an integrated approach to drawing rooted in composition to benefit every style.

Compose, compose, and compose the drawing in the space. Select: choose and decide what you will draw and what you will not draw. Decide where the drawing will occur within the space, being mindful that while a drawing of any kind may refer to something you may have seen, it remains a mere exercise if it fails to refer back to itself and the sheer visual qualities it possesses. Show the same regard for the space around individual lines as for the overall space that surrounds all of the lines. This space is not just something to put the drawing on; it is part of the drawing as a whole. ▮

OPPOSITE PAGE
Bruce Dorfman, *Dover et Dieppe*, 2007, paper, wood, acrylic, gouache, 25 x 18 inches.

ABOVE LEFT
Evgenia Fisher, *Untitled*, charcoal on paper. Student of Bruce Dorfman.

ABOVE
Yoko Suetsugu, *a place where beyond time and space*, 2009, mixed media on paper. Student of Bruce Dorfman.

LEFT
Diane Englander, *Form and Thin Lines on Rust*, 2009, mulberry paper, acrylic, and pencil on watercolor paper, 13 3/4 x 8 5/8 inches. Student of Bruce Dorfman.

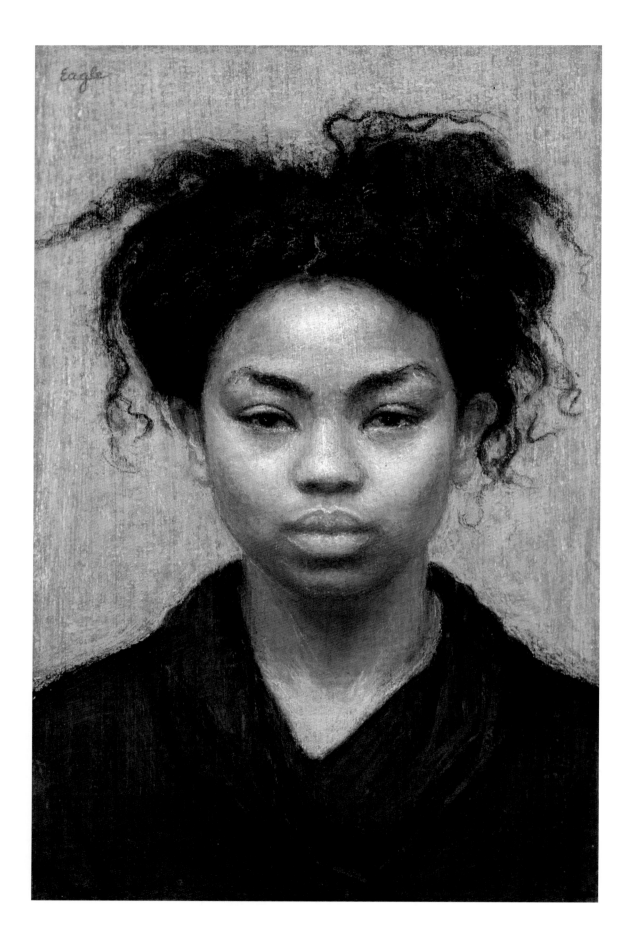

ELLEN EAGLE

ELLEN EAGLE EARNED A BFA from the California College of Arts and Crafts (now called California College of the Arts) before studying at the Art Students League of New York with Michael Burban and Harvey Dinnerstein, for whom she was a classroom assistant. Eagle has received numerous grants and awards, and her work has been exhibited nationally in galleries and museums. She is best known for her works in pastel, which are based in a view of classical beauty rooted in life drawing.

> Drawing is an exploration. We need to go beyond the ledger of facts to edit and find rhythms in the subjects that move us: our personal response, our empathy; we need to find our own harmony, our own bliss in our subjects.

Eagle's painstaking scrutiny of the effects of light on form and space function as essays on visual observation. Eagle's subjects, both human and ideal, are ennobled by her adoring gaze.

Along with some of her predecessors, such as Rosalba Carriera, Jean-Étienne Liotard, Maurice Quentin de La Tour, and Edgar Degas, Ellen Eagle stands astride conventional distinctions between drawing and painting in the reputation she has built for herself as a master of pastel. She describes the importance of drawing in personal terms:

> Drawing for me is like waking up in the morning. My eyes open to a fresh vision, and I begin to see arrangements of shapes emerge. Slowly my vision comes into sharper focus, and I develop a more solid understanding of space and form and rhythm.

The drawing process forms the bedrock of her teaching and her studio practice.

> Drawing is fundamental to my depictions of individuals because specificity is fundamental to depiction in general. My students are studying the figure and the portrait. Close looking is fundamental to creating a connection to your subject, to the discovery of character and form. Training is the same for amateurs or professionals. We all start out at the same place. Where each person goes from there is up to her or him.

She describes how she approaches beginners:

> I advise beginners to leave behind ideas of what things are supposed to look like and to bring a naive eye to their subject. The most developed eye is a naive eye. We must look before we can interpret. I advise adopting an exploratory attitude and recommend the use of plumb lines and comparisons. Everything in drawing comes down to the principles of comparison: distances, angles, edges, values, weight distribution, and so forth.

OPPOSITE PAGE
Ellen Eagle, *April*, 2003, pastel on pumice board, 8 x 4 inches.

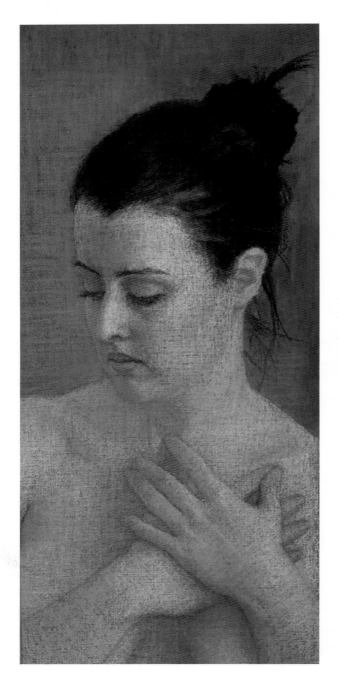

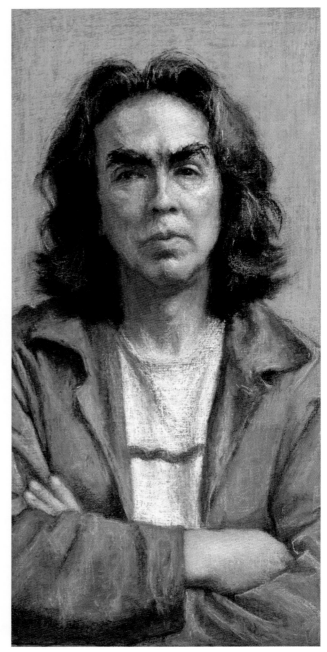

Ellen Eagle, *Nude with Hands Touching*,
2010, pastel on pumice board, 15 x 6 ½ inches.

Ellen Eagle, *Alfredo*,
2003, pastel on pumice board, 8 x 4 inches.

Every drawing, every work of art, has its own unique sequence of coming into being; the shapes of our subject impress themselves on our vision in an evolving way, like a kaleidoscope. We have to follow the path along which the subject leads us. Each experience is different: each person, each level.

Eagle encourages her students to be methodical, to pay close attention both to whatever source they observe and to the work as it develops:

I advocate that my students work slowly. I tell them that to draw is to begin to see. I tell them to squint to clarify the significant sculptural forms and rhythms of gesture, to look for vertical and horizontal alignments, to compare distances of height and width, and to do so initially without concrete measuring because I want them to know that their eye is their most powerful tool. In my pastel classes, I stress that color is subservient to value and that consistent value conveys solidity, one true figure in one true light.

Basic page placement and composition is a challenge for neophytes and advanced students alike; we sometimes focus too much on descriptive accuracy and not enough on an expressive use of space.

I notice that a lot of beginning students do not think about the proportions of their paper when they start their drawings. They don't realize that they are in charge of the shape of their canvas. I would advise you to take stock of the overall height to width of the figure and make marks on your paper that represent those largest proportional relationships.

Make all adjustments to the proportions of the parts of the figure within those largest measures, and indicate a border so that the figure is not floating in unconsidered space and so that the shapes between the edges of the figure and the edges of the paper relate harmoniously to the shapes you see within the body. With the first mark of a drawing, we are making a composition. Composition is there from the start; whether we consciously deal with it or not, composition is unavoidable and primary. I would advise you to step back frequently from your easel and your model to check your proportions, and to work lightly in order to maintain flexibility. Working lightly goes hand in hand, I think, with an exploratory attitude, and the drawing can develop slowly as the artist's perception sharpens.

In class I am driven to talk about abstract shapes, harmonies and rhythms, light, value, color, character, patience, observation, quiet awe, what I find sublime or disturbing. A foundation of anatomy is essential to the ability to select and compose. If I see that a student has not had exposure to anatomical studies, I will strongly advise the student to find an anatomy teacher.

Describing her teaching methods, Eagle reveals a preference for individual, one-on-one instruction. While she seldom gives technical demonstrations and lectures, she admits that telling is not the same as showing and that there will always be a few students who need to be shown how to perform certain tasks.

I do not give lectures, but I do engage in group discussions about all sorts of art-making issues. Primarily I work individually with each student, whether I am giving them instruction or doing a critique. I love to discuss motives for drawing, objectivity and subjectivity, changing course during a picture's development, the necessity of leaving behind one layer to move on to the next layer, and all the questions that arise during exploration. I rarely present formal demonstrations. I will sometimes do a small drawing at a student's easel to illustrate a principle I am trying to convey. I sometimes show digital images of my drawings and stages of my pastel paintings as they develop from the initial drawing through to completion.

Eagle describes questions that students might ask themselves to begin developing a critical method of their own. She encourages students to learn about anatomy and art history to inform the process of making their work and then finishing it.

I tell them to constantly check their big shapes and their values, being as certain as possible to convey correct values. Inconsistent values violate the laws of natural light and shatter forms. I recommend basic anatomy books, but mostly I refer students to specific artists whose work relates to issues that the students' work relates to or to issues that would, in my opinion, benefit from addressing.

I also ask them to think about the purpose of working from life by offering the concept that a drawing's state of finish is not dependent upon the mere accumulation of details or polish. I suggest that a drawing reaches a degree of completion when the values are convincing, when the details and mass are beautifully organized and the artist has expressed his or her genuine response to the model. It is impossible to over-state how important consistency of vision is to the conveyance of harmony. I think of the universe as one verse or poem in which every word and breath is necessary; every value, every line, must derive from one single vision. A gorgeous painting or drawing suggests to me all of nature in its perfection. Because of how our perceptions evolve as we work, it can be very tricky to recognize when a drawing is complete. Drawing is a living experience. ∎

OPPOSITE PAGE
Ellen Eagle, *Anastasio*, 2010, pastel on pumice board, 8 3/8 x 6 3/4 inches.

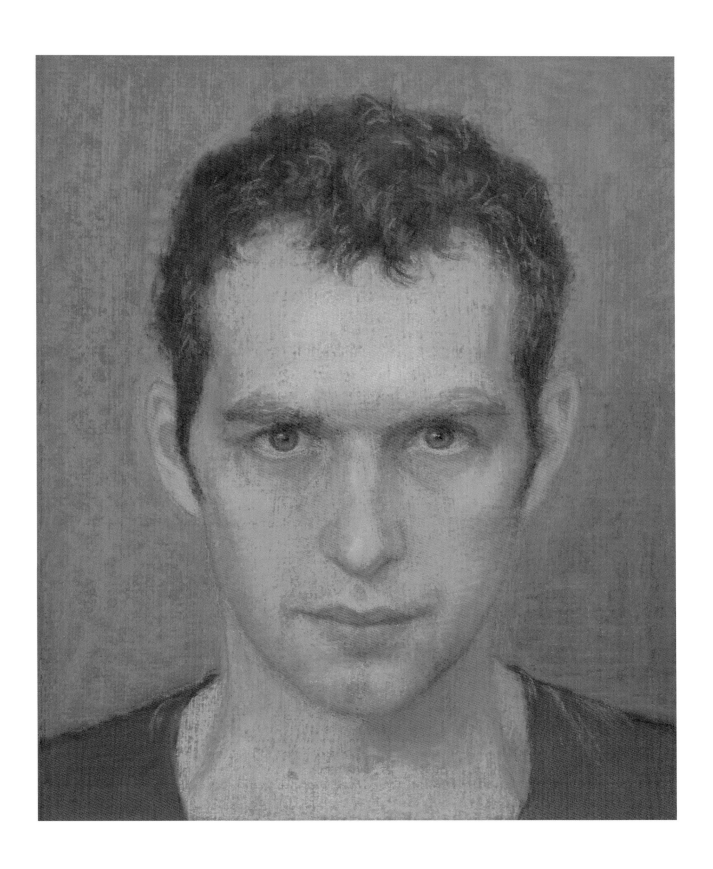

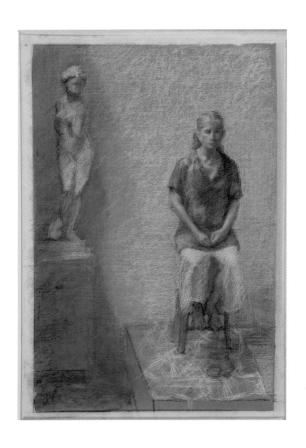

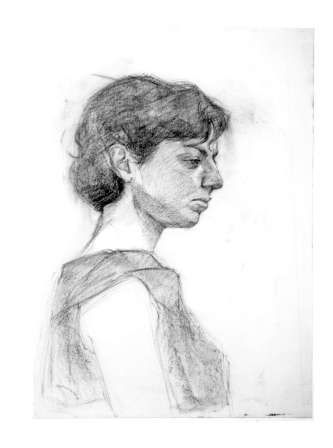

ABOVE
Karen Subek, *Untitled*,
pastel on paper. Student
of Ellen Eagle.

ABOVE RIGHT
Hiromi Arai, *Untitled*,
charcoal on paper.
Student of Ellen Eagle.

RIGHT
Okim Kim, *Gloria*, pastel
on paper. Student of
Ellen Eagle.

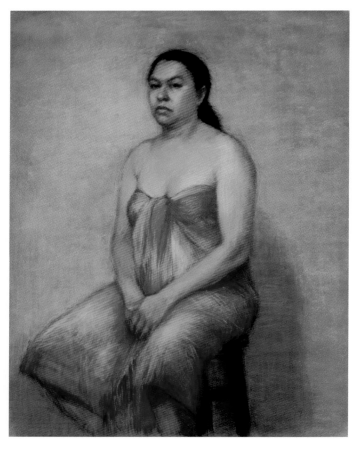

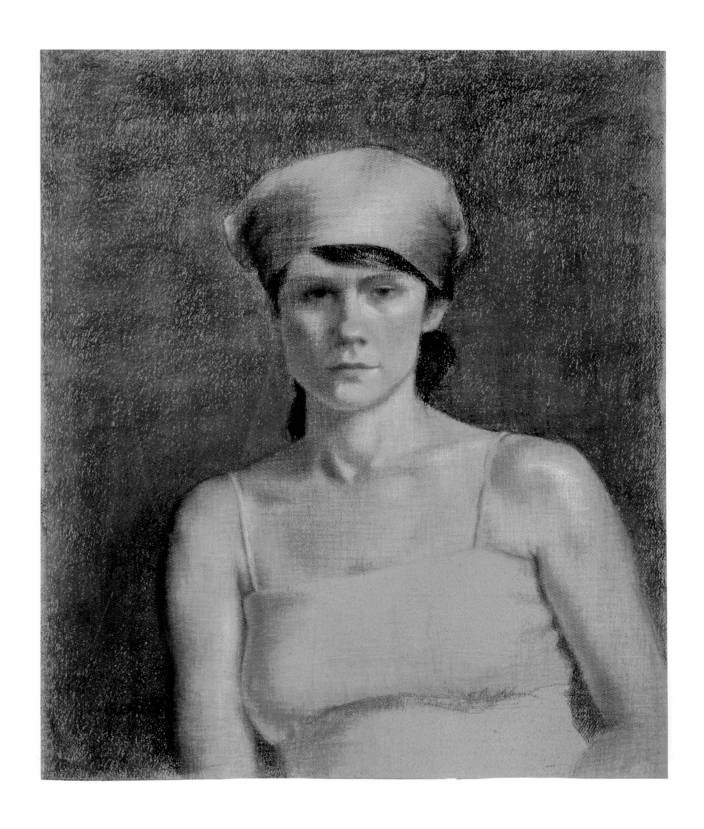

Laura Bleau, *Amanda Lee*, 2009, pastel on paper,
23 1/3 x 19 1/2 inches. Student of Ellen Eagle.

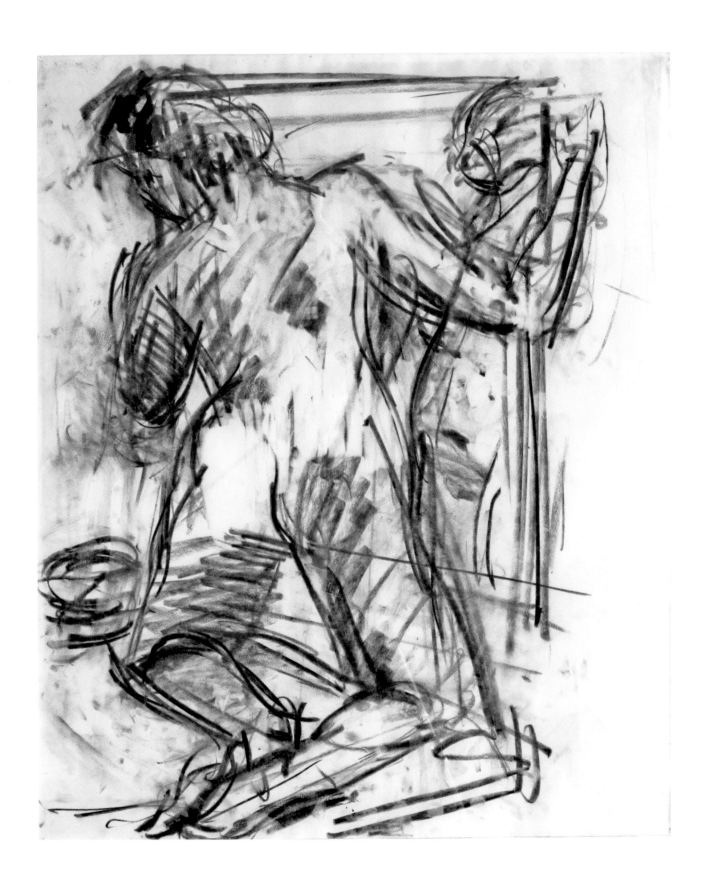

HENRY FINKELSTEIN

FIGURATIVE AND LANDSCAPE PAINTER HENRY FINKELSTEIN teaches drawing and painting at the Art Students League of New York. He received a BFA from Cooper Union and an MFA from Yale. In 1983 he received a Fulbright Fellowship for Painting in Italy. Since then, Finkelstein has received numerous awards, including a French government grant and the Julius Hallgarten Prize at the National Academy. He has had numerous solo exhibitions in the United States and France, and is on the faculty of the National Academy of Design, having previously taught at the Hartford Art School, the College of William and Mary, Pratt Institute, the New York Studio School, and the Washington Studio School.

HENRY FINKELSTEIN ON DRAWING

Drawing is as fundamental to the visual arts as writing is to the liberal arts. Just as a person who cannot write will not be able to express a philosophical or literary idea, one cannot truly paint or sculpt without proficiency in drawing. Drawing should be the most natural activity for any artist, like breathing.

Even painters who choose to give precedence to color won't get very far if they haven't drawn at some time in their lives. They won't see the possibilities for the pressure of one form against another, or for rhythm, shape, space, and volume. As a colorist myself, I might begin a painting by "abandoning" drawing in order to make color come first. But it is my drawing experience that informs my idea of drawing with color.

The same is true with sculpture. The best sculptures—those of Donatello, Verrocchio, Michelangelo, Rodin—all have a sense of drawing embedded within them. The worst don't. I was not surprised to see in a show of George Segal's drawings how unconvincing they were, since his basic concept of sculpture depends on the life cast—a process that directly replicates the figure as opposed to translating it into clay, stone, or plaster. He places his plaster figures into some kind of spatial setting, but that's about it. If you draw from Donatello or others working at the same level, you will understand this.

One should be drawing all the time, whether it is on paper, or canvas, or with clay. And one should continue to draw throughout the execution of a work, not just as a preliminary lay-in for a painting. Often you will see an artist like Rubens impose drawing into a painting at different stages, literally taking lines and moving the form, even in the final touches. I draw into a painting at various stages to remind myself what the work is about.

I am not very interested in drawing to make a product or result. This can be distracting from the course at hand, which is to discover, to search, and to move.

Drawing, for me, is all about discovery. It is the most direct way to find a theme or a visual idea. It is how you find out what interests you, what you have to say. Bob Dylan has said, "He not busy being born is busy dying." If you are not discovering something when you draw, when will you discover? As soon as you are no longer discovering something in a drawing you are taking away from it.

I also believe that there is no such thing as a sketch. Cezanne's late pencil drawings and watercolors prove this. From the very first mark he sizes up the whole page, making a declaration from the onset about the picture plane, its scale, and the nature of the space in terms of its compression, airiness, and weight. If one were to interrupt Cezanne at any time, there would still be a complete statement filling that page. One doesn't need to see all the leaves or windows to understand the volume of a tree or a house. The work might develop further, but it will be all at once. And this is the very nature of its development. But this sense of completeness can be a subtle thing, as in a detailed silverpoint by Leonardo. Even there, one can see that he is continually searching as he goes.

This speaks to the plastic nature of drawing, in which a whole piece is movable, malleable, precisely because it is unified. When a work develops all at once, as a complete statement, one can see the consequence of each move to that whole. With no exact outcome in mind (which is essential if the process is to involve discovery), one still has an awareness of the whole page as it develops. Drawing is the most direct way to understand how this occurs. The challenge later on is to apply this concept to one's chosen field.

Drawing helps you find out who you are and what you have to say as an artist. It is about developing a visual language and how you want to use it. It builds an understanding of what completeness and unity are to a work. Drawing seeks something that cannot be said in any other way. Ultimately, painting and drawing are the same thing.

Drawing is essential to my own practice as a landscape painter and a colorist. I start by wandering around in the landscape, drawing in order to find a motif. This is not so much to lay out a plan as to find a subject. I find a reason for the color idea through drawing. It's usually about the space and light, its scale, and a rhythm that runs through it. The sense of place is both formal and expressive. Even though I tend to draw more with line than with tone, I know that the light is crucial because when I see the place at a different time of day, nothing related to the initial motif is apparent. Light is not a bunch of colors placed on the form; it is the form. I'm not interested in creating a document about the place. It is what I have to say about the place that sustains me. I continue to draw on the canvas throughout the process in order to remind myself of my original intention. As a colorist I cannot separate drawing from color, and I have declined the opportunity to teach classes strictly limited to color because I can't honestly see any purpose to color without it being another kind of drawing.

In my teaching I stress that one cannot be a serious artist if one hasn't drawn in some way (and there are of course a variety of approaches to it beyond my own).

Drawing is the most direct way for any artist to understand the possibilities for a painting or sculpture and one's own point of view within those possibilities. For most artists, this process of discovery through drawing continues throughout their development.

Nonprofessionals can also find drawing to be an immediate and direct way to appreciate what has been accomplished throughout the history of art, not just a way to make a product or develop a craft. This will happen anyway. Drawing can open doors to what can be said through visual means. The materials of painting and sculpture can be overwhelming at first. Drawing allows students to gain insight and build confidence before they embark on slower, more arduous efforts.

I point out to students that it is through the cohesion with an abstract theme that a drawing becomes convincing. A rib cage or a foot seems more solid if it is tied to a meaning for the whole page. If you copy the riders of the Parthenon frieze, as you look for the rhythm you will arrive at horses that seem to be running and graceful. If instead you work only depictively, missing the rhythm, they will seem stiff and clumsy. Once students see this, they are hooked. Eventually one can't make any move, be it a good or a bad one, that doesn't matter to the whole page. This is what it means to have a plastic sensibility. Until you have this concept in your head, you are just piddling around, finding topical things perhaps, but nothing of real importance, nothing that can be said only through the language of art.

I'm not sure why, but for some reason a good deal of this can be conveyed by working from the human figure. There are of course other things one can draw to explore this, but the figure seems to offer a richness of overlapping concepts. Just as the figure has bones, so the drawing must have bones, or an underlying structure. I do not teach people how to draw figures. I teach them how to draw. And of course any student can feel proud once they have accomplished a strong drawing of a figure.

A typical lesson I give to my class might look like this:

Swirl—Copy Rubens drawings and then work directly from the figure in the following way: Think of the axis of the form and wrap the flesh around this axis in a spiraling movement. Think of your line as something that wraps around the figure three-dimensionally rather than as a flat contour/outline going down the side of the figure. In other words, one is drawing the figure from the inside out, seeing it transparently, as if it is made of glass. Seeing the form in this way, one can

Henry Finkelstein,
The Mill at Bragoux,
2006, pencil on paper,
12 $\frac{1}{2}$ x 13 inches.

understand what is going on around or behind it. The comparison of one axis to another can be seen more specifically in space. And this is one way of considering the volumes of air that are created by the volumes of the figure.

Other artists who use the swirl as something that runs through their whole composition include Tintoretto, Delacroix, and de Kooning. Late Delacroix paintings of lion hunts and some de Koonings share a propensity for using the swirl to twist or warp the whole picture plane into something like a potato chip. Even Ingres, the great artist of line, draws his figures from the inside out—for example, in the way he expresses the cylinder of a neck. The swirl is not spelled out, as it is in a Rubens, but it is on his mind. This is what makes his lines so beautiful; their resounding sense of volume also functions as contour.

With intermediate and advanced students, I work at bringing out what makes each individual tick, their aesthetic interests and goals. Usually it is something for which the student is especially gifted that their practice of drawing can make apparent. It is still abstract and compositional. There are as many ways of composing as there are people trying to do it.

In my teaching I give short lectures or demonstrations of ideas one can take from great works of the past. I try not to give demonstrations as a kind of technical formula or "how to," but rather as a challenge for students to include some piece of the concept for themselves. I include in my presentations a range of artists from different periods who have worked around a particular idea. Then I go around individually to each student as they are working to offer advice on how their drawings could be clearer. I am interested in any discoveries their work might suggest, be they on topic or not, because so much of what one finds in art is by accident. Sometimes I will draw on a piece of tracing paper over a student's drawing to "demonstrate" how they might attain greater clarity in what they are doing. This is a kind of discovery for me too, because I'm not always sure I can pull it off. I'm drawing on my experience, but I also find their concept as I go. Often drawing is a kind of thinking that occurs between the eye and the hand before it can be articulated verbally. I don't want my instructional style to be too "teacherly." I want to remain open to what the student is finding as much as to push my own particular agenda of the day.

Through all of my teaching efforts I am perpetually raising the bar. I tell students that until they are drawing on a par with Titian or Rembrandt there is always room for improvement. And this is really why anyone draws, to stay alive as an artist and to grow. ∎

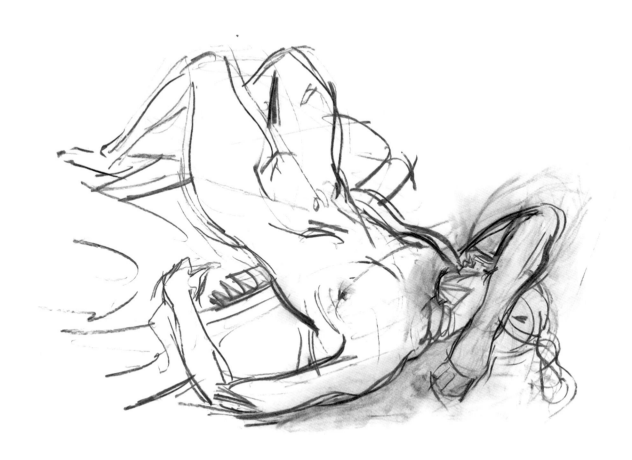

Henry Finkelstein,
Reclining Nude, 2008,
charcoal, 19 x 26 inches.

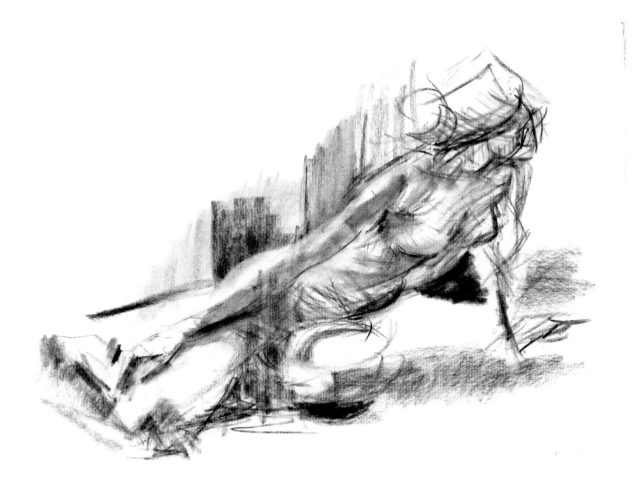

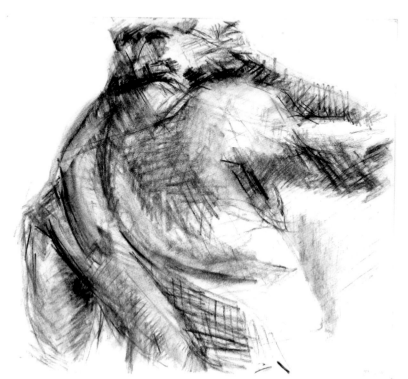

ABOVE
John Parnell, *Nude*,
2010, charcoal on paper,
18 x 24 inches. Student
of Henry Finkelstein.

LEFT
John Parnell, *Male
Figure, Back*, 2009,
charcoal on paper,
18 x 24 inches. Student
of Henry Finkelstein.

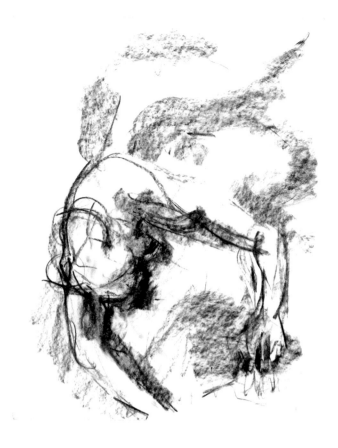

ABOVE
Ann Quackenbos, *Figure with Arms Descending*, 2008, charcoal on paper, 18 x 24 inches. Student of Henry Finkelstein.

LEFT
Ilona Rychter, *Seated Figure*, 2008, ink wash on paper, 11 x 8 inches. Student of Henry Finkelstein.

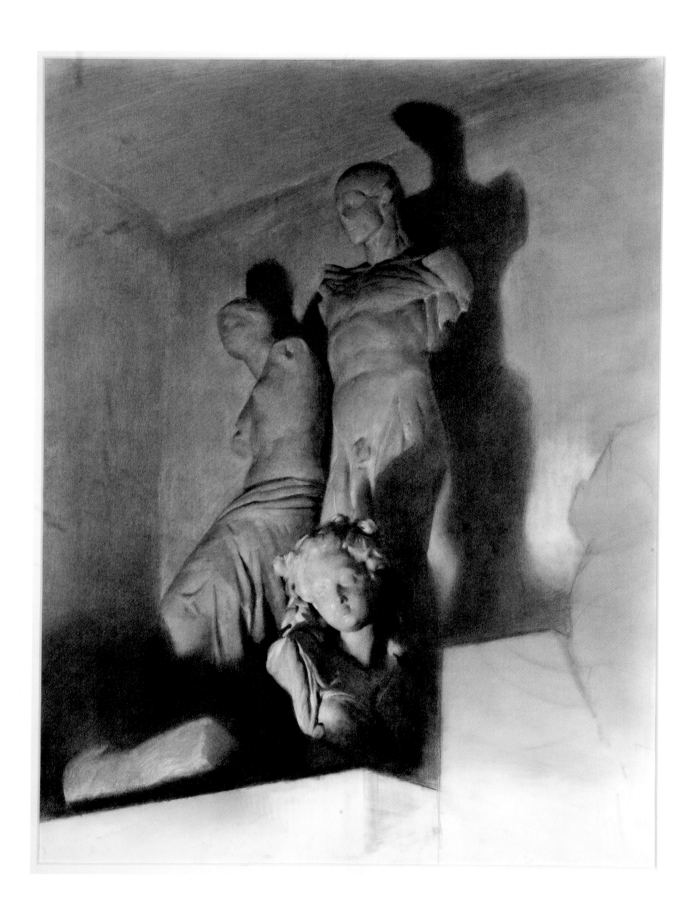

MICHAEL GRIMALDI

MICHAEL GRIMALDI TEACHES LIFE DRAWING and anatomy at the Art Students League of New York. He studied with Peter Cox, Ronald Sherr, Ted Seth Jacobs, and Michael Burban at the League. He also studied at the National Academy of Design, the New York Studio School, and L'École Albert de Fois in France. He was a cofounder of the Grand Central Academy, Studio 126, and the Janus Collaborative School of Art, all in New York. Grimaldi has been an outspoken proponent of classical instruction with a contemporary outlook. He embraces modes of representational drawing and painting long associated with the Pennsylvania Academy of the Fine Arts in Philadelphia, where he lives. His manipulation of light and shadow, reminiscent of Thomas Eakins and Edwin Dickinson—who both taught at the League—links him to other painters like Walter Murch and Antonio López Garcia.

MICHAEL GRIMALDI ON DRAWING

The science, art, and practice of drawing inform all aspects of my artistic outlook. In my own studio, practice drawing is the cornerstone of every work I produce. It is the impetus for inquiry into understanding a subject and is the source of all artistic expression: whether as one step among many toward a sustained investigation of my perceptions of a subject, or directly as a resolved work on paper. By simultaneously informing and challenging one's translation of the perceived world, drawing can shape visual experience into subjective yet concise statements.

Drawing should be taught as the foundation for all the visually based disciplines. My teaching method is built around developing and understanding visual relationships derived from the visible world and within the picture plane—inspiring student curiosity in the ongoing investigation into visual perception and a uniquely personal interpretation of the world around us. In my teaching method, I attempt to break the optical field into separate components. Exhaustive study of these abstracted components and their relationship to the other elements within the drawing will shape a unified and holistic statement. Such study fosters students' abilities to perceive the visual experience with intelligence and apply this knowledge to their work. As a by-product, enhanced visual self-awareness cultivates students' abilities to solve problems strategically through a sustained inquiry using the process of drawing.

I specifically encourage students to learn how to look at the subject in many different ways, understanding that the optical field is a complex relationship of complementary dynamics and phenomena; such looking includes separate and integrated study of proportion, gesture, perspective, anatomy, and light falling on solid volumes. Working through a process of thoughtful inquiry, from broad concepts to increasingly more concise ones, students will develop a sense of their own unique

objectives, create intelligent strategies, and learn to work with many versatile methods when approaching their subject. Built on classical principles, these precepts provide the means to develop insightful and reflective modes of discovery.

In my teaching I attempt to hone students' perceptual abilities through the practical application of concepts. Visual perception is a process of both "top down" and "bottom up" interpretation of information.★

We use many concepts, considered and then realized through methods of abstraction and learning, to sensitize ourselves, to comprehend and express visual relationships in general terms. Drawing serves as the foundation of that activity by enabling anyone to translate the essence of a three-dimensional experience onto the two-dimensional surface of the drawing. Comparing the flat, abstract shapes that are revealed by working from the bottom up with a drawing in which similar shapes are produced by working from the top down establishes a protocol for cross-checking decisions made in the process of visual observation. Students typically find that perspective is essential to perceive any subject in relationship to a uniform horizon from a specific point of view and then draw it with accuracy. The history of Western art is full of examples made before—and after—the discoveries of Filippo Brunelleschi and Leon Battista Alberti were made public.

An exercise that I assign my students is to construct a separate tonal study as a preliminary step toward a more sustained drawing. Primarily, it challenges the students to consider the broad tonal context of the model posed within an illuminated environment; additionally, it hones one's ability to bracket a tonal range. Considering the placement of elusive mid-range values based on the context established between the most extreme limits of value—the highest and lowest values—introduces students to the idea that value is determined by proximity to the light source (distance), by orientation to the light source (angle), by distance from the viewer (aerial perspective), and by local color. In addition to this, a separate preliminary study provides the basis for exploring mass: assessing how tonal design informs composition by reinforcing the idea that the way a figure can be realized in a drawing is conditioned by its environment.∎

★ *Studying the figure by following gravity from the head to the feet and following a growth pattern from the ground up, like a tree.*

TOP
Michael Grimaldi,
Getaway II, 2008,
graphite on paper, 18 x 24
inches. Private collection,
Philadelphia.

LEFT
Edmond Rochat, *Cave*,
2009, graphite on paper,
11 x 15 inches. Student of
Michael Grimaldi.

Michael Grimaldi,
*Untitled (Reclining
Female Nude with
Mannequins)*, 2009,
graphite, charcoal,
and chalk on paper,
14 x 36 inches.

Study for "Lotus"

Charles Cannon 89 ©

CHARLES HINMAN

CHARLES HINMAN TEACHES PAINTING at the Art Students League of New York. He is widely known as an abstract painter whose work explores dimensional space beyond a conventional two-dimensional surface. He studied at Syracuse University and the Art Students League and has taught at Princeton, Cornell, Pratt, the School of Visual Arts, Cooper Union, and the University of Georgia, where he was Lamar Dodd Distinguished Professor of Art. Hinman is the recipient of grants from the National Endowment for the Arts, the Pollock-Krasner Foundation, and the Adolph and Esther Gottlieb Foundation. He has exhibited in New York with Richard L. Feigen, Galerie Denise René, and Douglas Drake Gallery, and abroad in Germany and Japan. His teaching philosophy promotes individual learning:

> [I strive] to guide students toward finding their own identities . . . form their distinctive visions and aesthetic positions . . . to become the artists they want to be.

Commenting on his own work, Charles Hinman offers the following insight:

> From ancient times, polychrome three-dimensional forms have fallen under the heading of sculpture—being more strictly defined according to their shape rather than their color. Some of my works are three-dimensional wall reliefs. However, from the time that I began to study painting, I have always referred to my finished works as "paintings" because they involve color and the process of painting on a surface. My paintings on paper—curiously enough—I usually categorize as drawings.

Identifying the elements of drawing as line, chiaroscuro (or tonality), texture, and color, Hinman comments on how they are used and provides us with a few examples:

> Each one may be introduced into the drawing separately and then used together in a mutually supportive way. One or more elements can be used but held separately within a composition. Line may serve as part of the image, tone another part, texture or color yet another. The viewer combines them all in his mind. In a single Rembrandt drawing, lines move independently from tonal passages of ink wash. Fragonard also uses this technique beautifully. Joan Miró too is a master of combining disparate elements in a drawing; he provides a background tone against which he lays separate shapes and line configurations. The mind integrates all in the viewing of the work.

On the use of these elements in his own work, Hinman makes the following observations:

> When color is synthesized with other elements of drawing, it can effectively enable all elements to support one another. Used separately, color can be the

element that most strongly defines a space—and it is often the first element that is noticed. Lines may exist independently, or they may occur as elements within a drawing.

All my works begin life as drawings. I use the process of drawing to research those forms that I am trying to achieve. I make many drawings in this quest—using pencil, charcoal, pastel, crayon, and ink, independently or in combination. I end my search when I have made a master drawing that includes all the information I need—scale, angles, distances, color—a blueprint for building my finished work.

He emphasizes the necessity for all artists to know how to draw:

The importance of drawing is for artists to find a way to realize space in their works. Problems of scale, placement, emphasis, and arrangement may be solved through the process of drawing. Every artist has a mental vision of what his or her art is about. As the drawing progresses, ideas and techniques flow from that vision. It is beneficial for professionals, amateurs, and students alike to work from this premise.

Making preparatory sketches and drawings before embarking on a new work is the best recipe for its success. Such drawings may be at once useful. Other drawings will provide material for future reference and reflection. Because this is seldom clear when they are made, all such drawings should be preserved for later "study," the word commonly used to denote a preliminary drawing.

Beginners in Hinman's classes are asked to state goals and describe what they desire their work to accomplish:

I direct them to address the entire space. Forms may be keyed to the flatness of the paper and be pattern-like. As the students work, they may begin to detect the illusion of advancing or receding space, creating a depth of field. Some compositions may reveal a shallow space, or a deep space may appear. Any given line may divide space and at the same time create a depth that causes the space to advance toward the viewer or recede—sometimes leaving the page altogether to infinity or inviting imaginary space to intrude from outside the frame. At other times, lines may be drawn to confine all the activity within the edges of the page.

I encourage my students to employ whatever graphic techniques appeal to their individual sensibilities. At every level of proficiency, I find it useful to encourage students to imagine in their mind's eye the forms they will use to deal with the entire space, then to visualize those forms as advancing or receding within the space until a depth of field is created. When I see them narrowing their eyes and/ or lifting their hands, one before the other, to form planes in the space in front of them, I begin to know that they understand the concept.

Any good drawing respects the flatness of the page in achieving spatial depth and movement. Because ideas like this are best taught over a longer period of time, one student at a time, Hinman prefers individual instruction and critiques rather than technical demonstrations.

I talk to each student personally during a session. This way I can address each student's individual vision and answer questions specific to that student's work as it progresses. I try to offer suggestions to help students achieve their personal goals and avoid pitfalls.

Group discussions occur according to Hinman's version of a Socratic dialogue. Widely practiced today as a form of instruction in studio art, the group critique follows many paradigms intended to lead students to independent thinking that directs their own actions and measures their results. Effective instructors like Hinman function as ringleaders—facilitators who guide discussions but do not dominate them. Typically, one student will present his work to the class, assembled as a jury; the jury members discuss the work, troubleshoot problems, and make suggestions for improvement. Participants build mutual esteem through careful scrutiny and thoughtful commentary and achieve mutual trust through honesty, courtesy, and candor. In his own words, Hinman describes the benefits of this process:

> A favorite activity in my class is students presenting their drawings to the class—explaining their objectives and noting where they think they succeed and where they see problems. The whole class is invited to participate in the discussion. This way, all students learn from each other. ∎

Charles Hinman,
Via Sebastiano, 1993,
pastel on paper,
28 x 40 inches.

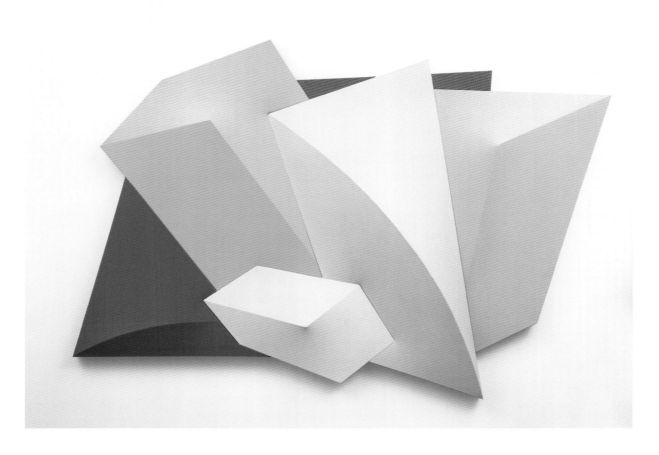

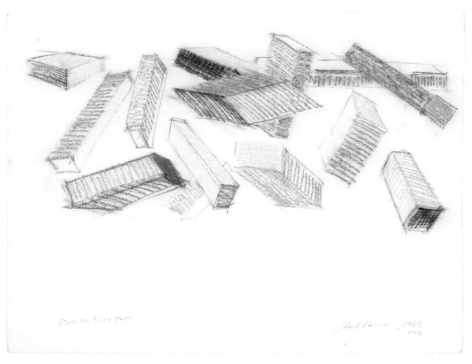

TOP
Charles Hinman,
Lalande, 1980,
acrylic on canvas,
64 x 86 x 6 inches.

LEFT
Charles Hinman,
Study for Block Party,
1964, pastel on paper,
18 x 24 inches.

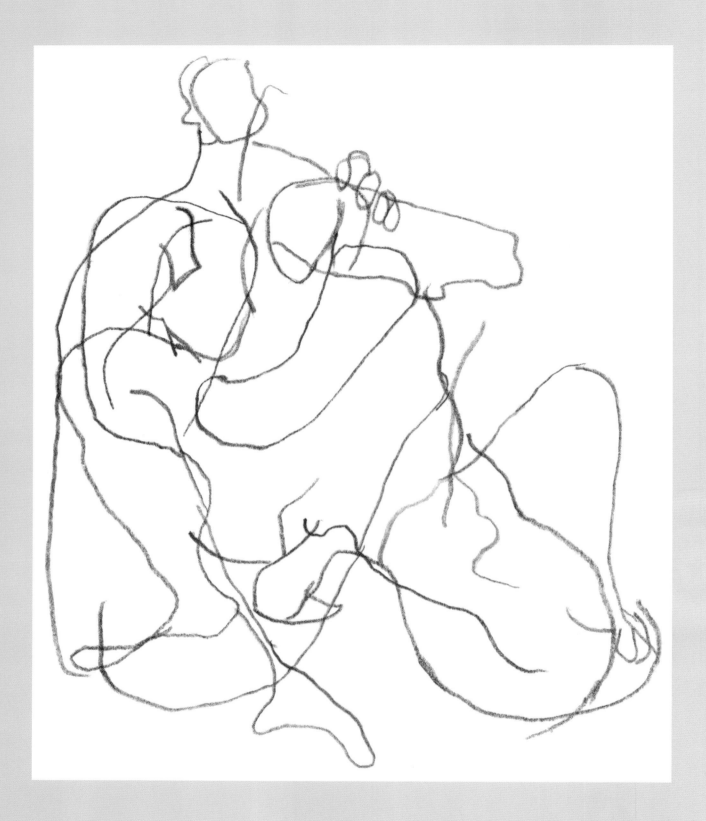

GRACE KNOWLTON

GRACE KNOWLTON GRADUATED FROM SMITH COLLEGE before going on to earn a master's degree in art and education from Columbia University. She has exhibited at Leslie Heller Gallery, the American Academy of Arts and Letters, and the Neuberger Museum of Art in Purchase, New York. Her work is in the collections of the Corcoran Gallery of Art, the Metropolitan Museum of Art, the Newark Art Museum, the Smith College Art Museum, and the Victoria and Albert Museum.

> I began as a painter, and at a certain point I started to make my paintings three-dimensional. I discovered form and space. In short, I began making sculpture, but still with a strong interest in surface—line, color, and texture.

Knowlton favors taking risks and pushing the envelope. In her classes, students are encouraged to experiment with different materials in both two- and three-dimensional form.

In her teaching, Grace Knowlton holds that drawing trains the eye to see, that it is also language, feeling, meditation. Drawing can be visual adventure, for people at all levels of experience. Knowlton approaches the process of instruction as a series of individual dialogues. Discursive circles might expand as other students eavesdrop or join the conversation.

Challenging students to take risks, Knowlton emphasizes the rewards obtained by going out on a limb in search of personal surprise, excitement, and discovery. Because drawing is a personal journey for everyone, she hopes that no two people—or students in her class—will draw the same way.

"What is the right way to draw?" Knowlton asks. "The right way to draw is your way."

Frustrated, a student tells her, "I can't draw."

Knowlton replies, "Wanna bet?"

Here is one of her favorite assignments, which is called (ungrammatically) "How to Draw Wrong":

> Sit down to draw—or, better yet, stand up. Find a drawing tool that doesn't work very well, such as a stick or a piece of dried grass; whatever you use for ink, try something else. Take your drawing tool in hand and put a big piece of paper in front of you. It should be good rag paper; this is going to be a good drawing, so you'll want it to last. If you're drawing from a model, look at the model. Where do you want to start? The bottom? The middle? The top? Place your drawing tool on the paper, preferably without looking; keeping your eye on the model, feel the contour of her head with your "pen." Continue down the neck; if you pick up your stick to dip it in ink, place a finger of your other hand on the spot so you

OPPOSITE PAGE
Grace Knowlton,
Crouching, 2004,
pencil on paper,
14 x 11 inches.

can find it again without looking at the paper. Of course, it is hard to know when you are out of ink without looking, but we're not after accuracy, and you can feel when it happens, more or less. Keep your eye on the model; keep your thinking mind blank. Feel the line you're drawing. Feel the contour of the body. Everything needn't receive equal attention: maybe the hand interests you; maybe the hand doesn't interest you. Keep going. Don't worry if you get lost on the paper. Guess where to pick up the drawing, or if you just can't help yourself, take a quick peek. If you do notice while peeking where the "pen" went dry and left either a faint line or none at all, try to resist going back and filling in. So? There is a line missing.

Don't worry if you go off the side of the paper—just get back on. Give up any idea of what the drawing should look like; that is not what this is about. You are going to be surprised. Why do you want to draw what you already know? The best you can get thinking that way is accuracy, which is boring. Allow yourself to be surprised; risk learning something. If you get too good at this technique, switch to your left (or other) hand and/or put a paper bag over your head and turn around three times before you start. ▮

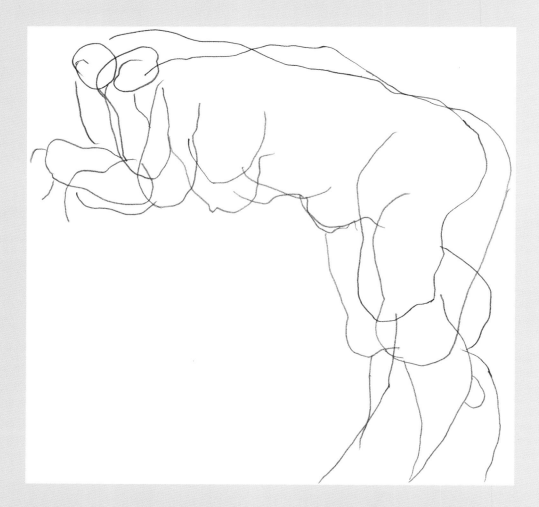

Grace Knowlton,
Leaning, 2004,
pencil on paper,
11 x 14 inches.

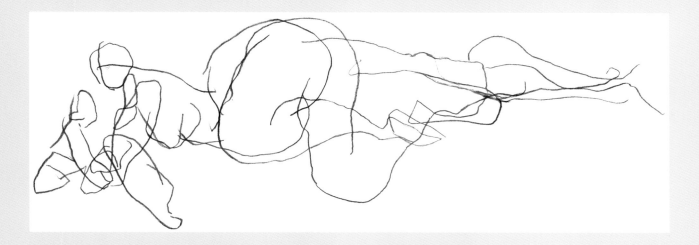

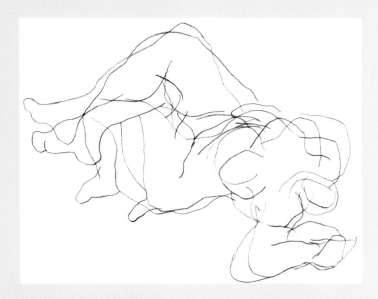

TOP
Grace Knowlton, *Prone*,
2004, pencil on paper,
11 x 14 inches.

CENTER
Grace Knowlton, *Supine*,
2004, pencil on paper,
11 x 14 inches.

LEFT
Grace Knowlton,
Reclining, 2004,
pencil on paper,
11 x 14 inches.

KNOX MARTIN

KNOX MARTIN STARTED TEACHING when Jack Tworkov invited him to join the faculty at the Yale School of Art in the early 1960s. Martin found himself working alongside Al Held, George Wardlaw, and Bernard Chaet. Among his students were such future luminaries as Janet Fish, Richard Serra, and Chuck Close.

Knox Martin's studio rambles through a couple of apartments in a 1920s building on the high river bluff running south from the Manhattan end of the George Washington Bridge. During an interview conducted in May 2009, we spoke about drawing, teaching, and his life in art amid rooms piled high with sixty-five years of his work. An African gray parrot clung precariously to a large piece of driftwood suspended from the ceiling. Knox Martin's deep and sonorous voice has a slightly patrician air, while a visible nautical tattoo on his forearm suggests a life of adventure. The following text recounts our conversation.

> I asked [Jack] Tworkov about teaching art. I queried everybody. Al Held, Alex Katz, and Joe Stapleton, who made a gesture and pointed to me as if drawing spelled out the way, which I didn't get yet.

Martin looked to history for the answer.

> I found this student drawing that Rembrandt had reworked; it was done by a student in his atelier [school] who had drawn the virgin in an Annunciation scene. There was this little angel, the figure turned this way . . .

Martin gestured with his hand.

> . . . and Rembrandt came down on the drawing in his own hand and went "wham whim whoom."

Martin's hand dived on the table dramatically.

> And suddenly Rembrandt filled the page. The corners suddenly were engaged and the whole thing took off. It made sense. I looked at that [drawing] and said to myself, "Now that, I can do."

I asked Martin about his father.

> My father was a painter. My father went to Paris to study painting in the 1920s. He was crazy about airplanes and dirigibles, gave up painting, came back an aviator. He flew for Pancho Villa [during the Mexican Revolution] observing troop movements and later flew for Chiang Kai-Shek [in the Chinese Civil War]. He started airmail service in Colombia and was the first man to fly over the Andes to Bogotá. After his death, I, at the age of five, inherited his paint boxes, easels, and art books.

I asked Martin how he found his calling.

At a young age, I read a book called *A Dog of Flanders*. This defined my future. The boy in the story was a painter, and his hero was the great painter Rubens.

Martin explained that while recovering at Brooklyn Naval Hospital from injuries sustained during World War II, he was visited by the artist Victor Kandel, who spotted his talent and encouraged him to enroll at the Art Students League on the G.I. Bill of Rights after his discharge from the navy.

When I was a student at the League there was one teacher—Will Barnet—who reached me with an aspect of what basic art was. He got me looking at Ingres and Van Eyck and all the old masters. There was a miraculous late-Byzantine Madonna and Child that I thought was one of the finest things I had ever seen. After haunting the museums, I went back to my teachers at the League, who helped shape my experience with painting and drawing, and I realized that they were talking about something else. One of [my teachers] was engaged in social movements; another's work was more geared toward illustration.

Former Hans Hofmann student Vaclav Vytlacil said that Hofmann could talk about the real thing but never really do it. Vytlacil's assistant Steve Wheeler told me a story about Hofmann reworking a student's painting in class one day. Twenty minutes later the student looked at Hofmann's corrections and said in a very loud voice, "Don't expect us to do it if you can't do it." A goal of my early student days was to draw as well as anybody ever. Later, as a visiting artist at colleges and universities, I saw student drawings which operated out of a system that was an illustration of concepts that led them to draw what they knew but failed as art. I told them, "If you know how to do it, you don't have to do it anymore." The astonishing thing was that after two months at Yale everybody moved into my class.

I asked how he got students to think about drawing and if he had any favorite assignments.

Once I was giving a talk in Oregon, showing slides of Velázquez and others, when someone in the audience stood up and declared that Tolstoy said all art is subjective, that nobody really knows what art is. I replied that I could show him what it looked like, talk about it, and do it. Silence—then I asked, "Are you ready for this? Are you sure?"

I held up a reproduction of a Cézanne painting, pointed, and said "Art!"—[and then] total silence.

Who else thought this? Picasso, Léger, Matisse, Dufy, de Kooning, five hundred plus books, all the museums—the whole world changed because of this artist. Cézanne created a new kind of reality. What's your reality . . . Mozart? What are you going to fill that world with . . . rap music, Wagner? Art made the world. People make

art. A snail didn't paint the *Mona Lisa*, and puppies didn't make the Hubble Telescope. When Columbus landed at Hispaniola, none of the natives on shore could see his ships. The Indians couldn't see the boats because seeing them was beyond their experience. The Spaniards took the medicine man and rowed him out [to the anchorage]. At first, all the shaman could see was the surface of the water being interrupted by something. He touched the hull. It seemed like a tree. Once he came aboard and walked around on the deck he began to comprehend it. He began to see it.

Martin removed some drawings from a portfolio and spread them out. Understanding the mystery of drawing might be like the medicine man discovering Columbus—learning drawing by drawing and by drawing from drawings.

> I copied hundreds of drawings by Ingres, Rembrandt, Holbein, everybody. I have lots of notebooks filled with those kinds of drawings.

Knox Martin, *Cezanne (reproduction of Boy in a Red Vest)*, 1985, oil on canvas, 38 x 28 inches. Collection of Galerie Martin du Louvre.

Martin always keeps a drawing book close at hand. He pulled one of his drawings from the stack—a vigorous line drawing of irises in a vase—and propped it up.

> I took the interstices of these lines and directed them first in one direction, then took these others and spun them back the other way, and then interrupted the spirals with rhyming shapes and slammed them into the edge while a strong horizontal pulls everything to one side. The background is active. For the Florentines, the background was null. It never did anything. It's just a bunch of other forms lying on top of it. I created this work to have no foreground, middle ground, or background. It's always ambiguous. The corners are radically different from one another.

He removed another more compact composition from the folder.

> This one does the same thing.

He describes taking a botanical illustration, which by slight manipulation of its visual elements is redeemed from mere reportage, and transforming it into an exciting work of art.

I also love to draw people, to find the presence of the people I draw—drawing what I see and never the conceptual; that kind of thing is totally dead.

He shows me a drawing of a young woman; a nervous empirical scratch parts her lips.

That's what I mean.

From the portfolio another drawing emerges—a clump of flowers bending to the right to avoid a collision with the top left corner of the page [opposite]. Horizontal elements shift in lateral opposition. His signature, KNOX, is lettered in capitals forcefully deployed as an element of composition. I compare his use of line with Katsushika Hokusai, whose work he admires and whose words he echoed.

I have thousands of drawings of everything I could find. Mountains, plants, people.

Another portrait centers the head, leaving the top third of the page open—a trait of certain Ingres drawings. Martin describes the reciprocal natures of drawing and painting.

Following on the perception of Matisse—"painting is an expanded drawing"— let's take the black-and-white painting of Paul Cézanne. The first thing to consider is the proportion of the working shape—be it rectangle, square, circle, et cetera. It's the first thing to regard with an artistic passion—to divide and place in the reciprocal action of top, bottom, sides the dance of intelligence among the forms, in perfect pitch. Each shape and line will be created out of its senior creation; thus the subject matter of any painting or drawing is creation and itself and the fresh metaphor, mitigated by its attendant dance.

For Knox Martin, reading drawings is very similar to making them. And making them expands how we look at the world. For his students there is no set lesson plan except doggedly interrogating visual experience—taking action in graphic terms to move space within the rectangle and marks across its surface. Martin rejects the notion of teaching drawing by recipe and rote exercise. Like a Zen master, he directs conversations about how visual skills are acquired, how artistic knowledge is attained and refined in ways that empower students to find their own path to achievement. These conversations occur when marks and lines fall, push, and dance across a restless page. For Knox Martin there is no path to truth. Art and drawing allow us to behold the truth.

Art creates nature, the subject matter of art is creation, and the work is about itself! ∎

OPPOSITE PAGE
Knox Martin, *Flowers*, 2010, pencil on paper, 12 x 8 inches. Private collection.

OPPOSITE PAGE
Knox Martin, *Ingres*, 1982, silverpoint, 8 x 6 inches. Collection of Galerie Martin du Louvre

LEFT
Knox Martin, *Ravin*, 2009, pencil on paper, 18 x 16 inches. Private collection.

BELOW
Ron Nelson, *Sitting Model*, 2010, pencil on paper, 14 x 12 inches. Student of Knox Martin. Private collection.

FRANK O'CAIN

FRANK O'CAIN WAS BORN IN SAN DIEGO. He studied at the Art Students League with Vaclav Vytlacil, from whom he gained a thorough knowledge of arcane, historic painting techniques, which he later combined with his own forays into abstract painting. O'Cain has exhibited his work in one-person shows at Purdue University and at the Miriam Perlman Gallery (Chicago and Flint, Michigan). He has also exhibited in New York, Korea, France, and Switzerland. Quoting his page in the League catalogue:

> I am always wandering around in the unknown, asking myself questions, creating new problems, finding fresh possibilities.

O'Cain's teaching addresses the basic principles of picture–making, giving his students starting points from which they may pursue their creative ambitions. Through a sequence of exercises exploring the formal elements of painting and drawing, O'Cain encourages personal experimentation and discovery, with the caveat that success depends on proficiency in drawing.

> The art of drawing is the most direct way to express our visual thinking. The desire to draw is innate, stemming from our earliest history. This is substantiated every time an archaeologist excavates a new tunnel or cave and finds more images painted on rock walls. Drawing is our first form of visual communication, driven by the need to express emotions or spiritual ideas in the embryonic stage of our evolution. For us today, all of these notions have merit. Drawing has also been used throughout history to initiate the process of the creation of major works of art. We see this in cartoons used in fresco painting from the twelfth century onward. Studies are also made to observe and describe the human body in part or as a whole.
>
> Drawings generate compositional ideas. The art of the past gives us a wealth of ideas about drawing, giving birth to new ideas that inform how we draw today. Looking at drawings by Rembrandt and Rubens, we can see differences in how line expresses movement, an inherent component of the aesthetics of art. We see how Van Gogh uses lines of differing weight, stroke, and density to create movement and tonality. Among twentieth-century artists, we can see how erratic lines can be put into motion to discover and build on an expressive idea. In drawing we can see how line functions as a personal formative language, how it tells us about our observations as we make note of them. We develop a feeling for what we behold and the ability to interpret our sensations: how the paper responds to the hardness or softness of a pencil or brush or whatever medium is applied to it. We discover patterns and spatial movement. [Sometimes we draw] simply to launch an idea.

OPPOSITE PAGE
Frank O'Cain, *Studies*, 2006, watercolor and ink on paper, 8 x 10 inches. Private collection.

Some may argue that the approach to initiating the work comes from seeing analytically as opposed to an intuitive response. In fact, it doesn't matter how one starts; one must find ways to do both, which, with practice, will evolve into a whole vision. Line is fundamental. Any materials can be used, from ink to charcoal to anything that will make a line—the quickest way to make preparations, solve problems, and retrieve ideas before physical mass or color come into play. From linear drawing, one can rapidly discover the strengths and weaknesses of any idea—from the first mark to the last—in a space where one can explore how visual elements can be gathered together as a whole.

Picasso and Cubism are generally credited with introducing collage to painting. Willem de Kooning sometimes masked out large areas of his canvas with pieces of newspaper that traced sweeping gestures and then repositioned these gesture-templates to overlap, creating unexpected shapes; sometimes he left transfer imprints of inked type and images in the drying paint. O'Cain describes a typical assignment that uses Cubist and Abstract Expressionist strategies:

> One assignment I give my students is to use their own handwriting as a model, noting the movement of line, geometry, shape, scale, placement, and position. Once this exercise has been completed, the student will cut the drawing into pieces and reorganize them into a collage on a new sheet of paper. I advise them to work very slowly and look carefully at what they are doing. The outcome is that students will discover and note how new shapes created in this way relate to one another on the surface—not as words on a page, but as a composition. New drawings can be made from these, using the reconfigured handwriting-collage fragments as models. If I see that students are not learning from this exercise, it usually means they need more basic instruction. I may send them to study with someone who can teach them about the human figure. Life drawing can help them learn about proportion and overall design.

In his teaching, O'Cain stresses the importance of process over the desire to make a finished product, backing up his argument with historical paradigms.

> The first thing a student has to learn is how to overcome the fear of failing or doing a bad drawing. The way I get students to overcome this problem is to have them doodle, which, like their handwriting, is something they're usually comfortable with. When they've done a series of doodles, scribbles, or repeats of their signature, I get them to see that what they have intuitively created can be broken down as expressive shapes within the boundaries of the page. Once they begin to see the line for what it is, those initial fears disappear and they can draw anything they like. I do not allow my students to trace or replicate what they are looking at. Instead I get them to find the energy of the line—at which point they become connected with draftsmen like Rembrandt, Picasso, and many others.

O'Cain employs a diverse number of instruction methods in his teaching, from individual tutorials to lectures, group critiques, and technical demonstrations. Lectures

describe ways of reading and understanding a work of art; how the work "works" in formal terms of space, volume, tension, and movement. He uses demos to illustrate particular concepts—not just to show students how to perform and repeat techniques.

> To be effective, instructors have to know every method of teaching to reach each student. At the League we see every kind of student. At the same time, concepts and processes must be reinforced through constant repetition. My lectures might begin with a slide of something like Leonardo's cartoon of the Holy Family. I will talk about how different forms behave, noting how the observer's eye moves within the edges of the frame, or I will explore the process by which an artist's work starts as a sketch and evolves until its completion.

Looking at art is a skill. Critiques are in many ways rehearsals of conversations artists have with themselves as they troubleshoot problems in the studio. Critiques might occur at the easel or in front of the entire class. Like many others, O'Cain models his critiques on the Socratic dialogue.

> A critique might include the whole class discussing a work by one individual, learning en masse how to explain why a painting or drawing does or does not work and, in the case of the latter, how it can be corrected and be brought to fruition. Demonstrations always start by drawing in line with a brush, usually with color as a way of showing how a dominant idea can be stated at the beginning. Color is needed to bring order to the total surface. If a drawing or painting feels too compact, too dense—meaning that the eye of the observer cannot "travel" across the surface of the work in a way that reveals its intended expressiveness—it may be due to the effect of all the forms being too similar, without enough variation in color, positive and negative space, emphasis, or line pressure. The challenge is to combine one's analytical skills with the vitality that comes from the intuitive act. ∎

Frank O'Cain, *Untitled*, 2006, watercolor and ink on paper, 8 x 10 inches. Private collection.

ABOVE
Frank O'Cain, *Untitled*,
2006, watercolor and ink
on paper, 8 x 10 inches.
Private collection.

LEFT
Helke Neumeister,
Untitled, mixed media.
Student of Frank O'Cain.

Tony Paciello, *Untitled*, 2008,
watercolor on paper. Student of Frank O'Cain.

RIGHT
Diane Waller, *Untitled Figure*, watercolor and pastel on paper. Student of Frank O'Cain.

BELOW
Janna Davis, *Untitled Landscape*, pastel on paper. Student of Frank O'Cain.

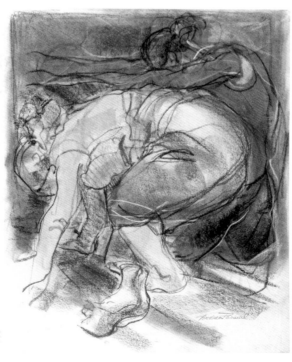

TOP
Craig Carlson, *Untitled*, mixed media. Student of Frank O'Cain.

RIGHT
Andrea Pascual, *Untitled Figure*, pastel on paper. Student of Frank O'Cain.

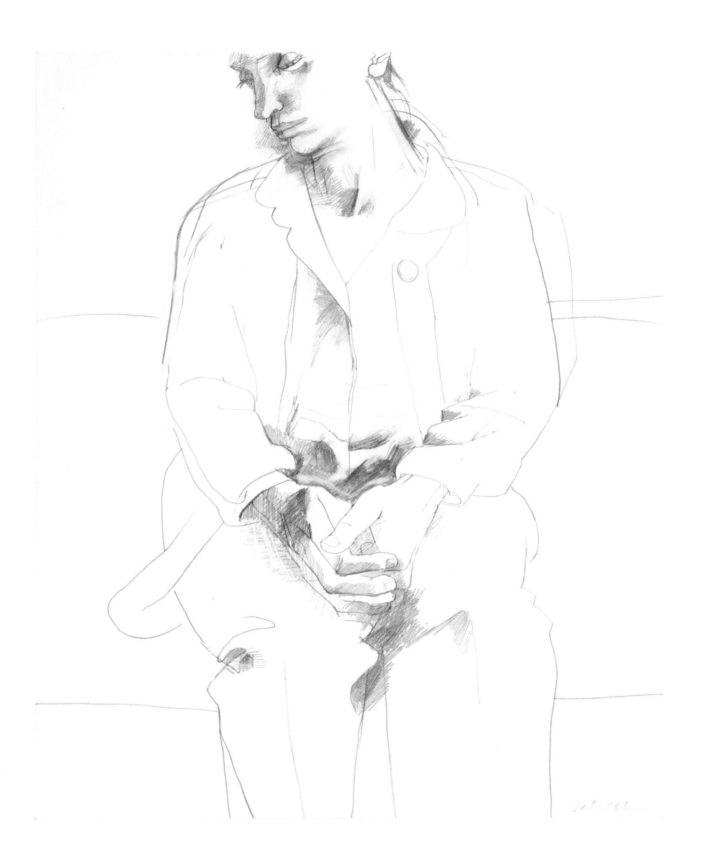

JONATHAN SHAHN

JONATHAN SHAHN WAS BORN IN OHIO in 1938. After two unsuccessful years in college, he spent almost four years at the Boston Museum School studying sculpture and two summers at the Skowhegan School of Painting and Sculpture studying painting and fresco. Shahn taught drawing and sculpture intermittently at a number of universities and art schools before being invited to teach sculpture at the Art Students League in 1977. He has been included in exhibitions at the American Academy of Arts and Letters, the Biennale di Roma, and many other exhibitions, including a number of group and one-person shows in both the United States and Europe; he is currently represented by the Jonathan O'Hara Gallery in New York City. Shahn's consistently figurative work in sculpture, drawing, and printmaking covers a wide range of approaches, from direct representation to more expressive and idea-based directions. His development as an artist has been more circuitous than linear; he returns to prior modes of expression, reviving themes, ideas, and stylistic notions and carries them forward or veers off in new directions. Discussing aspects of form with students, Shahn privileges seeing, observing, noticing, looking, and thinking, and gives secondary importance to style, manner, and "learning how to draw." For Shahn, craft and skill are aspects of drawing. Drawing is, above all, a way of seeing and of thinking about seeing.

JONATHAN SHAHN ON DRAWING

I am not a drawing teacher, although I have taught drawing classes, but it was many years ago. However, I draw all the time, and I think a lot about drawing and talk about it to my sculpture classes. I don't think I could teach sculpture without talking about drawing. So these are some thoughts about drawing. One of the reasons I find teaching so difficult is that no sooner do I say something about what we are doing to a student or to a whole class than I can see how the opposite might be just as true. Some of the thoughts or observations that follow may therefore be full of contradictions and ambiguity.

o

Drawing from life, looking at something before our eyes, we are always working in a kind of metaphorical way; that is, unless we are copying a photo or another two-dimensional work, we are inventing ways of creating an illusion of space on a flat sheet. We can't really transcribe nature—a three-dimensional phenomenon—but we are obliged to make up something that will give illusions of space or volume. This kind of invention has been one of the main preoccupations of drawing throughout history. I don't think I can teach anyone how to do this so much as talk about what it might be.

o

OPPOSITE PAGE
Jonathan Shahn,
Seated Figure, 1978,
pencil on paper,
17 x 14 inches.

What do I talk about to students in a sculpture class when I talk about drawing? I try to get them to look as carefully as they can, which sometimes means slowing down the speed of the process. I talk about the many different functions that line can fulfill: the design of the page, the enclosing of form, directing the viewer's eye into deeper space (and the many different ways this can be done), the weight of the line itself—just to name a few. Sometimes we talk about tone (or shading): how it can describe form, how the form of the shaded areas themselves can be dynamic or static, and how line and shade can work together, mutually reinforcing each other's "form-explaining" and expressive potential. In the class, I speak about these in the form of digressions, as the main subject is always the sculpture.

o

I have always tried to talk to students in my classes about books and museums and galleries, insisting that they look at more art—more sculpture, more drawings, more painting—from all periods and from all cultures. One of the biggest steps in becoming an artist is learning to know what you really like in art, what really speaks to you. As you look at more and more drawing and absorb greater amounts of visual information, it gradually becomes clearer to you what it is that attracts you to certain works and not to others. To really try to make drawings, as art, we have to start to know a lot about ourselves. This is one of the things we mean when we say we are studying art.

o

Jonathan Shahn,
Proposal for a Memorial,
2006, pencil on paper,
16 x 20 inches.

One of the biggest problems in learning to make sculpture, and in a certain way in learning to draw, is the difficulty of overcoming our conditioning by two-dimensional images. We are so surrounded by these images, both still and moving, that we have learned to see the world almost exclusively through the mediation of photographs, video, film, et cetera. Images of this kind have become so powerful that the perceived visual world can seem pale and lifeless. As learning artists we have to struggle against the seductive power of mechanically formed imagery. There is a lot to be learned from these media for visual artists; we can see things in time and space that we could never see by ourselves. But if we are trying to make the kind of art that is based on our actual perception of the world around us, we then have to try to teach ourselves the primary importance of seeing the forms of the world and of life directly.

○

Another difficulty that I've noticed when students are learning to draw a human figure is the way in which they have subconsciously absorbed an architectural/engineering vision of the world or of objects (such as the human figure) through a plan/elevation way of looking. Many students of sculpture, especially when they are at the early stages of learning to model figures, try to see them with a vision analogous to the one used when looking at buildings or other right-angled structures. Here is where drawing the same thing—for example, a standing human figure—over and over, from a large number of views, helps us begin to absorb, through this drawing/looking process, the complexity of nonregular forms, while at the same time forcing us to look, ever more precisely and accurately, at what is before us. We may gradually begin to understand, through this kind of careful study, how planes, large or small, curved or straight or twisting, can lead our eyes around these forms.

○

One sort of division we can make between the different kinds of drawing we do as sculptors is the one between drawing from perception, looking at something— a person, a thing, a space—and the kind of drawing we do when we have an idea, however inchoate, and we are trying to give this idea substance through drawing. Many of the skills we have been learning while drawing from life come directly into play as we try to represent these vague images that exist only in our mind, using what we know about how light and shadow, as well as line, can describe forms that we are trying to bring forth. Here is where the careful study of drawings of past sculptors can be of use to us. Picasso is a fine example of an artist who made precise, clear drawings of powerful forms that existed only in his mind.

○

I also would stress the importance, when visiting museums, of constantly drawing from sculpture. You never can look at a piece of sculpture as intensely as when you are drawing it, trying to understand its forms. This is especially true when we are fortunate enough for the sculpture to be exhibited in natural light, as in the recently redone Greek and Roman galleries at the Metropolitan Museum of Art in New York. The habits of intense looking that you form while doing this kind of "life drawing" can stay with you as you search your own work for errors or for successful form. I can't think of any better way to achieve deeper understanding of sculptural form and of the power of line, of understanding the idea of sculpture.

○

One of the most difficult tendencies to overcome in drawing is the desire to do a respectable job, to make a reasonable, proportional product. Since you don't always have to show what you do to anyone, it can be liberating to forget about proportion and anatomy for a while and just concentrate on the abstract qualities of form, of shadow and line, as being what represents the phenomenon of reality as much as proportion and measure. One of the most oppressive needs in drawing figures, for instance, is that of trying to fit a whole figure onto a piece of paper. It is helpful to tell students who are drawing from life to start looking at the middle of what they are drawing and let the drawing grow out from the center, so to speak, not caring where it runs off the paper. Then the human form can become a kind of landscape more than an object. This would be one example of how not trying to do a "good job" and make a respectable drawing can lead to different kinds of discovery. There are many others.

○

If there is no pleasure in drawing it will always be a disagreeable job. ∎

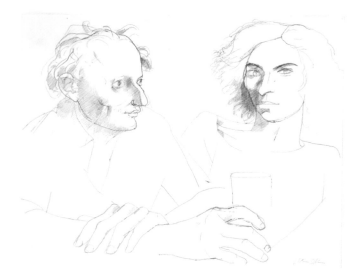

Jonathan Shahn, *The Filmmakers*, 1982, pencil on paper, 16 x 20 inches.

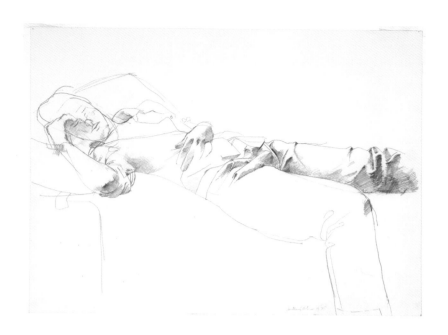

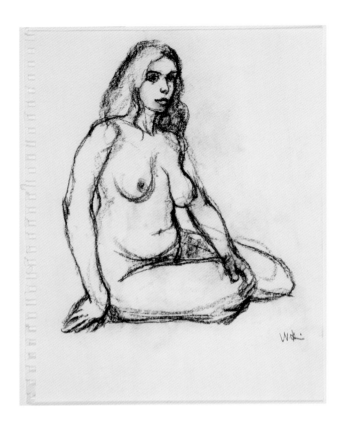

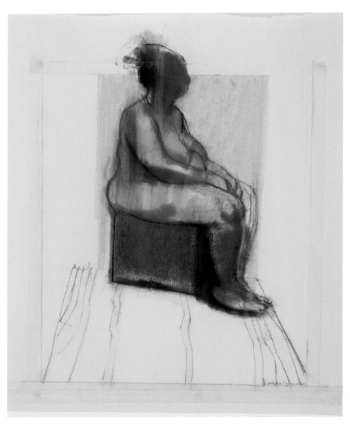

ABOVE RIGHT
William Hui, *Figure Seated on Floor*, charcoal on paper. Student of Jonathan Shahn.

ABOVE
Sarah Konstam, *Seated Woman*, 2009, pencil on paper, 20 x 14 inches. Student of Jonathan Shahn.

LEFT
John Mandile, *Untitled*, 2010, Conté crayon on paper, 25 x 19 inches. Student of Jonathan Shahn.

OPPOSITE PAGE
John Mandile, *Untitled*, 2010, Conté crayon on paper, 25 x 19 inches. Student of Jonathan Shahn.

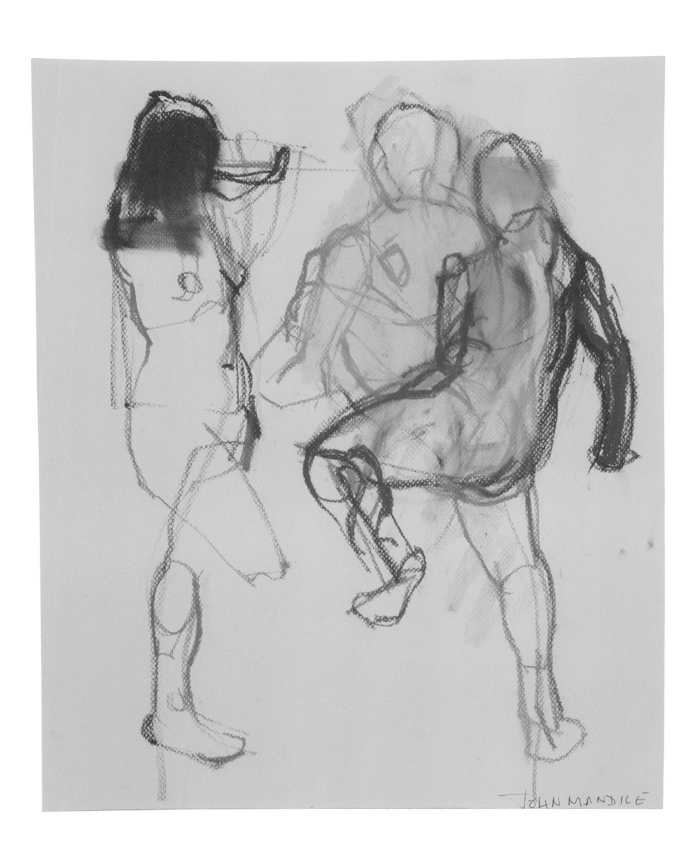

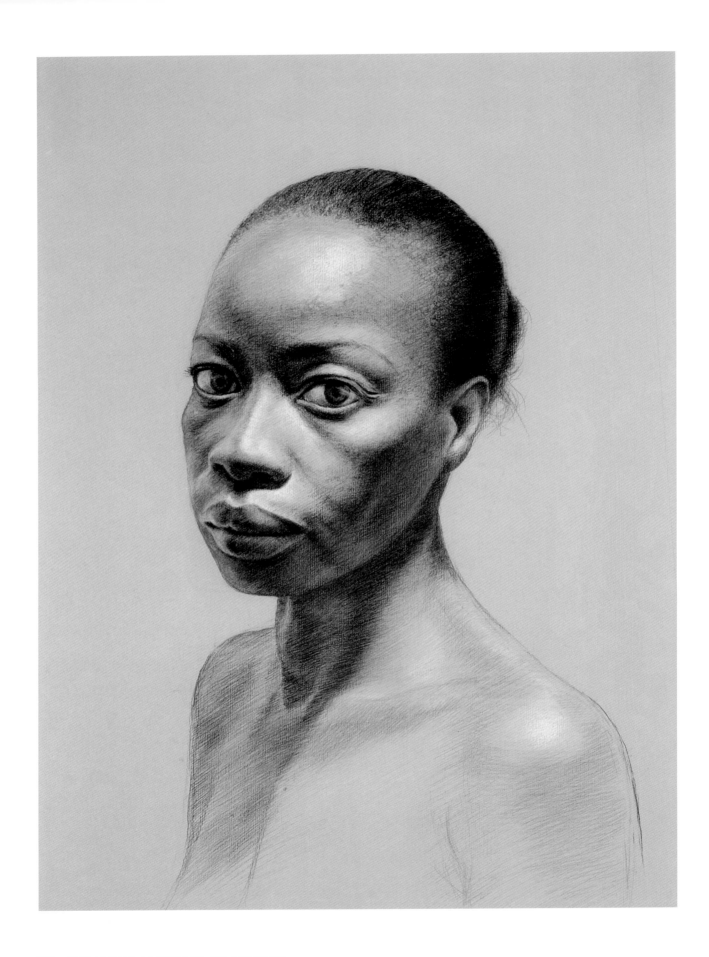

COSTA VAVAGIAKIS

REALIST PAINTER COSTA VAVAGIAKIS studied at Queens College, the National Academy of Design, and the Art Students League of New York. Close observation of nude male and female models guides his drawings. Vavagiakis has established himself with his unblinkingly specific nudes and portraits, insistent paintings and drawings that confront physical reality with startling honesty to explore the human condition. Employing classical academic methods, Vavagiakis places each of his subjects in an austere setting, lighting them from one side, and represents many of his subjects at life size. His subdued palette bows to form, while his direct approach to composition conveys a powerful sense of abstraction. Insisting on a high finish, Vavagiakis unflinchingly notes minute details of form and flesh. His teaching is always done in the presence of a posed model.

> Drawing, like any other skill, requires a person to do more than one thing simultaneously. An effective draftsman has to learn to use all perceptual and transcription tools continuously. In order to get the illusion of three-dimensional form the artist needs to have an understanding of the totality of the form in the round.

Vavagiakis's approach is formal and rigorous, stressing classical modes of observation, construction, and pictorial organization. Drawing for him is a process for visual investigation and experimentation—a way of planning future artworks or troubleshooting those in progress. He also regards drawing as an end in itself: not only preliminary, but equal to painting or sculpture. Working in graphite—a preferred medium—he develops drawings over long periods of time to achieve a highly refined sense of physical presence and detail. Proficiency in drawing is a necessity for students with professional aspirations. For students pursuing only the rewards of personal enrichment, Vavagiakis believes that competency in drawing will improve anyone's ability to understand and function in human environments. A solid working understanding of drawing reinforces and improves general problem-solving skills in many situations.

Vavagiakis offers beginners basic skills and knowledge: what a drawing is, how it can function as an idea, how different materials behave in concert with one another. His lectures explain concepts and methods used by historic masters, and he uses books and other visual media to provide examples. Technical demonstrations for the whole class can be compelling, but he finds that interacting with each student one at a time yields the best results. He believes that flexibility is the key to effective teaching.

> I mainly teach students one on one, but I also do group critiques with the whole class. I might demonstrate schematic-drawing methods to an individual working at the easel or to the whole class.

Vavagiakis gives beginners basic organizational skills like page placement, measuring, and proportion. He advises intermediate and advanced students to keep sketchbooks to take to museums and to draw constantly from observation: fleeting moments of everyday life found in streets, parks, and restaurants, images observed while waiting on a subway platform or riding the train.

Vavagiakis describes how he opens each class by warming students up with quick poses:

> The class begins with ten two-minute drawings. It then proceeds with the model taking one pose for the remaining session and rotating that pose every twenty minutes. We do four to six rotations, depending on the allotted time of the class. This lesson plan comes from being a teacher going from student to student; experiencing the pose from 360 degrees. The aim is to fully understand the form in the round and to achieve a clearer understanding of the figure within the context of a space it inhabits. It is like when a sculptor works around the figure by rotating the model stand or when an architect lays out a concept in a plan view with elevations. Just as it is important to the sculptor or architect to understand and feel the total form, the draftsman needs to conceptualize the form in all its aspects in order to effectively construct the figure.

He encourages his students to develop an active silhouette, together with a sense of mass and movement:

> In two-minute poses, the student must fully realize a representation of the essence of the figure. I stress the use of a preliminary system of construction lines to investigate and capture the silhouette, the proportions of the major volume-masses, and their relation to one another in terms of movement and thrust. Learning how to generalize, prioritize, and abbreviate what they behold, students begin to capture the underlying gesture of the figure. Students are taught to exploit their peripheral vision—allowing them to see the subject and the format while minimizing eye movement; exercising one's gaze to navigate rapidly over longer distances helps our empirical concentration for a more accurate description. We start with the whole concept and finish with the whole construction. In the course of two minutes, all the necessary information needed to explain the action of the pose is described. The effect of gravity on positioning anchors the concept in time.

> This system is used continuously throughout the duration of each pose. Twenty-minute poses can effectively be considered to be ten consecutive two-minute drawings, a continual loop of assessing the whole. I emphasize the importance of gravity on the forms of the body while the model is posing. A major challenge for students is dealing with these changes. Just as change is inevitable in life, life-forms are always in motion. In order to successfully execute a drawing of a human being, we have to experience and understand how motion plays on the forms of the human body as we perceive them.

As with shifts in weight and position caused by gravity and time, understanding these forces as they accumulate while we draw a posed model is a process representing yet another kind of movement.

We learn to develop a plan of action based on the knowledge or logical progression of gravity's effect on these forms—for example, starting a drawing by focusing on forms that are more fixed and static before progressing to those forms that exist in a state of flux. By continually assessing the gestalt [the whole] and by understanding the full aspect of forms in space, we are better able to construct an effective representation of life. ∎

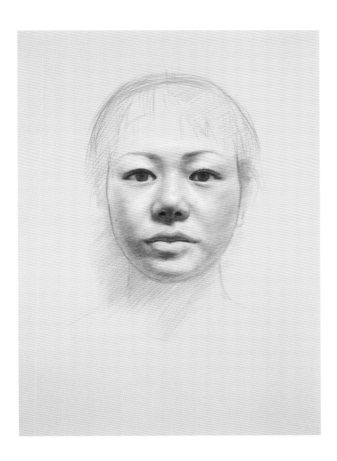

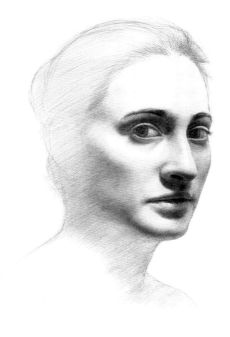

Costa Vavagiakis, *Yuko VII*, 2007, graphite and white chalk on paper, 16 x 11½ inches. Private collection.

Costa Vavagiakis, *Rainbow XII*, 2005, graphite on paper, 12 x 9½ inches. Private collection.

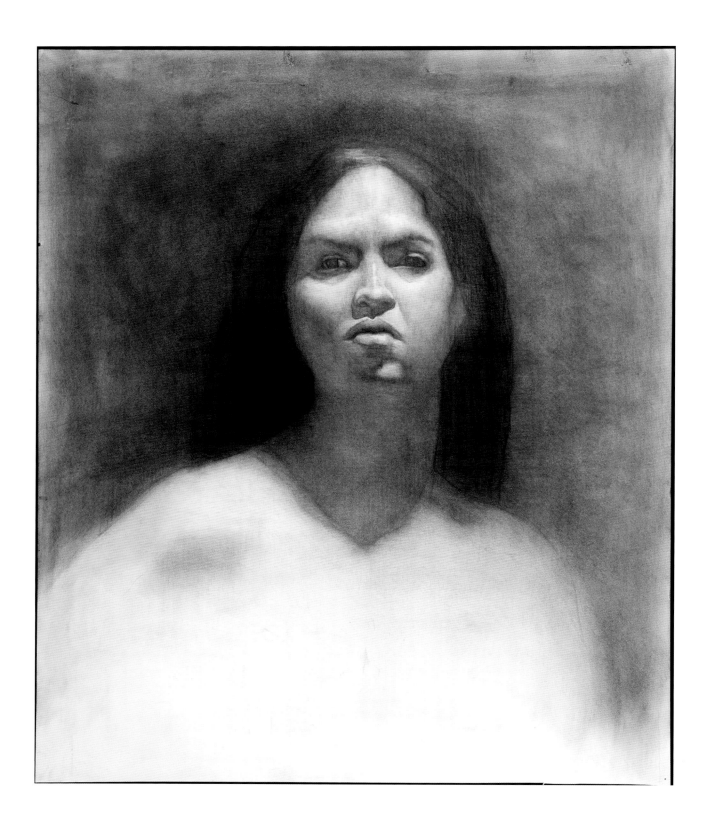

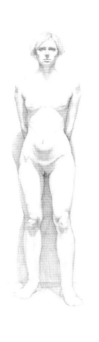

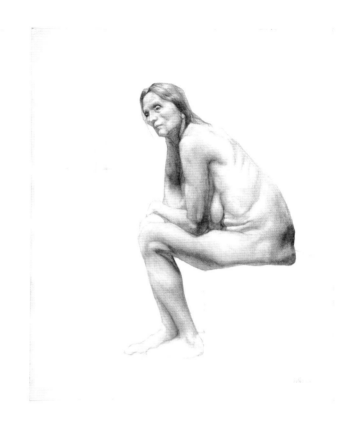

OPPOSITE PAGE
Marcelo P. Pittari, *Latin 200*, 2007, graphite on paper, 24 x 19 inches. Student of Costa Vavagiakis.

ABOVE
Satoshi Okada, *Camille*, 2009, graphite on paper, 24 x 18 inches. Student of Costa Vavagiakis.

ABOVE RIGHT
Marcelo P. Pittari, *Tiempo*, 2007, graphite on paper, 24 x 19 inches. Student of Costa Vavagiakis.

RIGHT
Vania Milan, *Tyrone*, 2007, graphite on paper, 21 ½ x 18 inches. Student of Costa Vavagiakis.

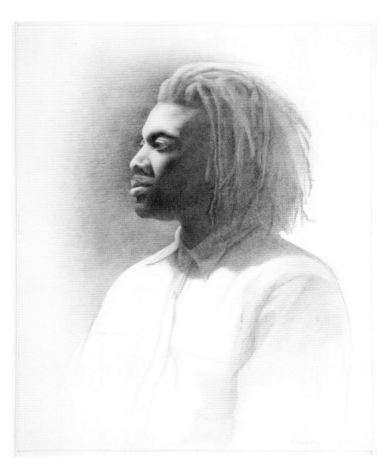

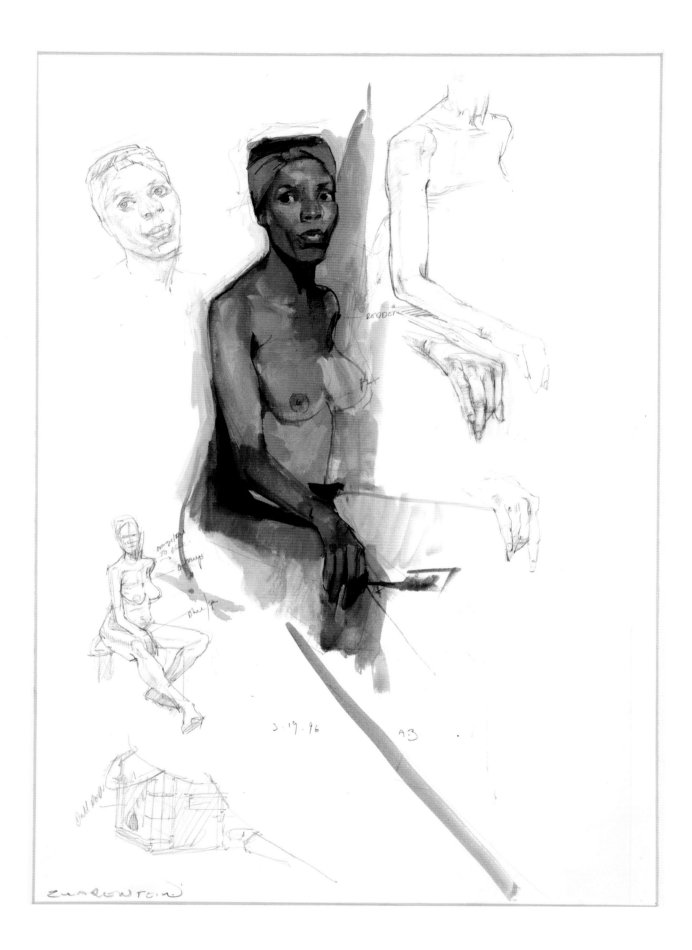

ALEX ZWARENSTEIN

ALEX ZWARENSTEIN WAS BORN IN SOUTHERN RHODESIA (now Zimbabwe) in 1952. He received a master's degree in painting from the Royal Academy of Arts in London, where he was the recipient of the William Turner Travel Scholarship. He has taught in London at the Harrow College of Art and in New York City at the Fashion Institute of Technology and the National Academy of Design. At the Art Students League of New York he teaches drawing with an emphasis on perspective.

Zwarenstein works in various media, including oil, gouache, and watercolor, to explore subjects that range from intimate figurative studies to urban landscapes. His city scenes employ a bold, yet refined sense of geometry rooted in his commitment to drawing:

> Drawing is a fundamental tool in . . . visual thinking. . . . It trains the eye to interpret the world as we see it into two dimensions. . . . Drawing is the primary means by which the artist thinks about spatial organization and design.

Anchored in his rigorous approach to perspective and organization, his paintings achieve a boldness and luminosity via painstaking glazing and impasto—old-master methods that confront contemporary issues by enlisting time-honored tools to tackle new tasks.

ALEX ZWARENSTEIN ON DRAWING

I use drawing as a descriptive tool to capture any scene that I might find interesting or compelling. Often these drawings or elements of drawings find their way into my paintings. Drawing is a fundamental tool in the process of visual thinking; as a skill set it trains the eye to interpret the world as we see it into two dimensions, while still giving the illusion of three. Drawing is the primary means by which the artist thinks about spatial organization and design. It is how one indicates planes and surfaces to model form, locate depth of field, establish a point of view (perspective), and create light, shadow, and chiaroscuro.

Drawings can be fascinating as works of art in and of themselves or as working drawings, a means of making visual notes from which paintings might develop. Finally, there is the element of serendipity—the ability to surprise oneself with unexpected relationships between form and subject matter that go unrecognized until they are visualized through the process of drawing.

My training prepared me to be an observational painter, but at the same time I have always found visceral satisfaction in looking especially for shape, geometry, and the design of a given scene or subject. My recent compositions involve figures drawn from memory in imagined and highly designed environments; I use rigorous

OPPOSITE PAGE
Alex Zwarenstein, *Model with a Blue Head Band*, 1996, gouache and graphite on watercolor paper, 14 x 12 inches.

perspective to set the stylized figures into a cohesive, three-dimensional space as the setting for a heightened psychological and atmospheric scene.

ON PROFESSIONAL TRAINING

For students who intend to become professional artists, I approach the task of teaching perspective in two ways. First, I address the basic principles of geometry as a matter of theory, explain the strategies involved in their application, and follow up by having them produce diagrams. The second thing I do is explain how these theories and methods work in observational drawing. Returning to the first step—students practice drawing diagrams as if they were creating three-dimensional abstractions based on repeating simple forms such as rectangular prisms, cubes, and ellipses; they then rotate these forms in different directions as they go about designing the page. The process is repeated with all the required geometric forms until the student feels comfortable with one-point, two-point, and three-point perspective systems.

When students become proficient in these tasks, I show them more complex geometric models that will allow them to build architecture—stairs, inclining and declining planes—and also to relate figures to one another and to their environment. To drive the point home and reinforce student understanding, I like to have them revisit at timely intervals the basic principles of perspective—assuring that as they make progress they will continue to relate complex strategies with basic ones, taking note of their reciprocity.

In the second stage of the course, I teach students how these perspective skills apply to objective drawing. I try to emphasize that when drawing and painting from life, the process is all about empirical observation, that it is not primarily about the mechanics of perspective. One can, however, use perspective to inform and check the drawing. A successful drawing is always done first by drawing intuitively; only later does the artist employ perspective strategies where necessary.

ON PERSONAL ENRICHMENT

I approach amateurs and general audiences in the same way as I approach professionals. The amount of instruction any individual can absorb—or the progress they make—can depend as much on time constraints as on whatever innate drawing ability the person might possess.

Since I always start with the fundamental principles, my aim is to bring students to a comfort level. If they learn nothing else after that, at least they will understand what they need to practice in order to expand their knowledge base.

AN ASSIGNMENT

A common assignment I might give would be to draw the interior of a room. Often it will be the studio in which we are working. I encourage students to draw intuitively at first, as they would normally do. As they perform this task, I encourage them to pause

and take measurements using a process known as "point relationship," which gauges proportions, such as the width to the height of an object by means of setting coordinates on the picture plane. Once a reasonably accurate drawing has been achieved by eye, a horizon line and vanishing point can be established at the intersection of two receding lines drawn from a foreground object that connects to a background object. The most obvious variable that I have come to expect as a teacher is a disparity of ability—either natural or learned—between different students in the same class. Some drawings will be naturally more accurate than others. However, whether the drawing is accurate or not (it will have only anecdotal reference to the subject at hand once perspective is applied), it will read as a convincing three-dimensional rendering, with spatial depth and veracity.

After learning how to use the fundamentals of perspective drawing, students report to me that for them it is an "eye opener." They see perspective everywhere they look—on the street, in paintings they only thought they knew. This all plays out in the drawing they do in their own sketchbooks and in how they think about composition. When they go to museums to look at pictures, knowledge of perspective adds another level to their enjoyment, allowing them to see what others have done and how they went about doing it. My own thorough training as a tonal painter leads me to enjoy the process of teaching all aspects of drawing, painting, and picture-making: light, design, line, form . . . and, of course, perspective. ∎

Alex Zwarenstein,
Townscape: Demo, 2008,
graphite on paper,
20 x 20 inches.

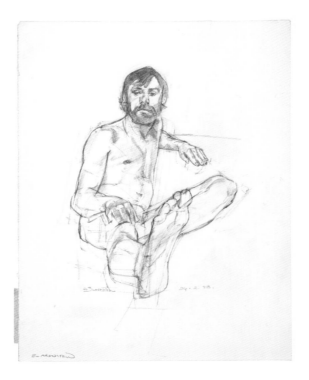

ABOVE
Alex Zwarenstein,
*Students Drawing at the
League*, 2006, graphite
on paper, 16 x 36 inches.

LEFT
Alex Zwarenstein,
*Male Figure: Forced
Perspective*, 1983,
graphite on paper,
17 x 14 inches.

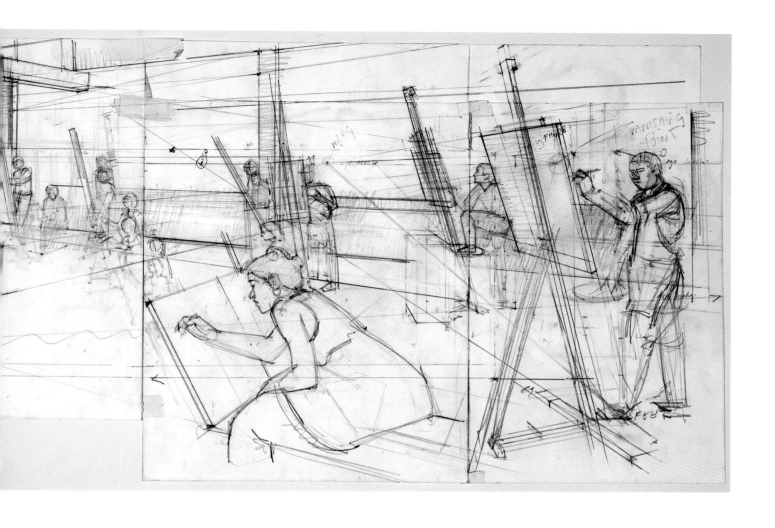

Alex Zwarenstein,
Figures at the Beach,
2005, graphite on paper,
17 x 32 inches.

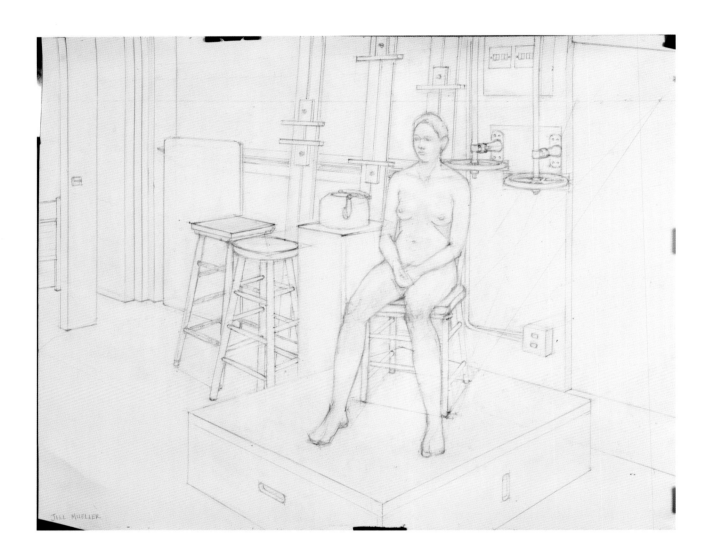

Jill Mueller, *Figure in the Studio*, 2007, graphite on paper, 17 x 24 inches. Student of Alex Zwarenstein.

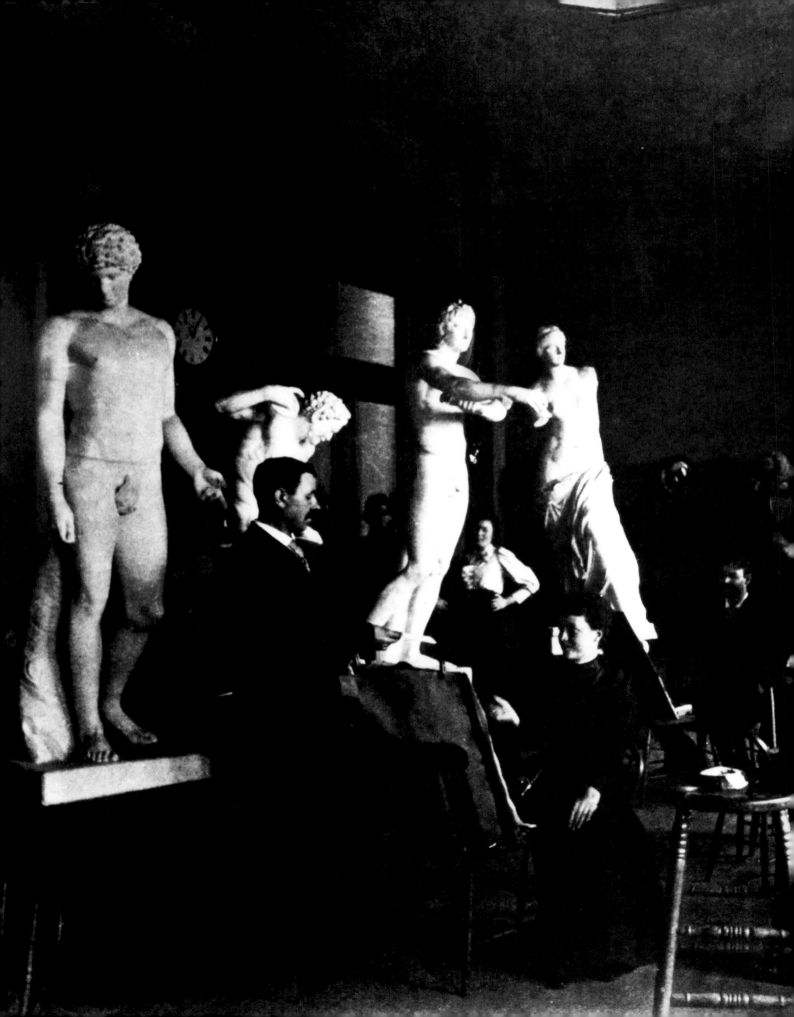

Drawing Concepts and Lesson Plans

An Illustrated
Outline for
Teachers and
Students

Female students draw plaster-cast
reproductions of classical statuary in Frank
Dumond's antique class at the Art Students
League of New York, c. 1892.

ANYONE WHO TEACHES DRAWING needs a plan. The best teachers never follow one textbook but instead use many in order to develop their own individual approach. If great drawing teachers from the nineteenth century and earlier were as distinctive in their teaching styles as teachers of subsequent generations, teachers during the late twentieth century were influenced by their mentors as much as they were motivated to break away from them. Drawing instructors at the Art Students League of New York today may be divided by style, but they are united in their commitment to serious instruction. Most will agree that making a drawing is less important than being able to see what we behold. Some favor an intuitive approach via gestural mark-making, while others promote analytical methods stressing measurement, proportion, and perspective. Arriving at the best result requires blending intuitive responses with analytical decisions in combinations as numerous as the people who employ them.

A century and a half ago, before art students enrolled in drawing academies—where they learned by working first from plaster casts and later from live models—most had received basic training in drawing and penmanship as part of a general education. Manuals compiled by Rembrandt Peale, John Gadsby Chapman, John Ruskin, and others supported this teaching both in the schoolroom and at home. Starting in the early twentieth century, art educators abandoned academic specialization in favor of programs, typified by the Bauhaus, that integrated fine arts training with the applied arts and architecture. The kind of basic instruction that previously occurred in a general education became the basis for the first-year foundation mandated for declared art students entering four-year degree programs.

By the late twentieth century, pre-college education had gradually done away with old-fashioned rigor in favor of more informal instruction that promoted awareness, expression, and creativity. Today studio classes in many colleges and universities have drifted toward theory. After more than fifty years as part of the liberal arts environment, studio training has become a liberal arts hybrid. In other art schools, colleges, and universities, rigor is being restored one department at a time—in a return to the practice of teaching logical, integrated, and progressive curricula.

The current revival of interest in freehand (analog) drawing is a predictable response to the deluge of new images available in print and on film, television, and the Internet. It echoes other moments in history: when movable type and the printing press allowed the Renaissance to be broadcast across the European world, and when photography, industrial publishing, and chromolithography energized the mid-nineteenth century.

Teachers sometimes neglect the fundamentals or present them in haste to students whose hunger for expression outstrips their felt need for visual literacy. It might be said that everyone teaches drawing from some kind of bias, with the caveat that the basic language of drawing transcends technique and ideology. Anyone must first master the forms and grammar of this language before embracing a particular style or philosophy. Expression follows mastery. Solid grounding in drawing fundamentals intensifies visual awareness and refines perceptual ability. The following sequence of general drawing concepts—offered not as a course, but as a source of ideas—is presented in the form of an expanded glossary that a student can use to learn basic drawing concepts or an instructor can consult in building lesson plans.

Many of these concepts are explored in greater detail in books devoted to specialized subjects such as anatomy and perspective. This book presents these topics in an ascending order, beginning with the simplest and proceeding to the more complex. The reader is encouraged to use this progression of ideas to learn about, study, and teach drawing. Successful teachers never stop learning. They inspire students to follow their example by continuing to study ways to comprehend what they behold. ∎

DRAWING AND DESIGN

THE FRENCH WORD FOR DRAWING is *dessin*. In Italian, it is *disegno* (where it also means "design"), while *segnare* means "to point, to indicate, or make a mark"— similar to the English *signal*, or *assign*. Thus *drawing* and *assignment* are two words sharing a common root. Drawing is the process by which visual ideas are given, or *assigned*, value. Joining one word to the other gives each greater force and purpose. A similar pairing of *drawing* and *design* may suggest different outcomes and represent the same process of visualization. *Drawing* implies a quest for meaning beyond project planning. One *draws* water from wells, blood from veins, and inspiration from visual experience.

1. Basic Advice

Instructional writing is full of maxims and admonitions. American artist John Sloan paraphrased Thomas Edison's remark about genius when he said that art is 1 percent inspiration and 99 percent perspiration. Chapman promised anyone who knows how to write an easier path to drawing. Teachers need to refine their own pedagogical rhetoric to attach memory-markers to concepts they want students to remember. It is always amazing to encounter students with prior training who never got basic advice like how to set up a bench or an easel; how to hold a pencil; when to erase; how to address an object, face, or figure they are trying to draw; or how to use their body in drawing. Here are a few examples:

Place yourself so that you address both the source object and the page from a single, fixed position. If you are right-handed, set your easel to your left. If you are left-handed, place your easel to your right. Limiting body movement allows you to maintain a single point of view.

Fully extend your arm while measuring, and if you are standing at an easel, never stand closer to the page than an arm's length; always keep the full page in view. If you are sitting at a bench, try to maintain a similar distance from the work surface, and set the bench at an angle to the left or right of your line of vision, depending on which hand you use to draw.

Hold the pencil not as you do when you write. Grip it with the thumb and index finger so that the pencil is suspended beneath your hand at an angle. Start a drawing by holding the end of the pencil that is farthest from the point in order to

make very faint lines. Holding the pencil closer to the point will produce darker lines. Try to begin drawing with lighter lines, then finish with darker ones.

Never erase errors before you make corrections. Mistakes removed too early are usually repeated. Draw over whatever it is that needs to be modified. Only when you have achieved the desired results—never before—can you safely remove the preceding attempts.

A few other essential principles to keep in mind: Critiques are equal in importance to methods. Drawing is the act of seeing made manifest; learning how to read a drawing is part of that process. Art is something begun by the artist and completed by the viewer.

2. Drawing a Straight Line

Although nothing could be simpler, people readily confess—without shame or fear of reproach—that they are unable to draw a straight line. Some proclaim it as a mark of normalcy. Lazy teachers let students draw straight lines with rulers. While straight-edge tools promise consistent results, they limit students to a process that requires them to remove a ruler to see any line they make. Rulers, drafting triangles, compasses, and CADD software are good for production and bad for designing; such tools get in the way of fluid, responsive thinking, imaging, and drawing.

VERTICAL STRAIGHT LINES
Gravity makes verticals easier to draw than horizontals. Hold the pencil in the palm of your hand between your thumb and forefinger. Make two points on the page, one a few inches above the other. Lock your wrist and extend your arm with the elbow slightly bent; placing the tip of the pencil on the topmost point, gently drop it to the

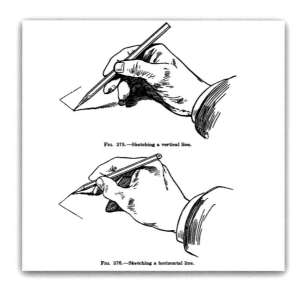

Fig. 375.—Sketching a vertical line.

Fig. 376.—Sketching a horizontal line.

This illustration from *A Manual of Engineering Drawing for Students and Draftsmen*, by Thomas E. French, published in 1911, demonstrates two ways to hold a pencil when drawing straight horizontal or vertical lines.

lower point. Take care to regulate lateral deviations; learn how to let your arm fall directly from one point to the other. Practice this exercise. Gradually increase the distance between the top and bottom points as you become more proficient. Master verticals before you attempt to draw horizontals.

HORIZONTAL STRAIGHT LINES

Horizontal lines present more difficulty because you are fighting gravity and your own body. As with the vertical exercise, make two points on the page; this time one should be a few inches to the left or right of the other. Connect them. It will be easier if you hold the pencil vertically at a right angle to the direction of the line you wish to draw. As you become more proficient, place the points farther apart and connect them. Those using the right hand will notice that the line tends to fall off to the right; for left-handers it will fall to the left. This is caused by two factors. First, the arm behaves a like compass; it is built to make curved lines. The second factor is gravity. To make a straight, freehand horizontal line you need to push upward as you extend the line. Because the movement is unnatural you will feel it in your arm; you will also remember it there as a muscle memory, like casting a trout fly, hitting a baseball, or wielding a tennis racket. Anyone can learn to draw a straight line.

3. Frames of Reference: Seeing the Page

A blank page is never an empty space. The first thing a draftsman sees when looking at a new sheet of paper is not just a pressed, desiccated mélange of plant material. A page has shape, direction, and proportions. The four edges are lines in the drawing, as are the vertical and the horizontal directions. The first mark that lands on a rectangle is the seventh visible line in the drawing.

4. Law of Quadrants

Rectangles can be divided into quadrants by drawing lines from the top left corner to the bottom right corner and from the top right corner to the bottom left corner. The lines intersect at the center of the rectangle. To create four quadrants, draw lines vertically and horizontally through the center point. (See bold orange perpendicular lines in drawing on opposite page.) The horizontal and vertical lines divide the page into four quadrants that repeat the proportions of the mother rectangle. If the quadrants are subdivided in similar fashion, the resulting subquadrants maintain the same proportions as the mother rectangle—as will further subdivisions.

5. Law of Thirds

Another concept frequently taught in composition (and often used as a shortcut for composing photographs) is the so-called Law or Rule of Thirds. To apply the Law of Thirds to a composition, you begin by locating four points with a viewfinder or frame, spaced at equal distances of one third of the width and height of the frame. These four points offer alternate sighting targets to the bull's-eye crosshair division of the frame into quadrants. Asymmetry moves the subject slightly off center, making the composition more dynamic. In order to divide a rectangle into thirds, first divide it into quadrants, as instructed in entry 4. Then draw lines—two horizontal and two vertical—that divide the same rectangle into nine equal rectangles, like a tick-tack-toe board (see drawing below). If done properly, each of the nine rectangles will possess the same height-width ratio—the same proportion—as the four quadrant rectangles created by dividing the mother rectangle into quadrants. Note how intersections between quadrants and thirds recur along the diagonal lines. Quadrants and thirds form the hidden armature of any rectangle regardless of its height-width ratio. They represent the lively interface between the reciprocal principles of symmetry and asymmetry, balance and movement. Grasping these concepts and how they coincide is the first step toward unlocking the secrets of pictorial composition.

A page divided according to the Law of Quadrants and the Law of Thirds. James McElhinney, *Mini-lecture Demo Drawing: Law of Quadrants and Thirds*, 2009, charcoal and Conté crayon on newsprint, 24 x 18 inches.

6. Intersections and Reciprocity

Thirds and quadrants are reciprocating systems for dividing a rectangle. Each of the four points created by dividing the rectangle into thirds rests in one of the quadrants, becoming one of a new set of four points representing a further division of each quadrant into thirds, and so on. Like proportions repeated by subdivided quadrants, each of the four points in each quadrant divided into thirds will occupy the opposite position in a new set of four in new quadrant subdivisions. Quadrants are used to help the draftsman project his or her idea onto the page with effectiveness, in the same way that the Law of Thirds creates four points meant to deflect attention away from the center of the frame.

The rule of thumb for a successful drawing is that it finds interesting ways to both fit the page and fill the page. Drawings that are centered are less exciting than those that play off the edges. If you take several drawings made without quadrants and plot quadrants over them, you will notice that the more exciting drawings engage each quadrant in a different way, while the less successful drawings tend to leave one or two quadrants on the sidelines or engage all quadrants in the same way. Explaining the principles of quadrants and thirds to students reveals to them the anatomy of an empty page and demonstrates that a blank page is never an empty space. One line drawn on a page is a composition. The way in which a drawing uses the whole page determines its success.

7. Golden Section and Golden Rectangle

The Golden Section, also known as the Divine or Golden Ratio, played a potent role in sacred geometry. It was known to the ancient Greeks and Romans, who used a rectangular form based on the ratio—the Golden Rectangle—as a proportional template in art and architecture and in planning public spaces.

The Golden Section is based on a numerical progression known as the Fibonacci sequence, named for the medieval Italian mathematician who first identified it. In the Fibonacci sequence—0, 1, 2, 3, 5, 8, 13, 21, 34, 55, 89, 144, et cetera—each consecutive number is arrived at by adding together the previous two. Mapping this proportion creates a curve similar to that found in endless formations and growth patterns in nature: the spiral cross section of a chambered Nautilus shell, a whirlpool, crystalline formations, spider webs, tree rings, the rotation of galaxies, to name just a few. Some believe the sequence is the key to nature's secret toolbox.

Long debated, like the origins and meaning of Stonehenge and other ancient mysteries, the Golden Section has acquired almost cult status. More prosaic models

like quadrants and thirds are equally rooted in antiquity but operate more simply and thus have wider utility. The Golden Rectangle was regarded for many years simply as a visually pleasing construct identified with classical antiquity; today it is regaining a certain cultural authority.

A Golden Rectangle is constructed by first drawing a square and then extending a horizontal line in a lateral direction from the mid-point of the square, past its lower right-hand corner at a distance equal to the length of a diagonal drawn from the center point of the bottom edge of the square to its top right-hand corner. The top edge of the square is extended to the same distance and then connected to the bottom edge by a vertical line. This maneuver creates a new rectangle with a proportion of 1:1.618. When the rectangle is divided by a square, the remainder retains the same proportions as the mother rectangle.

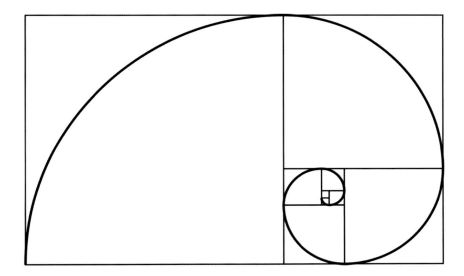

A Golden Rectangle divided by squares/arcs to form a progressive spiral, as a visual model of the Fibonacci sequence.

8. Plane

Geometry defines a plane as an infinite number of points moving in two directions. Like lines, planes do not occur in nature, but they give us a conceptual model for understanding things that do. Also like lines, planes divide space; they describe perhaps how the surface of a volume presents a kind of flatness or how a one-dimensional realm vibrates with another. Planes can exist in solid form, such as a tabletop, or as an atmospheric condition in which, say, warm air is divided from cold air. The flat surface of a page locates the picture plane, a membrane through which the viewer enters the virtual reality of a drawing.

9. Picture Plane

Apart from the properties of rectangles and other containment shapes, the picture plane is the most basic concept in pictorial organization. In a representational image, the picture plane is a transparent surface set at a right angle to the viewing direction, between the viewing point and the object(s) being observed. A famous engraving by Albrecht Dürer [below] shows an artist sketching a posed nude through a grid stretched across a wooden frame that locates the picture plane. Thomas Eakins uses the example of a sheet of glass within a frame to illustrate the concept.

In abstract paintings with nonillusionistic spaces, the picture plane represents the only tangible interface with the physical world outside the frame. The concept of the picture plane gained popularity during the rise of abstract art in the twentieth century, which also witnessed the incorporation of new media and criteria for making and understanding art. Abandoning the logic of perspective demanded new concepts and rhetoric to describe how space behaves in works of art. In many ways, the concept of the picture plane is based in the rise of photography and cinema as art forms in which images are not constructed but projected. It articulated for analog practitioners a graphic, manual equivalent to the photo-optical focal plane, establishing common ground between traditional studio disciplines and the new image-capture media. Piet Mondrian, Hans Hofmann, and Kenneth Noland in very different ways all sought to create depth and relief in front and behind the picture surface without a foreground, middle distance, background, line-point perspective, or the optical rendering of recognizable objects, measuring them instead against the picture plane.

Lecturing at Skowhegan School of Art in 1973, the late sculptor Philip Pavia characterized the heyday of abstract expressionism as a time when rising stars talked about finding a "new space" in their pictures. Picture plane was branded jargon in the new lexicon, despite the concept having roots in Renaissance drawing practice, where it represented the "window" surface that marks the forward limit of a deep picture space.

Albrecht Dürer, *Artist Drawing a Nude Woman Using a Perspective-Plotting Device*, c. 1525, woodcut on paper.

10. Composition

Composition—the first thing students grasp and the last thing they master—is the most individual quality found in anyone's artwork. Other signifiers like touch, technique, and style evolve and are thus subject to constant change. How someone manipulates space is far more personal. Using quadrants and thirds is the first step toward rectangular composition. When students consistently demonstrate that they consider the fundamental compositional realities of the page—its quadrants and thirds—they will be ready for more complex tasks. Ninety-nine percent of the errors in any completed drawing occur during the first 1 percent of the process. The way a drawing begins is the first thing a student must comprehend. Successful results require discipline—staying with an idea and seeing it through. Leapfrogging the process is self-defeating.

11. Graphic Language

Drawings are construction projects built with points, marks, lines, and shapes. Drawing and writing are historical twins, deeply related in process and function. Both encode and communicate messages and ideas in graphic form. Expressive "mark-making" and other forms of inchoate personal scribbling by seasoned professionals disregard convention such as horizon lines or canonical proportion in favor of expressive or critical value. Seldom are such endeavors successful for foundation or intermediate-level students. At the same time, encouraging beginners to focus on processes such as gesture-drawing can improve their performance over the long haul. Drawing logic and drawing expression are reciprocal conditions that rely on the same sensory judgment of pressure, touch, speed, direction, and media. Rectangles possess an armature, a spatial geography through which drawing elements are directed and organized into a cohesive, readable statement.

12. Point

The armature of the rectangle provides us with landmarks and a roadmap to get us anywhere within the page. Any position in space is expressed as a point, which is not a physical thing like a dot or a mark. A point denotes such specific locations in space as the corners of the page, the center point that appears when the page is divided into quadrants, or the four interstices created when we divide the rectangle into thirds. The point is a mapping device that can locate the extremities of an invented shape like a constellation or an object being drawn from observation.

13. Marks

Drawings can be made on anything that will accept a mark. Anything that leaves the path of an instrument is a mark: a brush, a *fusain* (charcoal crayon), a pencil, a Conté crayon, a reed pen, a digital stylus, or the tip of Zorro's sword. Effective mark-making depends on the materials used and the person using them. A 6H pencil will never replicate the effect of compressed charcoal; a brush wielding black ink will never produce the same result as a quill pen.

Making a mark is how a drawing idea is made visible using a physical technique. But drawing itself is not a technique, nor is it driven by technique. Choosing methods appropriate to the goals of a drawing may inform a drawing, but clarity of concept and expression defines it. The manipulation of materials carries the message, via the speed of a gesture, the density of applied materials, the sense of touch and pressure, direction, and the length of a sustained mark. One useful exercise inspired by *The Mustard Seed Garden Manual of Painting*, a seventeenth-century handbook of Chinese painting, is to have students cover two or three large pages with as many different marks as they can invent, with all the materials at their disposal. Another is for each student to take several fresh pages, divided into grids of sixteen rectangles by subdividing quadrants, and create a catalog of as many different marks as they can find in their previous drawings. It is a difficult task. Most students repeat a small repertoire of habitual marks and depend instead on different materials to provide variation. Repeat the assignment, raising the bar by restricting students to a single material.

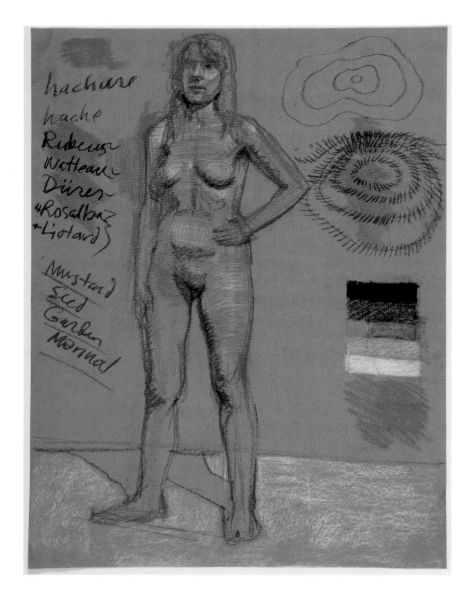

14. Line

High-school geometry defines a line as the shortest distance between two points. In drawing, a line can also function as a direction describing the path of any movement or static alignment, such as a plumb line (see entry 18) or a horizon. A line does not exist in nature per se. It must not be confused with an edge, a crack, or the surface of a volume retreating from our gaze. A drawn line is a mark that expresses a vibration between one space and another: it can race, dawdle, break, deviate, shudder, unravel, or strike with the force of a tactical missile. It can be taut like a bowstring or float like a length of monofilament used to cast a trout fly. In drawing, a line is an intelligent mark.

15. Proportion

Proportion measures the relative differences and similarities between diverse objects, different parts of the same object, and the same objects as seen from variable distances. In the most abstract sense, the concept proportion is fundamental to descriptive drawing. Every drawing, regardless of style, measures space and movement, if only within the confines of the page. Canonical systems of proportion set forth standard formulae that are used to shape images and written symbols, such as Roman, Greek, and Cyrillic letters, Egyptian hieroglyphics, and Chinese characters. Proportions inform how we recognize something as what it is—not always as it truly is, but the manner in which it exists as an ideal form. Alchemy, numerology, and astrology are superstitious realms of quasi-science rooted in prehistoric animism; they are systems of belief that locate mysterious powers in sacred geometries and living objects. As a visible expression of divinity, the human body was considered to be sacred, and it was divided into four humors regulating powers generated by the heart: liver, belly, brain, and genitals. Good health was preserved by balancing these powers in a salubrious ratio, in proportion. Not all of this is humbug. Empiricism did lead to some durable truths, while it preserved certain mysteries like the Golden Section (see entry 7).

16. Figure and Ground: Positive and Negative Space

A *figure* might be anything containing space: the silhouette of a human form, an object, an abstract shape. *Ground* is the space around or behind the figure that is bordered by the edges of the page. In representational drawing, ground is casually denoted as

background: the space behind a figure or an object. In an abstract context, it might be denoted as *negative space*: the space between a dominant shape and the edges of a page, or between one object and another. The notion of background has a representational bias that allows students to overlook the design function of negative space in favor of more literal readings of one form over or in front of another. Understanding that the concepts of physical space (background) and abstraction (negative space) are always reciprocal is essential to drawing effectively. One might look at a line as something static—like painted center lines on roads—or like an arrow flying toward its target. One can regard a line on a page as the simple division of space or as the vibration between two spaces. The figure-to-ground relationship embodies another pairing of reciprocal, interdependent opposites that define and reflect one another.

17. Shape to Volume

Moving from two to three dimensions on a flat surface requires more than sleight of hand and a dandy technique. Just as the concept of background distracts students from seeing lateral events on a two-dimensional plane, shapes that produce a satisfactory result can get in the way of seeing plastic—or three-dimensional—events in space. A cube is a square that has been projected in a perpendicular direction by a distance equal to one of its edges. A cylinder is a circle projected in any perpendicular direction. A sphere is a circle rotated 360 degrees on its axis. The difference between a flat shape and a three-dimensional volume is that volume implies movement. A cube represents the movement between its three pairs of opposite sides; a cylinder represents the movement between facing end circles and the rotation of the tube that divides them.

Simple ways of representing these concepts are de rigueur in most foundational drawing programs. Freehand orthographic drawing, sometimes denoted as axonometric or paraline (parallel line) drawing (see entry 21), portrays geometric solids transparently. Students are directed to consider the space within and around the volumes, including the surface on which they are placed. Drawing abstract volumes in concept drawings rehearses students before they apply the same principles to real objects: at first when drawing things like vessels, geometric objects, and architecture, and later when examining organic forms like plants, seashells, animal skulls, and eventually the human figure.

Lines do not exist in nature and thus are best suited to depicting ideas. Tonality interprets retinal experience and is thus more suited to sensory expression. Drawing from observation—transparently, with line, to represent volume—makes visible what we know; it is how we comprehend the internal logic of what we behold. Students who color in the model's hair or insert shadows for effect do not grasp these distinctions. Drawing is a language. Line is one of its many dialects.

FIG. 235.—Revolution to isometric position.

ABOVE

A cube represents the movement between its three pairs of opposite sides, as seen in this axonometric drawing from *A Manual of Engineering Drawing for Students and Draftsmen*, by Thomas E. French.

LEFT

One can regard a line on a page as the simple division of space or as the vibration between two spaces. This drawing incorporates the Laws of Quadrants and Thirds as well as demonstrating balance and asymmetry in basic composition. James McElhinney, *Mini-lecture Demo Drawing: Law of Quadrants and Thirds, Balance and Asymmetry*, 2009, charcoal and Conté crayon on newsprint, 24 x 18 inches.

18. Page Placement: Plumb Lines, Metes and Bounds, Gesture Drawing, Drawing from the Inside Out

Taking a standing figure or any irregular shape for a starting point, we can use four simple methods to position our idea on the page to best effect: plumb lines, metes and bounds (directions and distances), gesture and action drawing, and drawing from the inside out.

PLUMB LINES

Plomb is the French word for lead. A plumb line is usually a twisted, multi-ply cord weighted with a plumb bob (a conical metal bobbin); the weight of the plumb bob is drawn by gravity to point toward the earth's core. Plumb lines are used in masonry and carpentry to determine true verticals at construction sites, as well as in surveying to accurately position instruments. To position a standing figure onto the page, first locate the topmost extremity of the figure and then the lowest, running a plumb line or vertical through each, from the top of the page to the bottom. In the absence of a cord and a plumb bob, simply extend your arm in a locked position, hold your pencil vertically, and line it up against any vertical in the room. Without changing the position of your arm, rotate the alignment in front of the page and draw the vertical. A plumb line locates an axis within the figure that echoes the vertical edges of the page. The direction of the figure or shape suggests the placement of the rectangular page in a vertical or horizontal position. It is never an arbitrary decision.

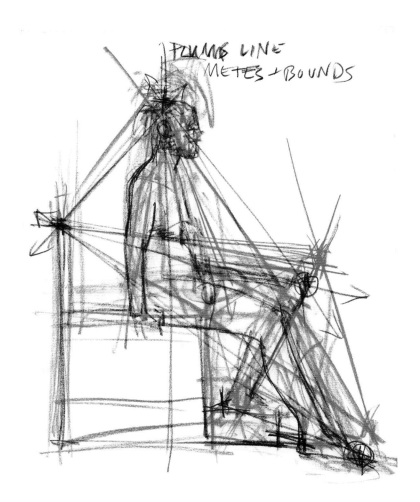

Use plumb lines to map each extremity to fit and fill a figure on the page, like stars in a constellation. James McElhinney, *Mini-lecture Demo Drawing: Plumb Lines, Metes and Bounds*, 2009, charcoal and Conté crayon on newsprint, 24 x 18 inches.

METES AND BOUNDS (DIRECTIONS AND DISTANCES)

Next, locate the remaining extremities of the pose—plus any erratic angles like elbows, shoulders, and knees. Using the plumb line in the same way a surveyor uses a baseline, we can plot angles from the ends of our baselines to the extremities. The result is a series of overlapping triangles that looks nothing like the model, but accurately locates the figure within the page in a similar way to metes and bounds, a method used in historic topographical land surveys. Page positioning with angles and distances must be carefully considered and the drawing must not proceed until each extremity has been mapped, like stars in a constellation, both fitting the page and filling it.

Many students automatically try to put the middle of an object or shape they are drawing in the middle of the page but fail for two reasons. The first is that they mistake the center of a dominant element of a shape or figure for the center of the whole form. (For instance a student drawing a standing figure with one arm extended to one side might locate the torso [dominant form] in the middle of a page because they assume the navel to be the center of the body, where in fact the center of the *pose* is probably slightly outward from the shoulder.) The second is that they neglect to relate the silhouette of the object to the edges of the page. Centering expresses a desire for balance that is seldom achieved.

Mark the top, bottom, left, and right of the object you are drawing; drop verticals through the left and right extremities, and extend horizontals through the top and bottom until they intersect, forming a rectangle. Draw a line between opposite corners. The point where they cross is the object's *true center.* In objects and figures that stretch out in an eccentric direction, the true center is frequently regarded mistakenly as an appendage and not understood correctly as an extension of the whole form.

Next draw a vertical through the true center. If you are working on a horizontal format, draw a horizontal through the center point. Determine which side of the form is the most active and varied and which is the least. Move the least active side closer to the edge of the page it faces. The more active side will activate the negative space it faces.

GESTURE AND ACTION DRAWING

Sigmund Abeles discusses gesture and action drawing earlier in this book. The origins of gesture drawing are as ancient as cursive writing forms; it is a mode of visual abbreviation that allows artists to create and review a large number of images in a short amount of time or to capture fleeting movements of people, animals, and nature in motion. Lines can move violently around a page like snakes trying to escape from a box or move gently like leaves falling to earth. Michelangelo, Rubens, Rodin, and Klimt produced thousands of rapidly executed drawings, many of which survive. Gesture drawing—*croquis,* in French—promotes an intuitive response to what is observed; it is favored by teachers who regard conscious, analytical page placement methods as daunting to beginners.

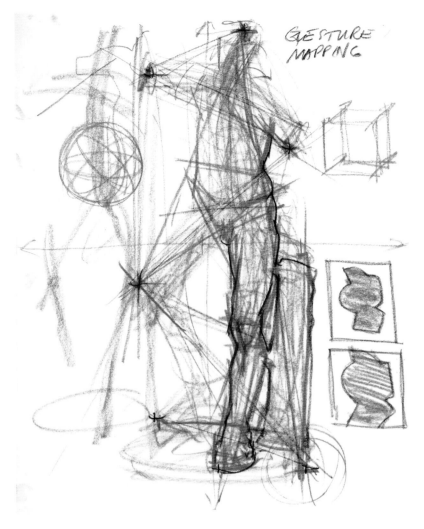

GESTURE
MAPPING

Gesture drawings begin when the artist fills the page with a single animated line describing the whole figure—not in appearance, but in terms of motion. Outlines are forbidden at first. Everything must be focused into a single, rushing mark. Every teacher develops his or her own exercises. Kimon Nicolaïdes, who taught at the League in the 1920s and 1930s, wrote a book that has been a standard text in American art programs for seventy years; *The Natural Way to Draw* describes rapid-fire drills for speed drawing with continuous contours and blind contours and using the opposite hand. Gesture drawings are like sand paintings; scornful of permanence, they are seldom made to survive.

DRAWING FROM THE INSIDE OUT

Students must avoid copying outlines —flat contours—and build the volume of a subject from the "inside out." They must use plumb lines and constellations; they must locate directions

James McElhinney, *Mini-lecture Demo Drawing: Page Placement, Gesture, and Mapping of Antique Plaster Cast of Dancing Faun,* 2009, charcoal and Conté crayon on newsprint, 24 x 18 inches.

expressed by gesture, weight, tension, torsion, twist, and spin. Volume and mass are achieved by wrapping gestural lines around a directional axis. The best results come about from blending the analytical approach (plumb line, metes and bounds) with an intuitive (gesture or action-drawing) approach—another pairing of opposites: rational problem-solving with responsive expressiveness. Gesture drawings celebrate the power of process.

A single line speeds across the entire page to express the essence of the figure, object, or form being drawn. Students are told to not think, but just to do. Drawing is not copying. You look at something or imagine something and propose a visual idea as a line, motivated by the observed or imagined object in response to the direction and edges of the blank page. Subsequent lines and gestures respond to every prior linear gesture. When you are working with tonal media like ink or charcoal, brushwork or smudges produce effects of light and dark, yet the path of a mark—the direction—remains a line.

19. Depth: Foreground and Background

Building volumes in drawing that advance, recede, and overlap—that exist, in other words, in a dimensional realm—expands the function of positive and negative space. Spaces in front of, behind, or around volumetric spaces deserve the same intense consideration as elements of design that we give to shape and placement in figure/ground agreement. Foreground, middle ground, and background are the conventional divisions of pictorial depth. Middle ground is a throwaway concept because it is too vague; it lacks a spatial position equal in specificity to foreground and background (the former being the position closest to the viewer, the latter the position at the greatest distance). The middle ground functions not as a position in space but as the intervening zone between foreground and background. Abstract painters Piet Mondrian and Hans Hofmann and the later color field painters proposed that a drawing or painting creates spatial depth that advances in front of the picture plane—a kind of inverse perspective.

20. Perspective: Point of View

Picture plane (entry 9) is a concept that is elemental to understanding perspective. Teaching perspective as a bag of ruler-wielding tricks by which we can ape the appearance of objects advancing and receding in space does disservice to the concept and misses the point entirely. Illusionistic perspective has been studied and practiced since antiquity. Different forms of perspective—methods of showing spatial depth—are found in Chinese and Japanese art, Indian art, Mughal and Persian miniatures, and the art of other civilizations.

One object depicted overlapping another implies a point of view. Getting behind the back object and looking the other way would reverse the order, putting the back object in front. Renaissance perspective is the systematic, geometric application of descriptive conventions for describing deep space on a flat surface; such conventions were already common in ancient Roman paintings and, more than a thousand years later, in the works of Giotto. In 1436, architect and master builder Leon Battista Alberti published his treatise *Della Pittura* (On Painting), which explained a system of perspective that revolutionized pictorial art in Europe. It was an idea that unintentionally bore seeds of social radicalism. Perspective located the *individual* in space, looking at the world. By allowing people to envision the physical world in rational terms and to represent it accurately, Renaissance perspective invaded the medieval imagination like a computer virus—undermining visual conventions, religious hierarchies, dogma, and power, while empowering the rise of science, the individual, and secular government.

21. Orthographic or Paralinear Perspective

Paralinear has recently been coined as a buzzword for axonometric or orthographic parallel line perspective. Paralinear perspective uses 30-degree and 60-degree angles; isometric perspective uses 45-degree and 90-degree angles. Orthographic drawing systems manifest three-dimensional blueprints of real objects, true to scale. Regardless of depth, their elements neither increase nor decrease in size. While Renaissance perspective more closely imitates visual experience, it is at the expense of scale, which becomes distorted: an object located closer to the viewer's position (perspective) will appear larger than an identical object seen from a greater distance. A paralinear drawing of an object can be measured for true scale dimensions like a map or architectural plan. Exploded views of machinery in repair manuals are common practical applications of these principles; they benefit students and help them understand specific objects and volumes by visualizing them in abstract terms, apart from the physical experience of looking directly at them.

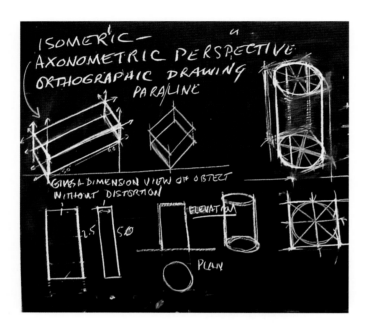

22. Spatial Illusion: Perspective at Work

Perspective relates objects to the viewer's position in space. Human vision is stereoscopic: our two eyes are aligned horizontally. Perspective expresses the viewer's eye level as a horizon line upon which are located several plotting points. Anchored on these points, linear projections are used to construct distortions that imitate the effect of looking at objects moving toward and away from one's point of view or perspective. By using perspective drawing, perhaps architect Leon Battista Alberti (see entry 20) hoped to save time and money that would need to be spent building complicated, costly models to show his clients as he bid for jobs. Just as computers do today, perspective drawings in the fifteenth century introduced the world to new virtual spaces.

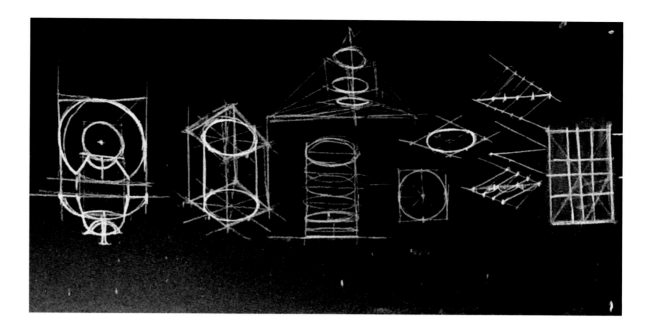

PRACTICAL PERSPECTIVE

You are in a room. Imagine instead that you are in a swimming pool. The water surface is perfectly calm, in line with the center of your eye. Find part of any object that is in line with your eye. Draw a horizontal representing your eye level; that will be your horizon. Next find a rectangular object with parallel sides, like a table or a chair seat. Follow one of the parallels up to the horizon and mark the position; this is a vanishing point. All edges parallel to the one used to plot this point should align with it. Objects aligned in different directions, including the edges of the wall, floor, and ceiling, will require different vanishing points to be plotted. Renaissance artists devised methods for plotting perspective using a grid mounted within a wooden frame, such as is illustrated by Dürer (see entry 9). A simpler, more empirical method is to use a bamboo skewer or an unsharpened pencil to track converging parallels to the horizon line.

ONE-POINT PERSPECTIVE

One-point perspective uses a single vanishing point to represent objects that have one side parallel to the picture plane as it advances and recedes, such as the apparently converging or shrinking space between railroad ties that recede in the distance or a row of vertical telephone poles that appear higher as they advance and lower as they recede.

The principle is based on parallel lines converging on a single vanishing point located on a horizon line that represents the viewer's eye-level. Depending on what is to be represented, the horizon line might be located near the top, middle, or bottom of the page, which in most perspective drawings will be addressed horizontally to allow for as much lateral extension as possible.

Linear projections are used to construct distortions that imitate the effect of looking at objects moving toward and away from one's point of view or perspective. James McElhinney, *Mini-lecture Demo Drawing: Linear Projections*, chalk on blackboard.

The basic element in any accurate perspective drawing is a right-angle grid of squares constructed within a single or double vanishing-point system like a checkerboard. Perspective distorts the regular proportions of a square, and while three sides of any square can be plotted without calamity, the human eye cannot judge with accuracy the exact location of the missing side of a square in perspective. Following the common procedure, in one-point perspective three sides of a square can be easily located by drawing a horizontal line below (or above) the horizon/eye level. On the horizon, in a position directly in front of your imagined position, mark a single vanishing point. The next step is to locate two lateral vanishing points (sometimes called station points) that are equidistant from the center vanishing point. In single-point perspective, the lateral station points represent the edge of one's peripheral vision.

To make a horizontal square, draw two lines converging upon the center vanishing point. Drawing a horizontal line across the lines converging on the vanishing point locates the third and most forward edge of the square. To find the distant horizontal edge of the square, draw a line connecting the two front corners of the square across the receding parallels to their opposite station point. Drawing a horizontal line through the points where these lines cross the converging lateral edges of the square completes the square. The plotting lines connecting the front corners, across the square to the opposite station point, function in perspective as the cross-corner diagonals found in a two-dimensional square. Drawing a horizontal between the points where these lines cross the receding parallels provides the fourth edge of the square.

TWO-POINT PERSPECTIVE

Two vanishing points are used to show objects positioned obliquely to the picture plane. In most two-point perspectives, the vanishing points need to be positioned outside the frame, requiring a wider horizontal for plotting angles. The front and

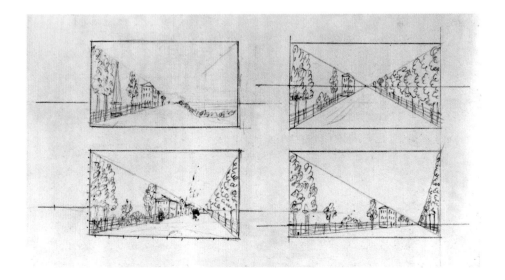

American architect Charles Bulfinch created this one-point perspective drawing showing four views of a street with a building and trees, c. 1790.

back corners of squares in this system are represented as obtuse angles. Left and right corners are represented as acute angles. In two-point perspective, horizon-point functions are reversed. Station points become vanishing points, and the central vanishing point in one-point perspective becomes the station point.

To construct a horizontal square in two-point perspective, draw two lines at an acute angle converging on one of the lateral vanishing points. Draw a third line across these parallels to the opposing vanishing point. These lines locate three sides of the square. Next draw a line connecting the front corner of this three-sided form to the station-point above, usually located midway between the lateral vanishing points. Through the point where this line crosses the rear parallel, draw a line across the paired parallels to the second vanishing point, completing the square. The horizontal line that connects the square's lateral corners and the orthogonal or perpendicular line that is drawn between the front corner and the station point function as cross-corner diagonals in a two-dimensional square.

RECIPROCITY BETWEEN ONE- AND TWO-POINT PERSPECTIVE SYSTEMS

There is reciprocity between quadrants and thirds, as there is with axonometric and isometric perspective (see entry 21); a similar reciprocity exists between one- and two-point perspective systems.

Draw a horizontal square using two-point perspective, as explained above. Draw a line between the left and right corners of the square. This line should be parallel to the horizon line. Through the back corner of the square draw two more horizontals parallel to the corner-to-corner line. Next draw a line from the left corner of the two-point square to the station point on the horizon line. Draw another line from the right corner to the station point. A new square is thus created in one-point perspec-

A demonstration of one- and two-point perspective. James McElhinney, *Mini-lecture Demo Drawing: One- and Two-Point Perspective,* chalk on blackboard.

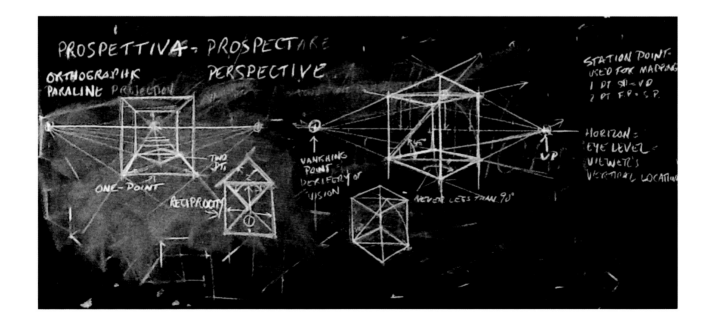

tive, using as its front edge the corner-to-corner line in the two-point perspective square. Reciprocity between squares drawn using one- and two-point systems is based on interchanging edges with corner-to-corner diagonals.

THE TRUE SHAPE OF PERSPECTIVE SPACE

Because most people learn perspective from people who understand the method better than the concept, they tend to retain a misguided notion that perspective depends only on making straight lines. Perspective (*prospettiva* in Italian) denotes a prospect, a point of view. A simple exercise brings the mathematical linearity of perspective back to the shape of human experience.

Plot a square in two-point perspective. The front angle is obtuse, although it represents a right angle. Logically, the limit of this fiction would be located at the distance from the horizon where this obtuse angle becomes a right angle. Plotting all possible right angles from the two vanishing points of your original square creates not a square but a circle—the shape perceived by the human eye, the so-called *cone of vision*. The curvature of the human eye bends straight edges it beholds. Two-point perspective ignores this fact by using straight lines to build convincing spatial fictions that must observe boundaries drawn by a circle. Perspective is neither mechanical nor boring when taught by someone who truly understands it as an expressive tool for imagining and manipulating pictorial space.

23. Light and Shadow

An entire book could be devoted to the use of the gray scale in drawing. Infinite vibrations between white and black can be observed and produced. The important thing to remember is that light-to-dark contrast is a reciprocal condition expressing relativity between two or more values (shades of gray). In representational drawings created with achromatic tonal materials, light and dark are used to denote either local value (the actual tonal value of an object surface) or a specific condition of light falling on an object to create highlights and shadows. The pattern and direction of shadows, together with the relative intensity of contrast between highlight and shadow, indicate the direction and proximity of the light source. Values can be manipulated in a drawing in ways that respond directly or indirectly to its linear elements. These methods for laying down lights and darks in a drawing apply to both abstract and representational imagery.

CROSSHATCHING overlaps cross-contour lines to express the direction of the surface of a volume. The term comes from the French word *hacher* ("to chop"), the root word for hatchet. Lights and darks are regulated in crosshatched patterns by varying the thickness of the lines, the distance between them, and the density of

overlaying patterns. Cross-contour hatching appears in the drawings of Michelangelo, where it resembles the grooved chisel pattern on roughed-out stone carvings. Albrecht Dürer's drawings anticipate the woodcut prints that reproduced them. These two artists found the same basic language—crosshatched lines informed by the process of carving. Rembrandt's pen drawings were informed by etching, a process in which one material resists another.

SHADING is a general term that many instructors resist because it is not specific enough. In the academic tradition, a method for drawing light and shadow involves defining an accurate silhouette of an object or figure and then filling in the lights and darks with charcoal and stump (a piece of paper or other material tightly rolled into a stick to form a pencil-like tool for rubbing marks made with charcoal to blend them in transitions from light to dark). In the so-called "window-shade" method the artist fills in all the values within the contours of the figure from top to bottom, mimicking the perceived light effects; this method is used when the instructor does not want the student to be distracted by mark-making when learning to control smooth transitions of value. Shading and stump drawing were fashionable during the nineteenth century; later they were discounted by some who favored the rigor of drawing with a pencil point and thus regarded stump-shading as optical copying and mere imitation, a labor-intensive mechanical replication that paralleled photography.

WASHES in ink or other aqueous media offer more gestural ways of expressing light and shadow, as found on the spontaneous brushwork of Rembrandt, Tiepolo, Goya, Hokusai, and Diebenkorn. Rapid sketches are more likely to employ these methods than are finished works; drawings made with washes were frequently fragments of underpainting studies or whole compositions in which ink was used because it allowed the drawings to be made quickly.

Washes are expressive ways of dividing light and dark in drawings. James McElhinney, *Mini-lecture Demo Drawing: Page Placement and Massing Light and Dark,* 2009, ink wash on paper, 24 x 18 inches.

TONED-PAPER drawings are done with light and dark marking tools on paper made from dyed pulp. The color of the page functions as one of the middle values in the drawing. The use of toned paper seems to be quite an ancient practice; popular during the revolution in oil painting that took place in Venice during the sixteenth century, it let artists prepare underpaintings by laying in the image with a light color and a dark color on canvases primed with a mid-value, earth-colored *imprimatura* (toned ground color). Rubens perfected the method, which was practiced by Watteau, Fragonard, Prud'hon, and others. When artists do toned-paper drawings, they seldom employ drawing stumps or water media; Conté crayons or pastels are most commonly used, as they produce results that closely approximate the effect of underpaintings in oil.

COLLAGE is a French word meaning "pasted thing"; it comes from the verb *coller* ("to glue or paste"). Georges Braque and Pablo Picasso are generally given credit for adapting the method from scrapbooking to high art, in which it is now widely practiced. Kurt Schwitters, Max Ernst, Henri Matisse, Willem de Kooning, Robert Motherwell, Romare Bearden, and Anselm Kiefer have all made liberal use of this technique, which replaces, say, the charcoal *fusain*, graphite pencil, or brush with cutout elements the artists either found or created. While Photoshop has rendered this once radical medium somewhat quaint, in its own way it is as traditional as any other historic medium. The advantage for some who use collage is the ability to lay the elements down onto a page without affixing them, a luxury that people who spend hours creating a tonal passage in ink or pencil do not enjoy. The same principles that apply to organizing values within any composition apply to collage, which is commonly used in concert with other wet and dry media because of the expressive limitations of shapes made only by cutting or tearing.

24. The Human Figure and Anatomy

Design is the process of adapting nature to human use. Thus design begins with nature, which in Western artistic heritage is distinctly anthropocentric. Concentrating on the attributes of nature located within the human body has powerful instructional value. These attributes are at once universal and individual. Any model can assume an infinite number of poses that can never be repeated precisely by another. The body delivers a vast quantity of permutations of volume, movement, light, shadow, color, texture, and expression. In the postindustrial present, bodies represent more than modern-day equivalents of bronze and marble Greco-Roman temple denizens. Knowledge of the body and the ability to represent it via drawing in any medium is useful to animators, game designers, fashion designers, product designers, transportation engineers, and anyone whose work engages the principles of ergonomics. Some regard the figure as a hallmark of tradition, while others simply

The human body delivers a vast quantity of permutations of volume, movement, light, shadow, color, texture, and expression. James McElhinney, *Mini-lecture Demo Drawing: Gesture, Page Placement, Mapping, Proportion, and Simple Anatomical Volumes*, 2009, charcoal and Conté crayon on newsprint, 24 x 18 inches.

use it as an effective teaching tool. Most students will never make a career out of drawing nude and draped models, but all will benefit from the lessons to be derived from life drawing if it is taught effectively.

ACADEMIC FIGURE DRAWING

Academic drawing methods, which are now enjoying a revival, were developed between the sixteenth and the nineteenth centuries, first in Italy and then in France and in art schools across Europe, as a way of constructing historic precedents to connect living artists to classical antiquity.

Rigorous curricula required students to copy two-dimensional images and ancient marbles (or plaster casts of the same) before advancing to the life-drawing studio. The history of academic life drawing is covered in *Classical Life Drawing Studio* (Sterling Publishing, 2010). In the past, most students, before enrolling in an academy or atelier, would have received instruction in basic drawing and penmanship as part of a general education. Before the history of art existed as a scholarly discipline, cast drawing exposed students to aesthetic traditions, and instructors stressed the notion that art existed to elevate nature, not to copy it. Students prepared in this way might avoid mere description when drawing live models, and they were more likely to attain a lofty result. Academic drawings were produced as training exercise, not as works of art in themselves.

Mary Tynedale, *Antique Drawing*, 1894, charcoal on paper, 24 1/2 x 19 inches. Student of J. Carroll Beckwit at the Art Students League of New York.

Schools differed greatly on issues of style and pedagogy. One might favor the point. Another preferred the stump. Artists were drawn to academies based on a philosophical sympathy of style and method. In the eighteenth century, most native-born American artists studied in London; after 1800, they gravitated to Rome, though many also studied in Germany and the Netherlands. Before the Gilded Age of the late nineteenth century, when Paris reigned supreme, a large number of American artists studied in Munich.

Academic drawing methods were abandoned in the twentieth century when atelier-trained artists embraced modernism, training students through sequenced, integrated curricula that blended the fine, applied, and decorative arts.

Today academic drawing is back in demand as artists, designers, and amateurs look to build the kind of visual muscle needed to survive in a world saturated with data-enriched images generated by new-media technologies. A call to action has come in part from a small number of self-styled "classical realist" artists who operate ateliers that promote new art in old styles. More compelling perhaps is the enthusiasm for freehand life drawing by game designers, graphic novelists, and digital animators. It is ironic that postmodern technology has inspired us to restore our connections to antiquity.

EXPRESSIVE FIGURE DRAWING

Deemed by twentieth-century British arts scholar Lord Kenneth Clark as "alternate traditions," expressive systems and canons for representing the human figure vastly outnumber the classical paradigm; such traditions range from Neolithic cave art to non-Western traditions, including those based in India, East Asia, Africa, and Meso-america. Within the European tradition, alternative styles of figuration include Celtic, Nordic, Byzantine, Romanesque, and Gothic art, together with numerous regional permutations and folk art. By contemporary standards, the drawings of "outsider" artists like Martín Ramírez evince naive classicism when compared to Schiele, Klimt, Rodin, or Twombly, whose drawings bespeak a sensualist aesthetic. The works of Cezanne, Picasso, de Kooning, and Giacometti owe a considerable debt to the classical tradition, even when blended with non-Western influences or novel decision-making strategies like cubism or surrealist automatism.

The section on gesture drawing in entry 18 notes some of the instructional methods and assignments designed to bring students into an expressive working environment. The popularity of these methods at various times in recent history reflects concurrent interests in Gestalt therapy and the subconscious mind. The resulting drawings face no comparison to any descriptive standard but are judged on their compositional merits and perhaps on how well they exploit the processes used to produce them. Meanwhile, debates rage about whether to encourage expressiveness or to lead students in more formal, structured modes of study. For many artists—including such abstract painters as Richard Diebenkorn and Jules Olitski—drawing from a posed model on a regular basis functioned as a whetstone for sharpening their personal vision against the hard facts of nature.

25. Anatomy in Drawing Practice

Drawing the volumes and surface of the body with any success requires seeing beneath the skin, where a skeletal armature is animated by the masses it supports, including muscle groups. Movement and structure are reciprocal in anatomical life drawing. Basic anatomy focuses on the three largest components of the skeleton—the rib cage, pelvis, and skull—and the extended structures of the arms, hands, legs, and feet.

One of the simplest and most common ways to explain anatomical function to students is to require them to make extensive drawings of the skeleton and to recognize pressure points where it is visible beneath the skin. In the head, these include the cranium, brow, nasal bone, cheekbone (zygoma), and jaw (mandible). In the torso, the spine, shoulder blade (scapula), collarbone (clavicle), sternum, ribs, and pelvic girdle (sacrum, ilium, pubis) are major skeletal elements.

One of the simplest and most common ways to explain anatomical function to students is to require them to make extensive drawings of the skeleton and skull. James McElhinney, *Mini-lecture Demo Drawing: Canonical Proportions for the Head, Formed Around the Skull,* 2009, sanguine and Conté crayon on newsprint, 18 x 24 inches.

In one useful exercise, students make a transparent line drawing of a human figure, lightly elaborating the skeleton within the body. At first they make an interpretive copy of an existing painting or sculpture; later they repeat the process working from a live nude model.

The most effective way to prepare students to recognize anatomical data in a live subject is to produce sculptural écorchés—three-dimensional models of the skeleton with muscles laid over them in clay. Costa Vavagiakis and Michael Grimaldi, contributors to this volume, teach anatomy in their life drawing classes at the League. Frank Porcu, featured in *Classical Life Drawing Studio,* is well known for teaching anatomy, following in the footsteps of artists Deane Keller and the legendary Robert Beverly Hale.

LIFE-DRAWING MARATHONS

Life-drawing marathons, festive events similar in spirit to today's poetry slams, became popular in the 1980s at a number of art schools. During a marathon, concurrent life-drawing classes are held from dusk until dawn or for days at a time, sometimes around the clock. Marathons promote an enthusiasm for drawing while raising money for the host institution. In one drawing studio a model may do two-minute poses, while in another classroom multiple models pose for the duration, taking breaks at twenty-five-minute intervals. Crowds of people can be found busily drawing, jammed cheek-to-jowl into a dozen classrooms where models are posing. At a recent drawing marathon in New York, one of the attendees insisted on drawing in the nude. Traffic

between studios creates rush-hour conditions in the hallways. Often musicians and refreshments lend a carnival atmosphere to the proceedings, which combine a joyous Bohemian mayhem with a serious, quasi-athletic approach to figure drawing. At the end of some drawing marathons, all of the nude models—men and women—gather together on stage for a group pose, a "Grand Finale."

26. Life Drawing Outside the Classroom

The Art Students League offers free, uninstructed life-drawing classes to its members and, for a small fee, to nonmembers. Many art schools, art clubs, and college and university art departments sponsor student guilds or unions that host uninstructed life-drawing classes on a weekly or even semiweekly basis, usually for a modest fee that pays the model and funds student art guild activities. Individuals who are interested in studying life drawing but who are unable to attend scheduled classes should encourage their local college, museum, or art center to organize instructed and uninstructed life-drawing classes. Hundreds of such programs exist across the country. Within the past few years a fresh crop of semipublic drink-and-draw life-drawing groups have started meeting in bars and nightclubs around Manhattan and other cities. While the artist/organizers seem more closely connected to the worlds of computer animation, game design, and graphic novels than to traditional studio art, such trends indicate a growing interest in drawing the human form from life.

PRIVATE LIFE DRAWING GROUPS

Private life-drawing groups, coordinated by artists unaffiliated with any organization, have become increasingly popular. In places where no art school or college exists to offer open life-drawing studios, drawing groups provide venues for artists—and nonartists who want to improve their visual skills—to draw from live models. Peter Steinhart's wonderful book *The Undressed Art: Why We Draw* (2004) describes his experience in various San Francisco Bay Area life-drawing circles; the book blends models' commentary and that of his drawing companions with his own musings and observations. Anyone who has not studied life drawing and is attracted to it should read this book.

Organizing a private life-drawing group is not as simple as persuading an exhibitionistic friend to disrobe for three hours while others draw. Certain etiquette is customary. Models should be given a dedicated space in a heated room where they may comfortably pose; space heaters should be provided, if necessary. Models will take breaks every half hour, sometimes more frequently. Masking tape demarcating a model's position can be marked on furniture, floors, and walls, to help him or her to accurately resume a long pose. In most private drawing groups, one person will have

studied life drawing and can familiarize the others with proper conduct and procedure. If a professional model is not available, students can pose for one another or invite friends to pose. Dancers and athletes are naturally disposed to physical activity and less likely to feel self-conscious when posing nude in a safe, well-organized life-drawing environment. Those who enjoy a first exposure to life drawing in private sessions are strongly advised to enroll in an instructed class, where the skills, knowledge, and experience they gain will enrich the work they do on their own.

27. Composition and Abstraction

Nothing is more important to the success of a drawing than the way it fills the space it occupies—in most cases, a rectangular page. Abstract painting represents an enormous leap in our visual awareness of pictorial art. It reveals how the underlying visual structure that exists within every kind of image is composed of certain formal elements—line, shape, color, texture—that, when organized into a pictorial composition, possess as much character and specificity in their own right as the objects, creatures, and spaces they might represent. Physiological anatomy reveals the biomechanical logic of the human body. Abstraction lays bare the muscle and bone of pictorial art. Nothing is more difficult to achieve than a sound abstraction. At the same time, a successful representational drawing or painting depends on the composition—the abstraction within it. Another way to understand this conundrum is to consider how a tour de force of descriptive rendering is doomed without a sound composition.

Pictorial composition generally denotes the way elements relate to one another within a two-dimensional surface such as a rectangle, tondo (circular picture), sweeping panorama, or site-specific mural. Clarity of spatial construction, movement, and depth is key—how well is the viewer guided through the space? The concepts discussed earlier—including figure-to-ground relationships, quadrants, the Law of Thirds, and the Golden Rectangle—address subsidiary divisions within a quadrilateral frame. Evolutions of pictorial space are exemplified in a huge variety of ways, from the triangular scaffolding of Giotto's compositions to the sweeping arabesques of Sandro Botticelli and, later, Peter Paul Rubens; to the angular spaces of Piero dell Francesca and Paolo Uccello; the depth illusions of Raphael nodding at antiquity; and Tintoretto's bare-knuckle compositional brawling. Leading us into their compositions with long diagonals, Nicholas Poussin and Claude Lorrain engage us as much with geometry as with golden vistas or saints and goddesses. Cezanne's tabletops are as vast as his beloved Bay of Marseilles. Piet Mondrian's exuberant grids display a mock restraint but push outward in front of the picture plane; Hans Hofmann's compositions exude muscleman push-pull isometrics; and Jackson Pollock, though unfit for military service, led paintbrushes on violent, high-altitude bombing raids

TOP LEFT
Giotto di Bondone, *The Presentation of the Virgin in the Temple,* 1305, fresco, Cappella Scrovegni (Arena Chapel), Padua.

TOP RIGHT
Sandro Botticelli, *The Temptations of Christ,* 1480–1482, fresco, Sistine Chapel, Rome.

CENTER LEFT
Piero della Francesca, *Procession of the Queen of Sheba, Meeting of the Queen of Sheba and King Solomon,* c. 1452–66, fresco, Basilica di San Francesco, Arezzo.

CENTER RIGHT
Workshop of Raphael, *Drawing after The School of Athens,* c. 1520, pen and ink and wash, Uffizi Gallery, Florence.

BOTTOM LEFT
Tintoretto, *Miracle of Saint Mark Freeing the Slave,* 1548, oil on canvas, Gallerie dell'Accademia, Venice.

BOTTOM RIGHT
Claude Lorrain, *Imaginary View of Delphi with a Procession,* seventeenth century, oil on canvas, Galleria Doria-Pamphilj, Rome.

against canvases staked out like Gulliver. Great art is made not just by realizing a novel image through skillful use of technique, just as music is created by neither scores nor instruments. Great art must resonate with visual intelligence. Just as one must excavate the image to discover the logic within a composition, one must also learn how to construct a composition from the inside out.

One effective method for studying composition is to copy works of art at museums or from books. The practice was the subject of the 1988 *Creative Copies* exhibition and accompanying catalog at the Drawing Center in New York. A number of the instructors in that show stressed the importance of firsthand encounters with great works of art. The goal of interpretive copying is not to reproduce an artwork but to penetrate its mysteries by using the process of drawing to see it, to understand it.

A common error made by students copying artworks into sketchbooks is that they begin with some part of the image, when the first step should be to accurately draw the shape of the frame in correct proportion. Seldom will a painting or drawing conform to the shape of a sketchbook page. Dividing the page into quadrants and thirds will help you recognize the location of specific elements within the composition and make it easier to locate them accurately within the rectangle. Accuracy is important not for reasons of style but because drawing in this way is like downloading an uncorrupted file onto your computer. It is a way of eating the world through the eye, of becoming intimate with the work of art you are observing, and of training yourself to recognize underlying structures and concepts in any work of art, design, or architecture. This practice will illuminate some of the aspects of abstract art that certain students find challenging. A Mondrian or a Kandinsky may look simple until one tries to make a drawing of it and discovers an elusive precision of design that in some ways makes *Broadway Boogie Woogie* more complex and engaging than the *Mona Lisa*.

28. New Media

During the last two decades of the twentieth century, a lot of people forgot how to draw and sought comfort in the belief that it no longer mattered. Drawing is not a medium. It is a language and thus is indifferent to distinctions between media new and old. Some of the great filmmakers, such as Sergei Eisenstein and Akira Kurosawa, were excellent draftsmen, sketching their own storyboards before troubleshooting scenes on location. Magnum Photos cofounder Henri Cartier-Bresson devoted much of the final decade of his life to drawing. Architect Louis Kahn produced many hundreds of drawings related to his work and his travels. Architect Frank Gehry works on designs in freehand drawings that are later translated into production drawings using software created for aviation design. When asked if he used computers, Daniel Libeskind, who

developed the master plan for the rebuilding of the World Trade Center site in New York, laughed and said, "I think we have technicians for that." Exhibitions of site-specific projects by Christo and Jeanne-Claude are dominated by large-scale drawings. While some traditionalists may feel threatened by residual avant-garde polemics, by installation art and conceptual art, and by new artistic directions that use recycled materials or time-based media, they may rest assured that drawing is in no danger of becoming obsolete. People who draw will always quarrel about style and taste but will never question their need to draw.

DIGITAL MEDIA

Today drawing can be performed on a variety of devices, from handheld communication devices to sophisticated touch-sensitive tablets. New technology is restoring some old practices. The invention of the telephone replaced large amounts of written communication with irretrievable real-time conversations. E-mail and texting have returned people to writing letters and passing notes. Even more instantaneous real-time audiovisual communications media can be preserved and retrieved. The fact that major animation houses like Pixar, Disney, and Sony for years ran in-house (freehand) life-drawing classes reaffirms the idea that drawing is not a media-based practice but a language applicable to all media.

Discussions about digital painting and drawing are actually informing new modes of printmaking, because while images can be assembled and refined in virtual environments, their manifestation outside those environments depends on printers. Software programs running on binary code have simply replaced plates, stones, chemicals, and acid baths. Manipulating a computer image is fundamentally similar to biting and aquatint or scraping—processes that stand between drawing ideas and their physical manifestation. Novelty rarely hits the mark and always succumbs to something newer. Durable values prevail. For example, drawing practices such as the use of multicolored pens and markers for designing in analog media—directly analogous to medieval illuminators laying black lines over an image constructed with pen or brush in a light color like red or brown—are now applied to digital media. In collaborative processes, such as team-drawn graphics in a digital studio, each participant might also be identified by his or her use of a specific color. Advances in creative imaging technology have always empowered people who can draw. They always will.

29. Critiques

While the word *criticism* can have a negative connotation, critiques benefit students as useful milestones in the learning process that track personal growth and build communication skills. Criticism is the medium of verbal dialogue between artist

and audience through the mediation of journalists, scholars, and other artists. Critiques conducted within instructional settings, which rehearse this dialogue as a component of artistic pedagogy, follow three dominant models: individual critiques, group critiques, and online and distance learning, any or all of which may be employed by instructors and professors according to their individual teaching styles.

INDIVIDUAL CRITIQUES

Critiques can occur at the easel as discussion of a work in progress or in a private conference between student and teacher. They might address single pieces or a body of work. Individual critiques that occur within a classroom setting allow other students to benefit by eavesdropping. Students giving critiques to one another simultaneously develop social, conversational, and critical skills that they will need to possess as working artists.

GROUP CRITIQUES

Group critiques occur in a wide range of permutations that can include as few as two students with the instructor or an entire class. Courtesies and rules of engagement are followed based on each instructor's personal teaching philosophy. In graduate-level critiques, visitors from other classes gather to witness events that at one school might resemble a Quaker Friends meeting and at another might recall a gladiatorial contest. Effective critiques help students develop skills that will empower them to engage in articulate verbal discourse, refine their powers of discernment, and improve their studio practice.

ONLINE AND DISTANCE LEARNING

Distance learning can be very effective in certain kinds of classes, but it will never supplant the studio classroom experience, where the instructor can interact with each student at random, responding to events in the classroom not according to the convenience of technology but to events as they develop in real time. Online learning deprives students of the real-time classroom experience, where they learn from one another as much as from the teacher. Distance learning in art goes back to the Famous Artists School in Westport, Connecticut, and other snail-mail correspondence schools that offer training in everything from shorthand to divinity studies. The one-on-one instruction in artistic training made possible under this model is limited by the absence of group dynamics—everything from wall critiques to eavesdropping on individual classroom tutorials. Neither online learning nor instant messaging is the same as being in a classroom with an instructor and other students. Perhaps advancements in simultaneous teleconferencing can ameliorate these shortcomings, but for now online and distance learning cannot transport us into a physical environment where other people are also making and discussing works of art.

NOTES ON TEACHING AND CRITICAL STYLES

Teaching styles are laid bare in critiques. Dogmatic instructors who offer students a choice between "my way or the highway" may attract followers and imitators, while instructors who employ more Socratic methods measure their success by how well their students develop as original, creative individuals.

Dogmatic instructors who indoctrinate students into a specific aesthetic tend to conduct critiques within the context of their bias; they hinder the process of artistic development by using that aesthetic to reward or punish students who agree or disagree with them. Students who embrace the instructor's philosophy are encouraged, while those who question it are castigated or ignored. While some people may be offended or threatened by undemocratic pedagogy, a classroom is not a republic. Military training breaks down ego to promote team spirit, at the same time sharpening a recruit's mental focus and bolstering his or her physical stamina, strength, and courage. Academic training became more dogmatic near the end of its epoch, which may explain why so many of its best and brightest were willing to invent modernism. Doctrinaire training may be valid for some and anathema to others, but for many it has proved to be both durable and effective.

Instructors who promote originality and creativity will always take arms against a doctrinaire approach in the debate about artistic pedagogy that has raged for centuries. They believe that in effective critiques students are called upon to state their goals for the work in question, which is then examined by others present who determine if those goals have been reached before suggesting improvements. The critical dialogue may include other members of the class or the entire group. The challenge of this approach is that without a strong position on style or content and without concrete expectations for the outcome, the instructor must be very agile in his or her ability to maintain rigor, by steering the conversation away from subjective digressions that devolve quickly from nurturing to indulgence. In an interrogative environment that replaces doctrine with reason, critical acumen will develop rapidly; discussion is broadened when many voices disagree sharply on issues of style and content.

Critical philosophies are teaching philosophies. Doctrinaire training and the Socratic method are but two contemporary models that echo the historic differences of approach between the workshop and academy traditions discussed in the introduction to this book. ∎

MATERIALS AND TECHNIQUES

DRAWING IS NOT A TECHNIQUE BUT A LANGUAGE. It does inhabit certain physical realms from time to time, frequently as graphic essays comprising expressive marks on a page. Nearly anything can work as a drawing surface, and nearly anything can be used to make marks upon it. Drawings can be made with charcoal on paper or with a tattoo needle on human flesh. Knowing how a drawing surface receives and supports different kinds of marks informs technique. Sound technical practice means that you have studied how certain tools combine and can anticipate how they will behave. The following text gives a broad overview of drawing materials and practices. Authors Mark David Gottsegen and Ralph Mayer provide more detailed information on all of these subjects in their books, which are listed in the bibliography of this volume.

30. Paper

The word *paper* comes from the Latinized word *papyrus,* which in turn is believed to derive from the ancient Egyptian and describes a writing surface made from laminated sedge plants that grow in the Nile valley. The earliest European papers were made according to methods still in use today: Recycled rags are pulped, bleached, spread out on porous frames, and pressed to force out excess water. Sheets laid one on top of another, separated by absorbent felt in a vertical press, are termed "cold pressed"; those pressed through wooden or metal rollers and sometimes finished with a heated flatiron are "hot pressed." The absorbent felt sheets in cold pressing impart a rougher texture, whereas hot-pressed papers have a smooth surface. So-called "rice paper" (made not of rice but of fibers from other plants such as bamboo and mulberry, noted for their thinness and durability) and other paper products from Asia entered Western markets first in the sixteenth century and again three centuries later when Commodore Perry sailed into Edo Harbor and forced Japan back into the international trading community. During the Industrial Revolution, pulp papers (made from wood pulp) proliferated as vast quantities of scrap became available from mechanized sawmills; meanwhile, demand for inexpensive printing stock was fueled by a publishing boom.

Papers are measured for archival value according to their pH content. Archival value is based on how well a material will survive in storage that protects it from deterioration by exposure to heat, humidity, pests, and ultraviolet light. Pinewood

pulp newsprint possesses a high acid content that causes it to deteriorate eventually, whereas cotton papers are pH neutral and can be preserved indefinitely within a safe environment.

NEWSPRINT is a cheap paper made from pinewood pulp. A nonarchival, high-acid-content paper that yellows and becomes brittle within a few years, it is thin and prone to tearing; a sharp 2H pencil can easily slash through a single sheet. Newsprint will not hold up to revision; an eraser can easily rub holes in it. It acts like a blotter when an ink wash is applied, a capillary effect carrying the liquid out from the edge of a mark into the surrounding paper. It is not durable and is suitable only for disposable work.

RAG PAPER comes in many levels of quality. The paper in many commercially sold drawing pads is made of a combination of pulp and cotton rag content treated to reduce acid levels. Papers that are labeled 0 percent pH are more durable than newsprint, but not more so that true cotton rag papers. True rag papers, made by many different companies, are usually sold as watercolor or etching paper. In the last thirty years, a revival of artisanal papermaking has made available a wide assortment of handmade rag papers. Most such papers are characterized by a specificity of texture, as well as the presence of a *deckle edge*, a scalloped-edge irregularity shaped by the paper mold. Sheets deckled along every edge are produced individually, while those with two cut edges and two deckled edges are made in long strips and then cut and trimmed to size.

31. Marking Tools and Materials

The original graphic art may have been drawn with a finger in sand, with a burnt stick onto a cave wall, or with a sharp stone that scratched a flat rock. Anything that can leave a mark can be used to make a drawing. Following is a description of the most common materials in use today.

DRY MEDIA
CHARCOAL is made by burning sticks of carbon, uniform in diameter, in an oxygen-deprived environment similar to the reduction firing of black iron-glazed ceramics. **VINE CHARCOAL**, used for more delicate drawing, was originally made from thin grape vines. Today vine charcoal is produced in kilns using burnt dowels and square-sectioned baguettes milled from larger pieces of lumber and wood scraps. The relative hardness of woods like pine (soft) and oak (hard) used in the production of charcoal is retained in the finished product, graded as hard, medium, or soft charcoal. Harder varieties produce light lines, while softer grades produce darker marks.

COMPRESSED CHARCOAL AND THE CHARCOAL IN CHARCOAL PENCILS are not produced directly from wood products, as vine charcoal is; they are made from carbon powder, produced by burning bone and other organic material, that is fashioned using a binder (for example, gum Arabic) into sticks and cylinders. Charcoal pencils, similar to the common graphite pencil (see below), are rods of compressed charcoal fitted into cylindrical wooden holders. Compressed charcoal and charcoal pencils are available in varying degrees of hardness.

CHALK (calcium carbonate) is shellfish sediment that occurs in formations around the globe; one well-known location is the southeastern coast of England. Like its darker cousin graphite, chalk is a carbon-based compound that has been used since prehistory as a white pigment that can be quarried and mined directly from surface deposits. While its brilliant white color makes it an excellent marking material, it fades instantly when diluted in water or mixed with gums, waxes, and resins. It is used mostly as a neutral filler in the production of certain paints and drawing sticks to enhance their opacity, and an as ingredient in traditional hide-glue or "true" gesso. The most popular white pigment for centuries was white lead, now known to be toxic. The most common white pigments used today are made from titanium or zinc, or a combination of both.

GRAPHITE PENCILS come in varying degrees of hardness; ascending numbers indicate the degree of hardness (the letter *H*) or softness (the letter *B*). Sometimes called lead pencils because graphite (nontoxic) and lead (a poisonous heavy metal) are similar in color, the common pencil is composed of a narrow cylinder of compressed graphite—a high-grade variety of coal that is less flammable than standard coal— encased in a wooden holder. Graphite is an allotrope of carbon that was first mined in the sixteenth century and made into pencils by wrapping it with sheepskin or paper or by inserting a graphite rod into a *port crayon*—a slotted brass cylinder fitted with tension-rings at either end that hold the stick in place. Wooden pencils were first mass-produced during the third quarter of the nineteenth century and are still in wide use today.

COLOR STICKS AND PENCILS. Pastels, Conté crayons, oil pastels, and colored pencils are produced by forming earth pigments into drawing sticks with gum, wax, and synthetic binders. *Crayon* is the French word for pencil. Hybrids like oil pastels and watercolor pencils were invented as novel conveniences; they vary in quality as much as any art-supply product. The common crayon encountered by most schoolchildren is an inferior product that uses cheap pigments with a paraffin binder. Following is a general overview of color sticks and pencils.

o **Pastels** are color sticks made by grinding a mixture of chalk, pigment, gum binders, and preservatives into a paste that is rolled into a cylinder and sometimes wrapped in paper that can be peeled away. Rubbing pastels on a

surface releases the pigment, leaving a powdery residue. The resulting beautiful layered surfaces are fragile but may be stabilized with fixatives (see below). Pastels were transformed into a painting medium during the eighteenth century by Maurice Quentin de la Tour, Jean-Étienne Liotard, and Rosalba Carriera. Edgar Degas advanced the medium further a century later, and today Ellen Eagle and Charles Hinman—contributors to this book—use it as a drawing and painting medium.

○ **Conté Crayons** are square-section drawing sticks made by grinding earth pigments with a resinous wax binder—a centuries-old proprietary formula. Popular during the late Renaissance, they were widely used by the Venetians and by Rubens and Watteau. Conté crayons behave like pastels, but they are much harder and produce marks with better adhesion.

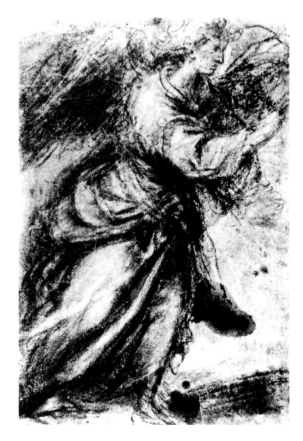

o **Lithographic Crayons** combine carbon-based pigment with wax binders of varying degrees of softness and hardness. As the name suggests, they were used in applying images to lithography stones and later to zinc plates. They produce a very durable mark and, when used effectively, are capable of producing varied dark tonalities and a rich black. Boxed crayons are sold in stick form. They are also available in pencil form as rods rolled in segmented paper wrappers that can be peeled away at intervals to expose the marking end.

o **Colored Pencils,** watercolor pencils, oil pastels, and other variations are specialized mark-making tools that combine pigments ground with gum, oil, wax, or resin binders. Some of these products, sold in rod form, are designed to be used in mechanical pencils or with a port crayon (see the section on graphic pencils, above). Others are rolled in paper wrappers like traditional pastels (described above), while others are sold in cylindrical wooden holders like conventional pencils.

SHARPENING DEVICES include manual and electric pencil-sharpeners for marking tools in wooden or metallic holders. The oldest and most reliable sharpening tool is the common penknife, so named because its historic function was trimming goose quills for use as pens. Any sharp-edged tool can trim a wooden pencil, crayon, or graphite stick to a fine point.

WET MEDIA

INK is a generic term for a water-activated substance comprised of a dye or pigment that is combined with a binder like gum or hide glue. Preindustrial inks were produced by grinding ingredients with a mortar and pestle. Coloring agents have included carbonized bones and plants, iron gall, cuttlefish ink, and sepia. Binders and additives have included shellac, tree sap, animal gelatin, and petroleum. Ink is commonly available today in liquid form, and some Asian inks are available in sticks activated by rubbing or grinding the stick against the wet incline of a small stone or a ceramic reservoir filled with water.

DRAWING INK is usually used with pens and brushes, some of which—including steel quill pens, reed pens, and Chinese writing brushes—are produced specifically for that purpose. Drawing inks should generally not be used in mechanical devices like fountain or technical pens unless they have been manufactured for that purpose. An infinite variety of markers and disposable pens are available today. Potential users must take care to read labels to discover whether an ink produces marks that are permanent or water-reversible, and whether they are alcohol- or water-based, toxic or safe. Care must also be taken to distinguish between drawing inks and fountain pen inks; the latter break down when dissolved in water and can produce multicolored oil-slick washes.

POWDERED GRAPHITE is activated by mixing it with denatured alcohol and other solvents to produce a unique drawing medium that is a hybrid of pencil and ink-wash drawing. The material itself is commonly used as a mechanical lubricant that in drawings conveys a slippery, dense surface. The process causes less buckling of paper than water media, but it must be used with adequate ventilation. A drawback of the material is that, like its cousin the pencil, it can never achieve a true black tonality. Within its limited tonal range, this wet and dry medium can produce a wide range of visual effects.

WATERCOLOR (*aquarelle* in French), a painting medium largely developed during the Renaissance and used mostly by such northern artists as Albrecht Dürer, gained widespread popularity among eighteenth-century scientists, cartographers, and explorers largely due to its portability and the ease of blending its use with drawing—the same qualities that has gained it a following among modern amateurs and hobbyists. Watercolors are produced by grinding pigments with gum arabic. In the mid-eighteenth century, watercolors were sold in hard cakes that were activated by grinding them like Chinese ink in ceramic reservoirs. In the nineteenth century it was discovered that when glycerin is added to the paste during the grinding process, the resulting cake can be activated with the touch of a wet brush. British artists like Richard Parkes Bonington and J. M. W. Turner helped transform water-color from a technical medium into an artistic miracle. Because many drawing

Albrecht Dürer, *Courtyard of Innsbruck Castle*, 1494, watercolor, Graphische Sammlung Albertina, Vienna.

inks—india ink, for example—are not water-reversible, the use of monochrome watercolor is sometimes a desirable alternative.

Many people mistakenly assume that because something is water-soluble it must be safe. In fact, care must be exercised with certain heavy-metal pigments such as cobalt and cadmium, which are toxic. Consult the Health and Safety section below.

PAINTING MEDIA IN GENERAL can and frequently are used to make works that can also be considered to be drawings. Painting is a form. Drawing is a language. Painting is thus more defined by its materiality than is drawing. Paintings on paper are frequently and perhaps incorrectly categorized as drawings. Drawing occurs naturally within the process of painting, as it also does in architecture, sculpture, storyboarding for movies, graphic novelizing, and mapmaking. Artists like Giacometti produced painting on canvas that, if it had been done on paper, would surely be identified as drawing. The same might be said of the work of such artists as Franz Kline, Cy Twombly, Agnes Martin, Sol Lewitt, and Jim Dine. Such distinctions can be philosophical or commercial, or both. One can draw with a brush as well as with a pencil because the medium is not what defines the practice. Students who grow too comfortable with defining drawing according to a familiar media will benefit by being forced to explore new media. For example, if they excel at pencil, have them work with a big brush held in the opposite hand. Drawing is most rewarding when it is most challenging.

32. Health and Safety

Certain art materials are hazardous to our health if we do not take precautions to use them in an environment equipped with ventilation and waste-disposal facilities. Instructors have the responsibility of making their students aware of the dangers to their health posed by the use of certain materials. Many artists know that plastic resins and solvents like toluene can cause irreparable damage but wrongly assume that all the materials associated with drawing are safe.

More than ten years ago, the College Art Association published a guide to art materials that included cautionary advice about the use and handling of aromatic spirits and solvents, heavy metals, and toxic pigments. By law, paint tubes must display the contents of the product and must print warnings on products containing substances like cadmium and lead. Most trained artists know that artists like Eva Hess and Duane Hanson, to name but two, suffered ill effects from unprotected use of polyester resins. Drawing fixatives can also cause respiratory and other health problems. Pastels are especially dangerous if used in confined spaces, as airborne dust can be inhaled. Charcoal dust, lighter than pastel dust, is also dangerous if inhaled.

Teachers, students, and self-learners must be vigilant in educating themselves about the materials they are using. The American Society for Testing Materials (ASTM) offers pertinent information about any materials an artist might use. If the product you are using does not have an ASTM rating or if the packaging does not disclose its contents, replace it with a product that does. American products are required to have ASTM rating and disclose contents by law. Some foreign manufacturers refuse to comply, claiming that product content is proprietary information. Do the research and protect your health.

33. Presentation and Preservation

For professional artists, exhibiting is as much a learning process as a possible path to fame and wealth. Like a bottle of wine that must be opened and consumed before it is truly and fully appreciated, works of art must be removed from the studio where they were made and reappear in neutral territory. Only then will the artist, as the first member of his or her own audience, fully understand these acts of creation. In the last three decades, many books have been published about how to conduct oneself as a professional artist, but none convey the fact that dealers and venues like museums, art centers, and university galleries are each as unique and idiosyncratic as the artists they show. There is a kind of alchemy to professionalism in art. No uniform standard exists because the few who might tolerate it would never heed it. The following comments are confined to matters related to drawing.

FRAMING

The first trip to a frame shop might involve a conversation about the color of one's wall or couch or about choosing a frame to match a color in the drawing being framed. For most professional artists, the most important function of the frame is to be a protective environment for the artwork; it also must act as a device that allows the work to be supported and presented—most commonly, hung on a wall or positioned on an easel. Frames might be glazed with picture glass or Plexiglas, based on the amount of travel the piece is expected to do. All materials that will be in contact with paper originals, including mat boards, hinges, backing, and spacers in float frames, must be archival, acid-free, and assembled by a professional framer. Frames available at the local shopping-mall hobby palace are unlikely to fit the bill, although some hobby stores do custom work.

Drawing frames are best fitted with two D-ring mirror hangers and not strung with wire; this makes them more difficult to hang but less likely to shift or fall once they are installed. Tensions exerted on hanging wires by the weight of a frame can convey stress back to the frame itself, causing it to distort. Generally speaking,

a drawing does best when presented in a frame that does not compete and thus detract from the image. Select a frame that is strong and affordable, archival, and unobtrusive. When framing works for commercial galleries, professional artists know to expect collectors who buy their work to sometimes replace a gallery frame with one better suited to their taste.

ARCHIVAL STORAGE

Drawings are some professional artists' most-prized possessions, yet artists who produce drawings often find themselves the stewards of vast amounts of paper, which compared to canvas and marble is a very fragile material. Likewise, people who collect drawings tend to regard the practice as the mark of an advanced, highly sophisticated taste, and while there tend to be fewer collectors of drawings than of paintings, many collectors cannot display all the drawings they own.

Unframed drawings are best stored flat, in cabinets, known as flat files, designed for that purpose. Individual drawings should be separated by acid-free glassine paper, in a climate-controlled environment free of insects, rodents, and other pests that eat paper.

Drawings on rag paper should be stored only with others possessing the same pH. Drawings done on nonarchival papers like newsprint should be stored together, apart from those done on archival materials. Students and others who cannot afford costly flat files should store their drawings in flat folder portfolios—the rigid kind that open in the middle like a book, with lengths of cloth tying-tape on the edges to secure them. These portfolios can be stored anywhere flat, such as under a bed; they should not be stored vertically for long periods of time. Drawings should never be rolled, because curling makes them difficult to handle and prone to chipping and tearing along the edges.

CONSERVATION

Paper conservators can reverse damage done to books, drawings, manuscripts, and ephemera, and can stabilize them in an archival condition for safe storage. However, processes like lining, washing, and removing stains and foxing can be safely done only with proper materials and in proper settings by trained and qualified individuals. Few accredited conservation programs exist. Their graduates must be as dexterous as the best artists, and with a grasp of science and chemistry that few artists possess. The demand for their services is high, which can cause lengthy delays for their clients. Some how-to art books describe certain restoration methods, none of which should be undertaken by anyone but a trained conservator. Over the years, many dealers have notoriously restored their inventories as if they were detailing an automobile—a practice that must be discouraged.

Restorers, like any other service providers, can be capable or incompetent. Always check their credentials and references. Discover and consult with their

existing clients. Some commercial restorers may be working with practices that were formerly deemed safe but that today are known to damage the objects they intend to preserve. Innovations in chemistry, technology, and new product development are rapidly changing the field of art conservation.

34. Study and Appreciation of Drawing

Apart from practice, the best way to learn about drawing is to see as many original graphic works of art as possible. Books and the Internet can provide a secondary experience of viewing artworks, but nothing can replace seeing original drawings firsthand. Most people are confined to looking at valuable historic drawings in museums, framed and behind glass.

Most museums possess a vast number of drawings that are seldom displayed because of lack of space. They may be kept in flat files or, if they are framed, stored vertically on wire racks. The mission of most public-access museums, regardless of their institutional governance, is to make works of art available to scholars and other members of the public who are engaged in serious study. Appointments can be made to visit drawing departments in most museums for private viewing. Security in museums, libraries, and map rooms has increased as a result of recent, well-publicized thefts. Visitors are expected to present a valid reason for their requested visit. If you lack academic credentials, you might ask a professor or art professional to provide a bona fide introduction.

ORGANIZING MUSEUM VISITS

Bearing in mind that job titles may change from one institution to another, identify the curator in charge of prints and drawings. Research the collection you wish to visit. Make a list of specific drawings you want to view, and compose a brief paper letter (not an e-mail) addressed to the curator requesting a visit. Be patient. Do not expect a speedy reply, but you may follow up with a courteous phone call or e-mail after a month if you have not received a response. Once you have established yourself at several museums as a visitor, you may find that you are more welcome at others. The curator at one museum may even suggest future visits to another. Having gained admittance to a museum study room, you must observe certain courtesies; in many institutions they are strictly enforced.

COURTESY AND CONDUCT

Leave all bags, notebooks, pens, and pencils outside the study area. Check to see whether cameras are allowed. Many museums provide paper and pencils for note-taking and magnifying glasses for close inspection. Observe all rules and regulations

without comment or objection. You will be required to handle fragile paper goods with white cotton gloves. In some places, you may have to wear a surgical mask to avoid damaging materials by breathing or sneezing on them. Usually a curator will bring drawings into the room—individually or several at a time, perhaps in a clamshell storage box—and will remove any protective tissue before arranging the piece(s) for viewing. One must never touch any part of a mat or drawing unless invited to do so. When you are ready to view another drawing, ask the curator. Unless you are a scholar working on a specific project, do not expect a visit to last more than an hour. Focus on a few pieces, and return another day to view more. Many museums will make accommodations for small school groups as well as individuals.

APPRECIATION: VIEWING DRAWINGS

Drawing collectors tend to be advanced collectors in some other field who are drawn to the graphic arts as a window into an artist's mind; they wish to be a witness to the most primary expression of the creative process. Drawing collectors are few, despite the fact that a drawing by a famous artist is priced at pennies on the dollar when compared to a painting or sculpture by the same person. While novice collectors are easily impressed by splashy products, it takes years of visual cultivation to fully appreciate fine drawings. Like really understanding wine-tasting or admiring the salt-glaze on a fine Japanese tea ceremony *chawan* (tea bowl), the appreciation of drawing is a cultivated skill that, in addition to pure aesthetic enjoyment, can bring the viewer into dialogue with the draftsman and provide insight into the artist's working process. Following a few simple steps will greatly enhance one's experience when looking at original drawings not covered by glass.

TAKE NOTE OF THE PAPER'S SIZE, color, texture, and condition. Look at the edges to see if it has a deckle or cut edge. Note the presence or absence of gridded screen-marks in the paper surface that might reveal how the paper was made. Note any visible fibers or anomalies in the body of the sheet.

NOTE THE CHOICE OF MATERIALS. If multiple materials are used, which came first and which followed? Note whether wet or dry materials were used or wet and dry materials were used together.

LOOKING AT THE MARKS on the page, try to determine which mark was the first and which the last. Note any evidence of erasure or scraping. Were elements pasted onto the surface? Was the page cut down? Was it expanded by the addition of more paper to one or more edges?

TRY TO DETERMINE whether the drawing was a study for something else or was produced as a finished product. How does the specimen at hand fit within the artist's oeuvre?

TAKE NOTES. Record your responses to the drawing(s). If you are permitted to take your sketchbook into the study room, use it. Make an interpretive copy after the original. The purpose of copying a work of art is not to simply reproduce it but to imprint a strong memory of viewing it by downloading it into one's mind with the tip of a pencil.

BUILD A PERSONAL DRAWING REFERENCE LIBRARY

Few artworks survive transcription into secondary media as well as drawings. Drawing books are frequently priced more reasonably than other art books. Exhibition catalogs, museum catalogs, and monographs are frequently found on the remainder tables at bookstores at reduced prices. Museums sell reproductions of drawings in their collections as postcards. Students and others who cannot afford to buy many books can afford postcards. Today many museum collections are searchable online. In some cases, like the Library of Congress and the Smithsonian American Art Museum, those collections are vast, and many images can be downloaded onto a personal computer. Many historic books—such as Rembrandt Peale's *Graphics*—are now in the public domain and available online. See also the bibliography on pages 186–188. ∎

— James L. McElhinney

Bibliography

Sources and suggestions for further reading

Ackerman, Gerald M. *Charles Bargue with the Collaboration of Jean-Léon Gérôme: Drawing Course*. Paris: ACR Edition, 2003.

Adler, Kathleen, Erica E. Hirshler, and Barbara Weinberg. *Americans in Paris 1860–1900*. New Haven: Yale University Press, 2006.

Alberti, Leon Battista. *On Painting (Della pittura)*. New Haven: Yale University Press, 1977.

Allen, Elizabeth K. *Open-Air Sketching; Nineteenth-Century American Landscape Drawings in the Albany Institute of History and Art*. Albany, NY: Albany Institute of History and Art, 1998.

Anderson, Albert A., Jr., William L. Joyce, and Sandra K. Stelts. *Teaching America to Draw. Instructional Manuals and Ephemera 1794–1925*. An exhibition at the Grolier Club, May 17–July 29, 2006, and the Special Collections Library, Pennsylvania State University Libraries, September 20, 2006–January 7, 2007. University Park, PA: Pennsylvania State University Libraries.

Anonymous. *A Drawing Book of Landscapes*. Philadelphia: Johnson & Warner, 1810.

Aristides, Juliette. *Classical Drawing Atelier: A Contemporary Guide to Traditional Studio Practice*. New York: Watson-Guptill, 2006.

Bermingham, Ann. *Learning to Draw: Studies in the Cultural History of a Polite and Useful Art*. New Haven: Yale University Press for Paul Mellon Centre for Studies in British Art, 2000.

Bridgman, George Brandt. *Bridgman's Complete Guide to Drawing from Life*. Edited by Howard Simon. New York: Sterling, 1952.

Callow, James T. *Robert W. Weir and the Sketch Club*. West Point, NY: Cadet Fine Arts Forum of the United States Corps of Cadets, 1976.

Camhy, Sherry Wallerstein. *Art of the Pencil*. New York: Watson-Guptill, 1997.

———. "Silverpoint: Old Medium, New Artists." *Fine Art Connoisseur* 4, no. 4 (August 2007).

———. "Sparkling Magic Wand." *Linea: Journal of the Art Students League of New York* (Spring 2007).

Chaet, Bernard. *The Art of Drawing*. New York: Holt, Rinehart, and Winston, 1970.

Chapman, John Gadsby. *American Drawing Book: A Manual for the Amateur and Basis of Study for the Professional Artist, Especially Adapted to the Use of Public and Private Schools as well as Home Instruction*. New York: J. S. Redfield, Clinton Hall, 1847 (and subsequent editions).

Cuthbert, John A., Jessie Poesch, and David Hunter Strother. "One of the Best Draughtsman the Country Possesses." Morgantown, WV: University of West Virginia Press, 1977.

Davis, Elliott Bostwick. *Training the Eye and the Hand: Fitz Hugh [sic] Lane and Nineteenth-Century American Drawing Books*. Gloucester, MA: Cape Ann Historical Society, 1993.

Dürer, Albrecht. *De symmetria partium in rectis formis humanorum corporum* [On the normal proportions of the parts of the human form]. Nuremberg, 1538.

———. *Underweysung der Messung* [Four books on measurement]. Nuremberg, 1538.

Faragasso, Jack. *Mastering Drawing the Human Figure from Life, Memory, Imagination*. Woodstock, NY: Stargarden Press, 1979.

Felker, Tracie. *Master Drawings of the Hudson River School*. New York: Metropolitan Museum of Art; Gallery Association of New York State, 1993. Exhibition catalog.

Fink, Lois Marie, and Joshua Taylor. *Academy: The Academic Tradition in American Art; An Exhibition Organized on the Occasion of the 150th Anniversary of the National Academy of Design, 1825–1975*. Washington, DC: United States Government Printing Office, 1975.

Forbes, R. J. *Studies in Ancient Technology*. Leiden, Netherlands: E. J. Brill, 1955.

Fort, Megan Holloway. *Archibald and Alexander Robinson and Their Schools, The Columbian*

Academy of Art and the Academy of Painting and Drawing, New York, 1791–1835. PhD diss., CUNY Graduate Center, 2006.

Foster, Kathleen A. *A Drawing Manual by Thomas Eakins*. With an essay by Amy B. Werbel. New Haven: Philadelphia Museum of Art in association with Yale University Press, 2005.

Frankel, Stephen, ed. *The Drawings of Paul Cadmus*. Introduction by Guy Davenport. New York: Rizzoli, 1989.

Gerdts, William H. *Robert Weir: Artist and Teacher of West Point*. West Point, NY: Cadet Fine Arts Forum of the United States Corps of Cadets, 1976.

Glanz, Dawn. *How the West Was Drawn: American Arts and the Settling of the Frontier*. Ann Arbor, MI: UMI Research Press, 1982.

Goldstein, Nathan. *Figure Drawing: The Structure, Anatomy, and Expressive Design of Human Form*. New York: Prentice-Hall, 1976.

Gottsegen, Mark. *A Manual of Painting Materials and Techniques*. New York: Harper & Row, 1987.

Groseclose, Barbara. *Nineteenth-Century American Art*. Oxford: Oxford University Press, 2000.

Hale, Robert Beverly. *Anatomy Lessons from the Great Masters*. New York: Watson-Guptill, 1977.

———. *Drawing Lessons from the Great Masters*. New York: Watson-Guptill, 1964.

Haverkamp-Begemann, Egbert. *Creative Copies: Interpretive Drawings from Michelangelo to Picasso*. London: Philip Wilson, 1988.

Holbrook, Nelson M. *The Child's First Arithmetic Book*. Kalamazoo, MI: D. A. McNair, 1853. Reprint, Morgantown, PA: Sullivan Press, 1998.

Ingres Centennial Exhibition, 1867–1967; Drawings, Watercolors, and Oil Sketches from American Collections, Fogg Art Museum, Harvard University, February 12–April 9, 1967. Cambridge, MA: Fogg Art Museum, 1967.

Johnson, Borough, S.G.A. *The Technique of Pencil Drawing*. London: Sir Isaac Pitman, 1930.

Karolik Collection. *M. and M. Karolik Collection of American Watercolors and Drawings 1800–1875*. 2 vols. Boston: Museum of Fine Arts, 1962.

Koob, Pamela N. *Drawing Lessons: Early Academic Drawings from the Art Students League of New York*. New York: Art Students League of New York, 2009.

Korzenik, Diana. *Drawn to Art: A Nineteenth-Century American Dream*. With a foreword by Rudolph Arnheim. Hanover, NH: University Press of New England, 1985.

Kreutz, Gregg. *Problem Solving for Oil Painters: Recognizing What's Gone Wrong and How to Make It Right*. New York: Watson-Guptill, 1997.

Landgren, Marchal E. *Years of Art: The Story of the Art Students League of New York*. Introduction by Walter Pach. New York: Robert McBride, 1940.

Lougherty, John. *John Sloan: Painter and Rebel*. New York: Henry Holt, 1995.

Lucas, Fielding. *The Art of Drawing, Colouring, and Painting Landscapes, in Water Colours*. Baltimore, 1815.

——— and John Latrobe. *Progressive Drawing Book*. Baltimore, 1825.

Marzio, Peter C. *The Art Crusade: An Analysis of American Drawing Manuals, 1820–1860*, Washington, DC: Smithsonian Institution Press, 1976.

Mayer, Ralph. *The Artist's Handbook of Materials and Techniques*. Revised edition. New York: Viking, 1970.

McElhinney, James Lancel. "From Peale to Pixar." *American Arts Quarterly* 23, no. 4. Newington Cropsey Cultural Studies Center, Fall 2006.

———. "The Rebirth of Drawing." *American Arts Quarterly* 21, no. 2. Newington Cropsey Cultural Studies Center, Spring 2004.

continued

Mitchell, Mark. *The Artist-Makers: Professional Art Training in Mid-Nineteenth-Century New York*. PhD diss., Department of Art and Archaeology, Princeton University, 2000.

Morris, I. H. *Geometrical Drawing for Art Students*. London: Longmans, Green, 1919.

Olson, Roberta J. M. *John Singer Sargent and James Carroll Beckwith, Two Americans in Paris: A Trove of Their Unpublished Drawings*. New York: Master Drawings Association, 2005.

Peale, Rembrandt. *Graphics: A Manual of Drawing and Writing, for the Use of Schools and Families*. New York: B. & S. Collins, 1835.

Phagan, Patricia. *Hudson River School Drawings from the Dia Art Foundation, April 12– June 15, 2003*. Poughkeepsie, NY: Frances Lehman Loeb Art Center, Vassar College, 2007.

Postle, Martin, and William Vaughan. *The Artist's Model from Etty to Spencer*. London: Merrell Holberton, 1999.

The Progressive Drawing Book; Containing a Series of Easy and Comprehensive Lessons for Drawing London, 1853.

Prown, Jules. "An Anatomy Book by John Singleton Copley." *Art Quarterly* 26 (Spring 1963).

Reel, David M. "The Drawing Curriculum at the U.S. Military Academy during the Nineteenth Century." *West Point, Points West*. Western Passages, No. 1. Denver, CO: Institute of Western American Art, Denver Art Museum, 2002.

Robertson, Archibald. *Elements of the Graphic Arts*. New York: D. Longworth, 1802.

Rossol, Monona. *The Artist's Complete Health and Safety Guide*. New York: Allworth Press, 2001.

Ruskin, John. *The Elements of Drawing*. London: Smith, Elder, 1857. Reprint, New York: Dover, 1971.

Shelley, Marjorie. "The Craft of American Drawing: Early Eighteenth to Late Nineteenth Century." In *American Drawings and Watercolors in the Metropolitan Museum of Art*, by Kevin J. Avery, Vol. 1. New York: Metropolitan Museum of Art; New Haven: Yale University Press, 2002.

Sims, Lowry Stokes. *Stuart Davis: American Painter*. New York: Metropolitan Museum of Art, 1992.

Sloan, John, with the assistance of Helen Farr Sloan. *Gist of Art: Principles and Practice Expounded in the Classroom and Studio*. New York: Dover, 1977.

Stebbins, Theodore. *American Drawings and Watercolors*. New York: Harper & Row, 1976.

Steiner, Raymond J. *The Art Students League of New York: A History*. Saugerties, NY: CSS Publications, 1999.

Steinhart, Peter. *The Undressed Art: Why We Draw*. New York: Vintage Books, 2005.

United States of America. Secretary of War John C. Calhoun. *General Regulations for the Army, 1821*. Philadelphia: M. Carey, 1821.

Vasari, Giorgio. *Lives of the Artists*. London: Penguin, 1995.

Viola, Elisa. *The Accademia di Venezia: The Masters, the Collections, the Premises*. Edited by Gloria Vallese. Venice: Marsilio, 2005.

Vitruvius Pollio, Marcus. *Ten Books on Architecture*. Mineola, NY: Dover. 1960.

Ward, David C. *Charles Willson Peale: Art and Selfhood in the Early Republic*. Berkeley: University of California Press, 2004.

Whalley, Joyce Irene, ed. *Pliny the Elder: Historia Naturalis*. London: Victoria and Albert Museum, 1982.

Index

Note: Page numbers in *italics* include illustrations and photographs/captions.

Picture Credits

All artworks are either from the collection of the Art Students League of New York or individual artists, as credited next to each image, except for the following images:

Courtesy the Arkansas Art Center / Will Barnett: 30: *Lifestudy*

Courtesy Google Books: 3bl: From *The Elements of Drawing: In Three Letters to Beginners*, John Ruskin (1857); 3br: From *Graphics: A Manual of Drawing and Writing, for the Use of Schools and Families*, Rembrandt Peale (1835); 12bl: From *Euclid's Elements of Geometry*, John Keil (1723); 141, 151t: From *A Manual of Engineering Drawing for Students and Draftsmen*, Thomas E. French (1911)

Courtesy Google Patents: 156t: "Improvements in Machines for Forming Temple-Teeth," Nathan Chapman, 1874

Courtesy the Library of Congress
Prints and Photographs Division: 6: LC-DIG-jpd-02787; 8: LC-USZ62-87609; 12tr: LC-USZ62-59061; 158: LC-USZ62-102832
Geography and Map Division: 12br: g3300.ct000232

Courtesy National Library of Medicine: 2: Frontispiece from *De humani corporis fabrica libri septem*, Andreas Vesalius (1543), http://www.nlm.nih.gov/exhibition/historicalanatomies/Images/1200_pixels/Vesalius_Portrait.jpg

Shutterstock: 12tl: © Shutterstock/Mike Flippo

Courtesy Wikimedia Commons: 145: Fibonacci spiral 34.svg/Dicklyon; 146: DURER2.png/Jean-Jacques MILAN; 169tl: Giotto --08-- Presentation of the Virgin in the Temple/Petrusbarbygere; 169tr: Tentaciones de Cristo (Botticelli).jpg/ Erzalibillas; 169cl: Piero della Francesca - 2. Procession of the Queen of Sheba, Meeting between the Queen of Sheba and King Solomon – WGA17487.jpg/Web Gallery of Art/JarektUploadBot; 169cr: Raffaello Sanzio - The School of Athens – WGA18925/Web Gallery of Art/JarektUploadBot; 169bl: Tintoslave.jpg; 169br: Claude Lorrain 027/The Yorck Project.jpg; 177t: Rosalba Carriera 002.jpg/Gothika; 177b: Tiziano, studio per angelo annunciante.jpg/Web Gallery of Art (#22993)/ Sailko; 179: Courtyard of Innsbruck Castle.jpg/COREL/Shassafrass